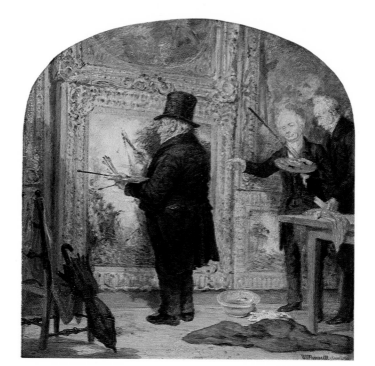

100 Masterpieces
of Art

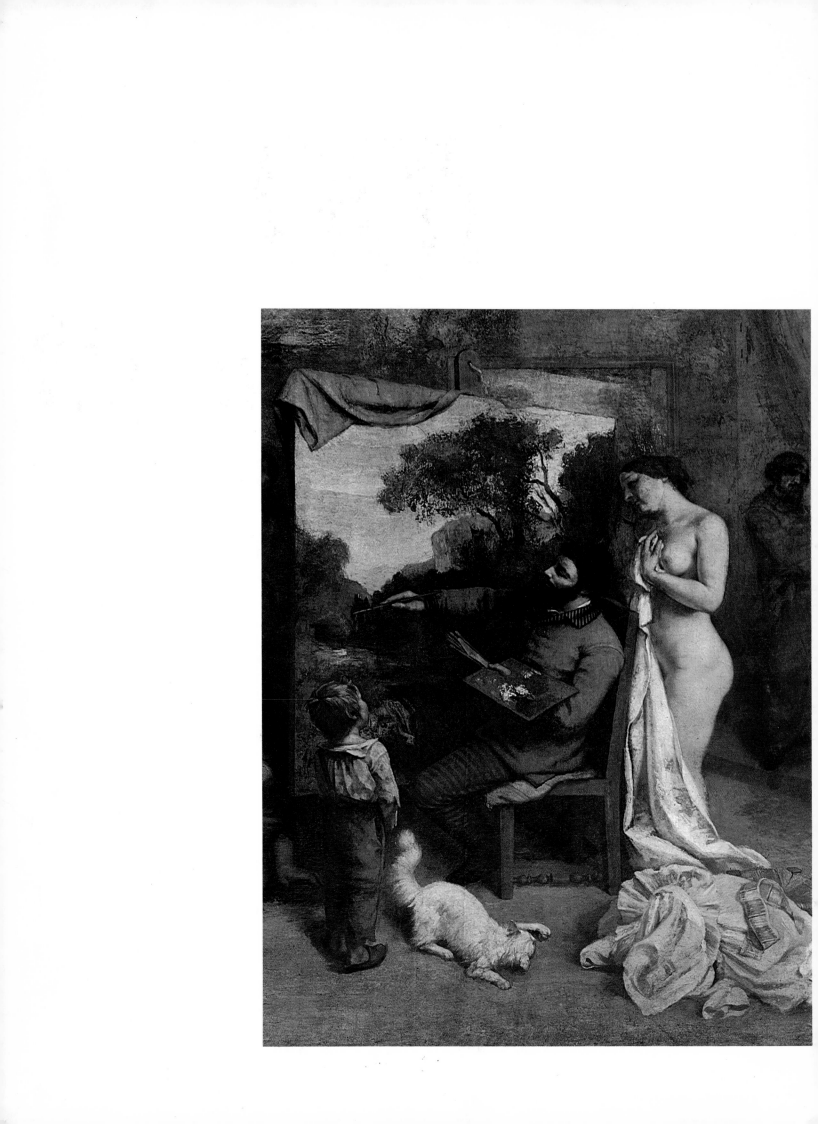

100 Masterpieces of Art

Marina Vaizey

EXCALIBUR BOOKS
NEW YORK

Contents

For my Family

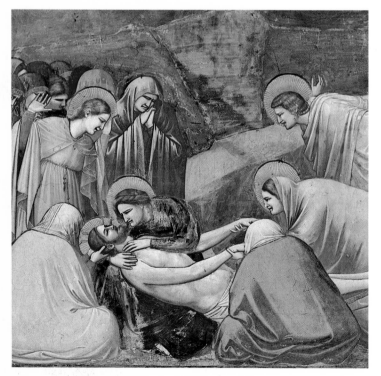

Detail from *The Lamentation*

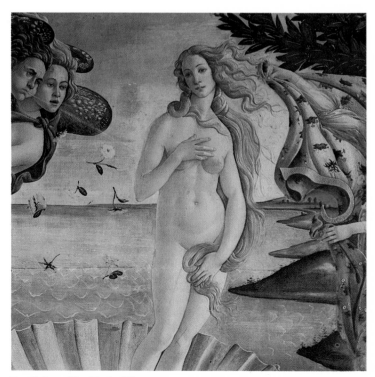

Detail from *The Birth of Venus*

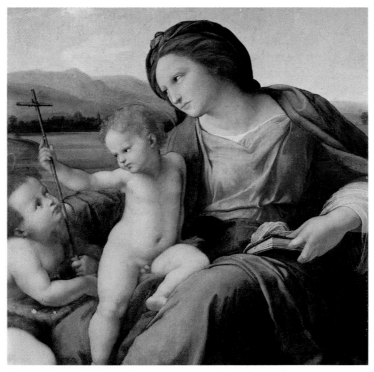

Detail from *The Alba Madonna*

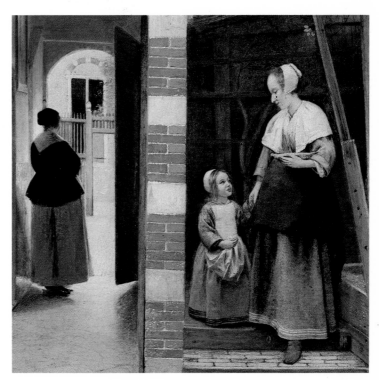

Detail from *The Courtyard of a House in Delft*

CONTENTS

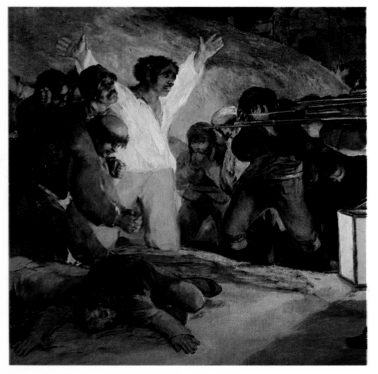

Detail from *The Third of May, 1808*

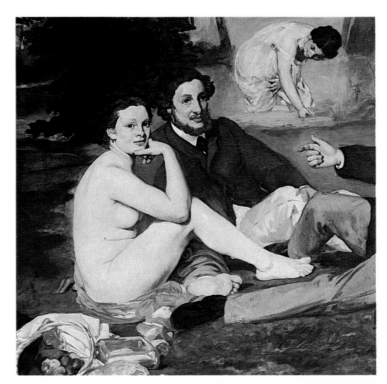

Detail from *Le Déjeuner sur l'Herbe*

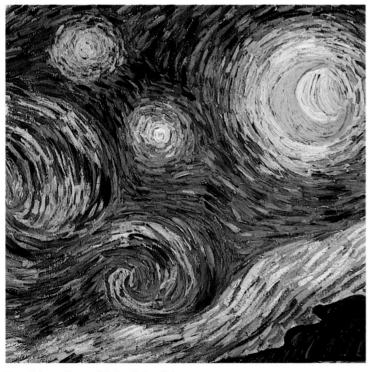

Detail from *Starry Night, Saint-Rémy*

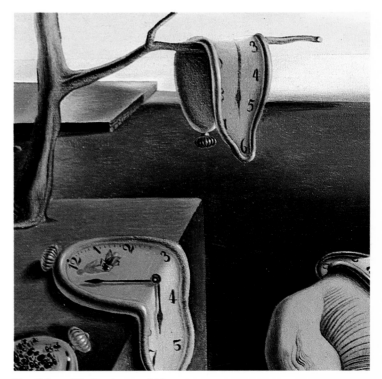

Detail from *The Persistence of Memory*

Introduction

THE PAINTINGS SELECTED FOR THIS BOOK are representative of a hundred of the greatest Western painters from the thirteenth century to the present day. They are considered to be masterpieces either because they are supreme examples of the work of a particular artist or because they broke new ground and were revolutionary in their own time. They are some of the most enduring and familiar pictures in the great museums of the world, and a vital part of our heritage.

One of the functions of art is to reflect the world that produced it, and variations in style, medium and subject matter emerge from the life and attitudes of each period. There are technical advances of course, but they do not always produce greater art. Neither old nor new is necessarily better; there are changes rather than improvements.

New techniques have evolved largely as a result of the changing purpose of art. Some of the earliest works included here are frescoes (see p. 12), a method of painting directly on to walls, which was frequently used in medieval times to decorate religious buildings for the Christian Church and palaces and country villas for the ruling families. Smaller works until the fifteenth century were mostly carried out in tempera on wood panels (see p. 26). As art became more general in subject matter and appeal, the medium of oils (pigment mixed with oil) began to be developed. It has the enormous advantage that it can be applied in an endless variety of textures, and is infinitely versatile. In the last two hundred years canvas has taken over from wood, and today oil paint on canvas is by far the most widely used medium.

Labels have been invented to describe different movements and styles, and many of them are represented in this book. The following paragraphs briefly discuss the development from Byzantine art in the South and Celtic in the North to the Renaissance and Baroque eras. Other movements, spanning much shorter periods, are covered within the text on the relevant pictures, with an explanation here of their chronology.

The two great centres of civilization under the Roman Empire were Rome itself in the West and Byzantium (present-day Istanbul) in the East. The arts had reached supreme heights in the first century BC, but when Rome fell to invading barbarians its culture died with it, and the Dark Ages submerged most of Europe for hundreds of years. A large part of the Empire was gradually restored under Charlemagne in the late eighth and early ninth centuries, and the culture of Byzantium, which had continued to flourish, began to filter through to the West.

For hundreds of years painters in Southern Europe drew on Byzantine traditions for their ideas, and its flat, decorative and rather severe style characterized religious pictures produced in Italy well into the fourteenth century. It was handed down from one artist to another, and each faithfully copied his predecessors without attempting to produce anything original. Patrons of the arts – the nobility and the Church – were not at all interested in individuality in the pictures they commissioned; they expected painters to follow the accepted formula, and produce work which glorified God in the way they knew and understood. The painter himself was relatively unimportant, and as a result we have very little information concerning the identities of any artists before the mid-thirteenth century.

Religion was the single most important influence on the lives of Europeans in the early Middle Ages, and, in response to its needs, artists produced superb illuminated manuscripts, sculptures in stone or painted wood, and biblical pictures to decorate the walls of the superb cathedrals and churches that were being built all over Europe. The medieval spirit expressed itself above all in architecture and the cathedral was a complete art form in which paintings, carvings and sculpture were subsidiary parts of a magnificent scheme dedicated to God.

Once an artistic tradition has been established it requires imagination as well as skill to shake off its conventions and progress to something new. But by the fourteenth century the limitations of the Eastern religious style were beginning to be steadily eroded – a transformation was taking place, and it led to a much more realistic style of painting, which gradually spread from Italy to the rest of Europe. Its earliest signs can be seen in the first two Italian painters included here, Duccio and Giotto.

A more human, analytical and intellectual approach to life began to take hold, and the focus of attention to shift from the Church to man and the world around him. Art reflected this, and artists from the time of Masaccio turned back for their inspiration to the humanity and realism of the art and attitudes of ancient Greece and Rome. This revival of classical art came to be known as the Renaissance (or re-birth), and it centred in a wholly realistic and scientific way on the human figure. It was a period of discovery and invention, which reached its height in the fifteenth and sixteenth centuries in the genius of Leonardo da Vinci, Michelangelo and Raphael.

The Church was still a powerful force, and the greatest artists of the day worked for the Popes of Rome and decorated chapels for the ducal families of the Italian city states. But they also produced superb portraits, landscapes and mythological scenes. The classical revival renewed an interest in the myths of ancient Greece, and they became popular subjects: the artist was provided with an excuse for painting the naked human figure, and the splendour of the themes was suitably impressive for the entertainment of the aristocracy.

The early Middle Ages in the North had been dominated by the influence of Celtic rather than Byzantine art. Cultural centres grew up as a result of trade, which produced money for commissions, and merchants filled their houses with paintings to show off their new prosperity. Van Eyck, van der Goes and van der Weyden in the Low Countries, and Grünewald, Cranach and Holbein in Germany all created

magnificent portraits and biblical scenes in response to this demand.

Largely as a result of Dürer's visits to Venice in the fifteenth century, the ideals and achievements of the Italian Renaissance began to influence the art of the North, and to result in work of an astonishing brilliance and realism.

Many artistic movements are followed by a period when their aims are exaggerated to the point of absurdity before a reaction causes the birth of a new style. Mannerism emerged from the Renaissance and extended its ideas into an elegant artificiality that was sometimes overdone; but it also produced brilliant and dazzling creations like the work of Bronzino (see p. 40).

The reaction to it was the Baroque movement, when painting, sculpture, architecture and music were all filled with a new energy and emotion. In painting it was a time when the problems of perspective and space were tackled with tremendous dynamism and confidence, and movement, light and colour were used to achieve highly dramatic effects. The age of Baroque reached its greatest heights in Italy with Caravaggio in the late sixteenth century, and spread to France, Spain, Germany, Austria and, to a lesser extent, the Netherlands, over the next two hundred years.

The Baroque style never acquired in the North the extravagances reached in Italy, Spain and France, largely because the Protestant Church was puritanical and disapproved of such opulence. Calvin, the Reformation leader, declared: 'Man should not paint or carve anything except what he can see around him, so that God's majesty may not be corrupted by fantasies.' Dutch painters turned therefore to their immediate surroundings for their subjects. Scenes of the placid Dutch countryside, and the intimate portraits and interiors of Vermeer, Hals and de Hooch became very popular. The greatest masters of the age of Baroque in the North, however, were Rubens and Rembrandt, who transcended both conventions and traditions in their powerful and highly individual work. This immensely productive period came to be known as the Golden Age of Dutch painting.

After the long period of the Baroque came the lightness of Rococo, which was mainly developed in France, Austria, Germany and Northern Italy in the early eighteenth century. It was characterized by the charm and elegance of the work of Watteau, Tiepolo, Boucher and Fragonard. Neoclassicism followed it, and reacted to its frivolity with a new revival of classical art. Its most famous examples are the paintings of David. This in turn caused a swing to the opposite extreme and produced the Romantic movement, in which artists such as Friedrich, Turner and Delacroix painted landscapes and historical episodes charged with emotion and drama. The Pre-Raphaelite Brotherhood was created in the 1850s by a group of artists who wanted to return to the serious spirituality of art before Raphael – Millais (see p. 82) was one of its leaders. In Paris in the 1870s Monet, Pissarro, Renoir, Degas, Manet and others formed the Impressionist group. They worked in the open air, studying the effects of light and shade, and painting everyday scenes with a beautiful clarity and freshness. Cézanne and the Post-Impressionists concentrated on an analysis of structure, and influenced Picasso and Braque, who developed Cubism (see p. 105) in the early part of this century. The Dada movement (see p. 108) led to Surrealism, the dream-like world of Magritte and Dali, which was developed mainly in France and Germany in the 1920s and 30s. Today in Western Europe, communications are easier, people travel more than ever before and are open to ideas and influences from all over the world, and this is reflected in the wide variety of styles in twentieth-century art.

Different countries have dominated art at different times. For about three centuries – from 1250–1550 – Italy was pre-eminent, partly because it was the centre of the wealthy Catholic Church, and partly because of its immense inheritance of the art of ancient Rome. In the seventeenth century, when wealth from trade produced the Golden Age of Dutch painting, Holland was supreme. Since then shifts have occurred as other countries have prospered, suffered political upheavals or introduced social changes and developments, and artists have responded with work inspired by the new climate. A colour chart on the following pages provides an immediate and fascinating picture of the transitions that have taken place over the last seven centuries.

Much of our knowledge of the lives of early painters has come from the records of the Painters' Guilds, formed in medieval times. As the status of the artist was raised during the High Renaissance from tradesman to gentleman, the guilds began to die out, and they were replaced by academies which took over the vital job of teaching. The artist came to be regarded more as an inspired creator than as a craftsman working to order, and he was given increasing opportunity to express his own ideas and imagination. At the same time wealth was distributed more widely, and he could paint for a far larger audience and reflect a broader spectrum of life. His personal interpretation of his subject began to be valued above all, and art itself to be prized as the deepest and most expressive medium for the communication of ideas.

Paintings of the late medieval era were easily understood by their audience because they conformed to a set pattern, and expressed a shared outlook on life. Nowadays, when self-expression has become the order of the day, art is sometimes complicated and enigmatic, but it is also infinitely rich, adventurous and exciting.

Each painting is discussed here in the context of its own time. Not only does each one reflect the life of its period, but it also communicates ideas which we can understand and relate to today. The book is arranged chronologically so that techniques and styles can easily be traced, with an Index at the end to artists, movements and technical terms.

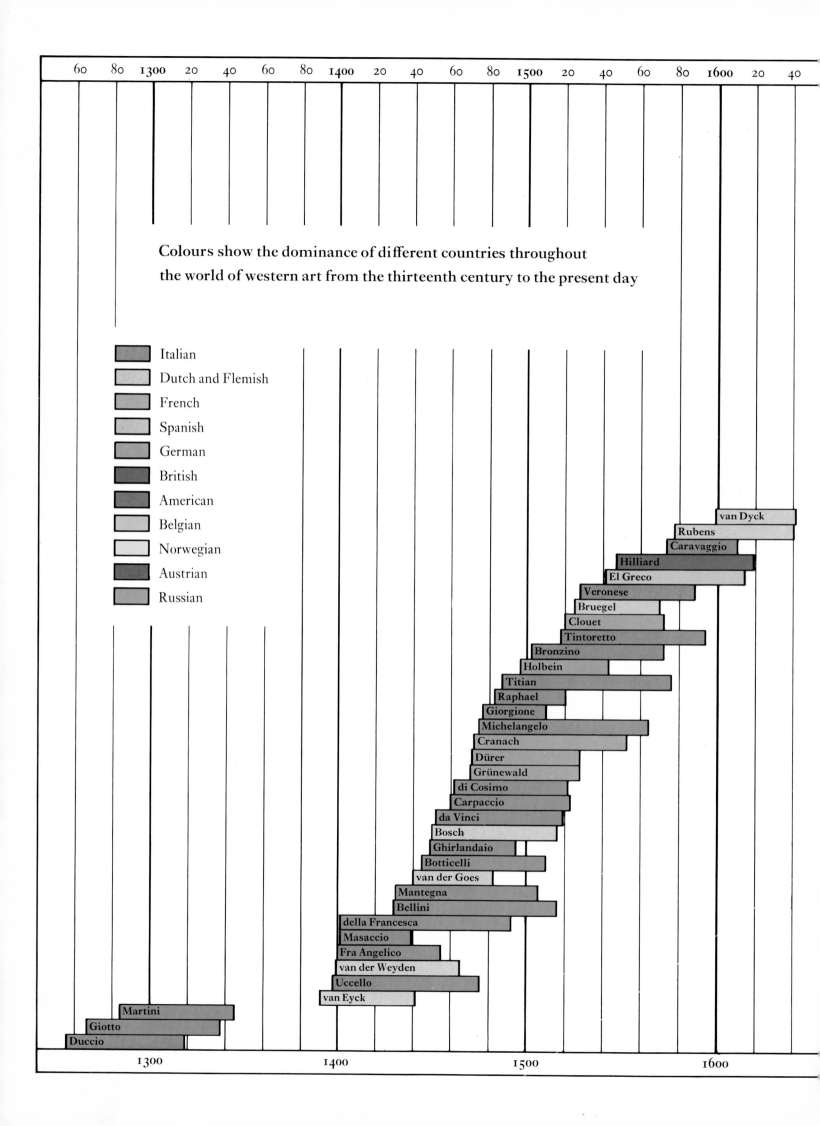

Colours show the dominance of different countries throughout
the world of western art from the thirteenth century to the present day

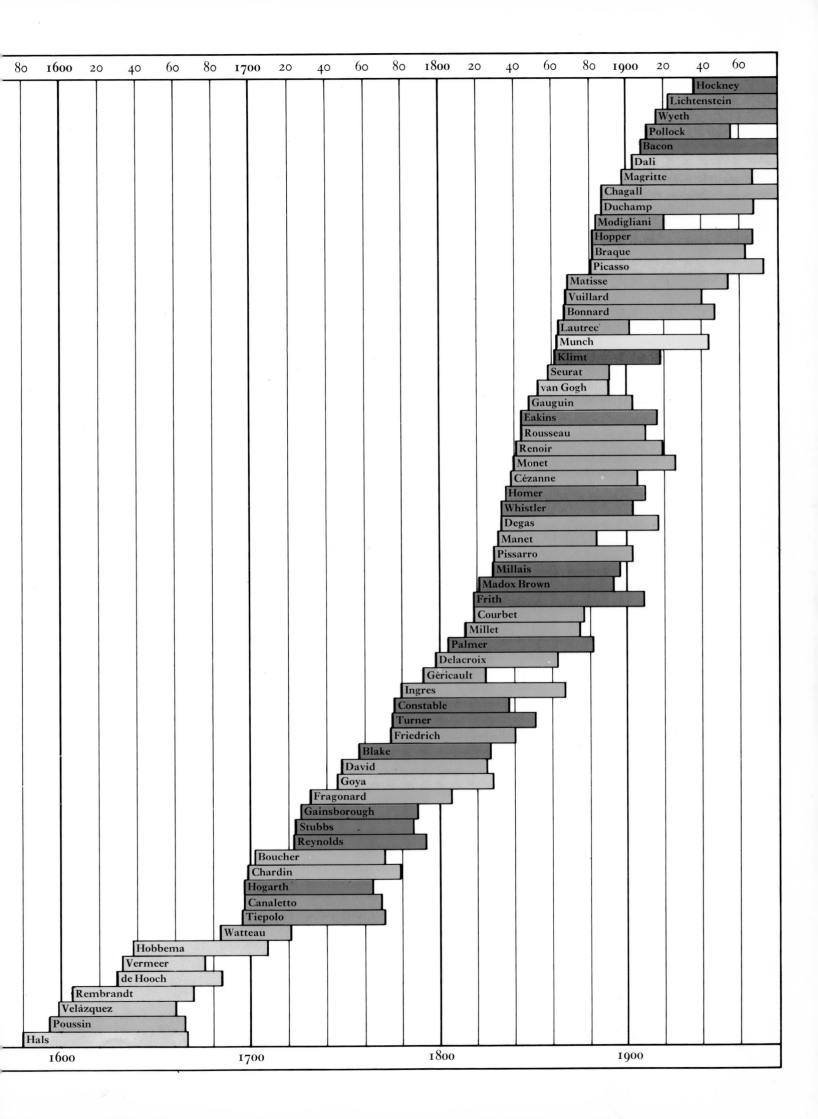

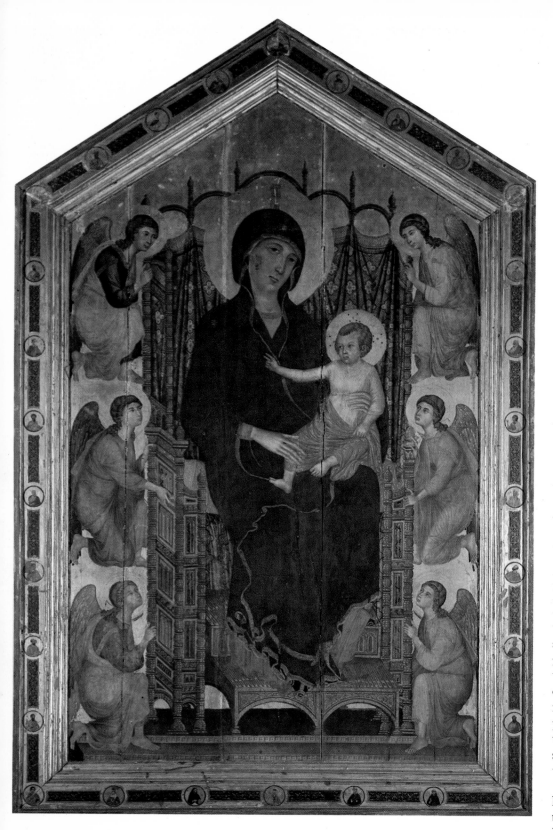

moves in a particular way. This achievement had a profound effect on the Sienese painters who followed him.

In 1285 he painted *The Rucellai Madonna*, a large work named after the aristocratic Rucellai family of Florence, who probably commissioned it and in whose private chapel it was placed in the church of Santa Maria Novella. The characteristics of Byzantine art can be seen to persist in its decorative formality: the Madonna and the Holy Child face towards us, the figures stylized and rather stiff against the gold background. The throne is an elaborate structure, its architectural features symbolizing the Christian Church. But there is a new liveliness and movement in the angels clinging to the throne. The gilded border of the Virgin's dark blue robe flows down and across the painting, following the contours of her body and suggesting that it covers a living, three-dimensional figure, not just a painted representation.

Colour as well as line was significant in Duccio's work. He used it to create a harmonious scheme, rather than just to define the separate figures; and here the variations in the angels' robes – light blue and rose, green and pale violet – make a glowing pattern. The Virgin was traditionally portrayed in blue as it was an expensive pigment, and its use implied reverence and respect; it also denoted purity since it is the colour of the sky and therefore of heaven. The figures are surrounded by a gilded frame decorated with medallions of saints and prophets.

Above all, this devotional painting heralded a gradual new development in the art of Siena. The beginnings of a new humanity and warmth pervade its grave and austere beauty, and Duccio has conveyed deep religious feeling in a far more accessible way than did the art of the Byzantine masters who preceded him.

Duccio di Buoninsegna (1255/60–1315/18)

The Rucellai Madonna (after 1285)

The Uffizi Gallery, Florence

Duccio was the first and perhaps the greatest of the religious painters of medieval Siena, then the capital of one of Italy's northern city states. His work sums up the highly formal tradition inherited from the eastern civilization of Byzantium, but it is also more realistic and more natural. In the Middle Ages, when artists had been content to follow the Byzantine tradition, their principal aim was to express their strong religious beliefs in a highly decorative and spiritual way. Their figures were two-dimensional, and they made little attempt to represent them accurately or realistically. Duccio introduced something new: his work marks a turning point in that it began to express the idea that a body has life, and it

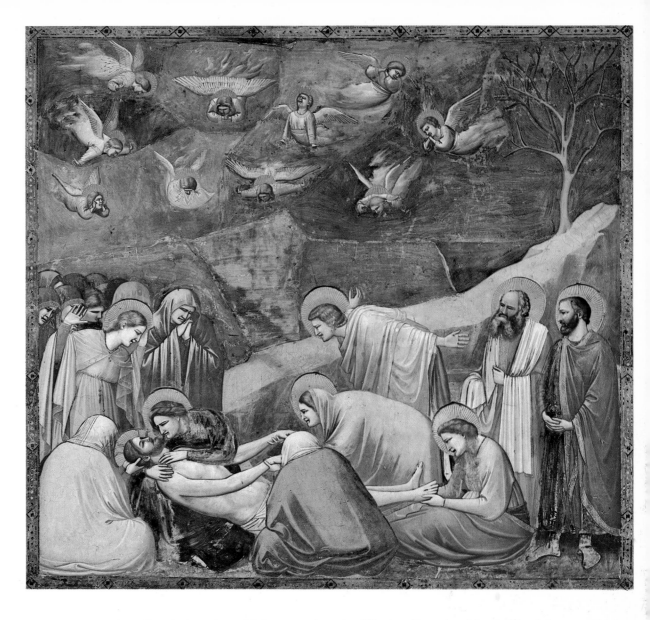

Giotto di Bondonè (*c.* 1266–1337)

The Lamentation (*c. 1306–13*)

Fresco

The Arena Chapel, Padua

Giotto was to Florentine painting what Duccio was to that of Siena – a pathfinder – and his work had a far-reaching effect. He moved away entirely from stylized formality, and gave his figures a greater degree of solidity and movement than had been seen before in Western art. His work represents a breakthrough in the way it expressed human emotion with imagination and understanding. He applied to his religious paintings a close observation of the world around him, so that they are believable and relate closely to life.

His success produced commissions in Padua, Naples, Milan and Rome, but most of his life was spent in his home town of Florence. Much of his work was done in the technique known as fresco, a method

of wall-painting in which water-based pigment, similar to watercolour, was applied directly on to wet plaster. The paint and plaster then fused together as they dried. It was used most often in the decoration of religious buildings in Italy. The frescoes for the Arena Chapel were commissioned by Enrico Scrovegni, a member of a wealthy banking family of Padua.

Giotto decorated the chapel with scenes from the lives of Joachim and Anna (the parents of the Virgin Mary), the Virgin herself and Christ her son, which together provide a powerful narrative of the lives of Christ's family. Each scene is set in a separate rectangular border, painted to resemble a mosaic, in which are small insets depicting Old Testament stories.

The Lamentation is simple and dramatic in composition. A large outcrop of rock leads sharply downwards from the right in a diagonal line, so that our attention is focused on the group around the dead Christ. His body has been taken down from the cross, and the figures of the

Virgin, Joseph, Mary Magdalene and some of the disciples cluster round in attitudes of grief. Their feelings are expressed in a new and lifelike repertoire of gestures. The Virgin cradles her son on her lap, fiercely protective of him, and Mary Magdalene holds his wounded feet. A group of angels, materializing from the clouds, weep and wring their hands in distraction. On the rock is the skeleton of a tree symbolizing the Tree of Knowledge, which was said to have withered and died when Adam fell from grace.

Separating us from a full view of Christ's body are two cloaked and hooded figures, their backs towards us. Compared with the stiffness of Byzantine art, in which figures by tradition had faced the spectator, this was a remarkably informal and realistic device. As a result of it we are drawn into the group, as if we are looking over their shoulders and sharing their involvement in the tragedy. Giotto has depicted the event with great imagination, and conveys the human reactions to it with a compassion that brings it alive.

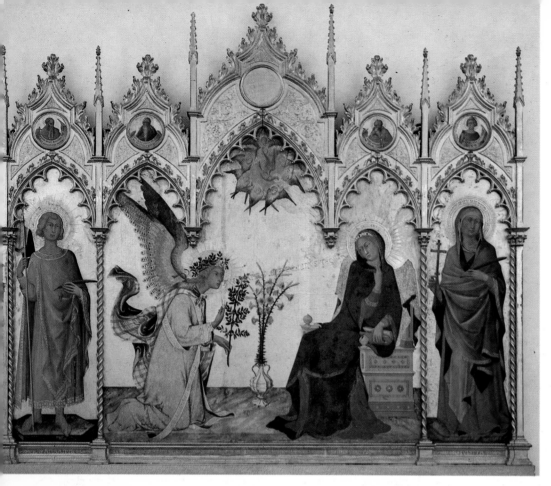

Jan van Eyck (1390–1441)

The Arnolfini Marriage (1434)

The National Gallery, London

In the fifteenth century the Belgian city of Bruges was one of the principal artistic centres of Europe. It was a prosperous seaport until its river silted up around 1500, and its wealthy merchants commissioned paintings to celebrate themselves, their families and their success. Artists reached new, triumphant heights hitherto unequalled in Europe, and Jan van Eyck was one of the most remarkable of them all.

For a long time he was credited with the actual invention of oil painting, and although this has been disproved, it is certain that he perfected a medium of pigment, oil and varnish which has allowed his rich colour to survive almost unchanged.

The Arnolfini Marriage was probably the first double full-length contemporary portrait in the North. It was painted for a merchant of Bruges, and it is generally thought that the picture celebrates the marriage of Giovanni Arnolfini, a silk merchant from Tuscany trading in the Netherlands, to Giovanna Cenami. The artist was witness to the ceremony, and as proof the words 'Johannes de Eyck fuit hic. 1434.' (Jan van Eyck was here) are inscribed on the wall above the mirror.

The room is lit by clear, cool daylight, and each object stands out with crystal clarity on the highly finished surface of the painting, showing van Eyck's remarkable feeling for texture and the effects of light. It is no chance collection of items: everything has a direct relevance to marriage, or to the circumstances of this particular marriage. The house itself is substantially built of brick, and the rich clothes of the couple, the hangings of the bed, the Turkish carpet, the mirror on the wall, even the oranges which were hard to obtain in the North, are all signs of their prosperity. The apple on the window ledge may be used to symbolize the fruit of the Tree of Knowledge; a single candle, representing the Spirit of God, burns in the ornate brass chandelier; the frame of the mirror contains ten scenes from the Passion of Christ, and next to it hangs a rosary made of crystal or amber, reflecting the light. The blue of the woman's sleeves and underskirt may be used to denote

Simone Martini (1284–1344)

The Annunciation (1333)

Fresco

The Uffizi Gallery, Florence

The Annunciation, Simone Martini's masterpiece, was painted for the chapel of Saint Ansanus in the Cathedral of Siena, and it is as perfect an example of pure craftsmanship as anything produced in fourteenth-century Italy.

Simone Martini has depicted with great elegance and economy the moment when the Virgin is visited by the Angel Gabriel, and told that she is to be the mother of Christ. The gold background and the slim, elongated figures, ethereal and highly stylized, reflect centuries of Byzantine religious tradition; but their gestures, the softly curving outlines of their bodies and the delicate colours suggest their tenderness and gentle piety. These fine lines and graceful contours, weaving a pattern throughout the composition, are typical characteristics of Simone Martini's work.

The Angel's message announcing Mary's destiny is written in Latin across the space between them. Her hand marks her place in a devotional book, and at her feet is a golden vase containing four lilies, the accepted symbols of purity.

Gabriel's head is wreathed with olive leaves, signifying peace, and he holds an olive branch instead of the traditional lily; this was a gesture in support of Siena because the lily was the official emblem of the city state of Florence, and Florence was Siena's greatest rival. Framed by the arch is a dove, the symbol of the Holy Spirit, surrounded by the heads of winged angels.

The traditional white of Gabriel's robes, the deep rich blue of the Virgin's gold-bordered mantle and her red underskirt provide a magnificent contrast to the gold background. The burnished gold of the vase, the haloes and the Angel's wings is intricately patterned.

In the panels to right and left are the figures of Saint Judith and Saint Ansanus (painted to Simone Martini's specifications by his brother-in-law Lippo Memmi). Ansanus was a young nobleman of third-century Siena, an early Christian who was betrayed by his father, and martyred for his belief by being thrown into a vat of burning oil. He became the patron saint of Siena, and naturally his chapel was very important.

Simone Martini was a pupil of Duccio, and his refined and elegant style was one of the greatest features of medieval Sienese art. He worked for Robert of Anjou, the French overlord of Naples and Sicily, and ended his days at the Pope's court at Avignon.

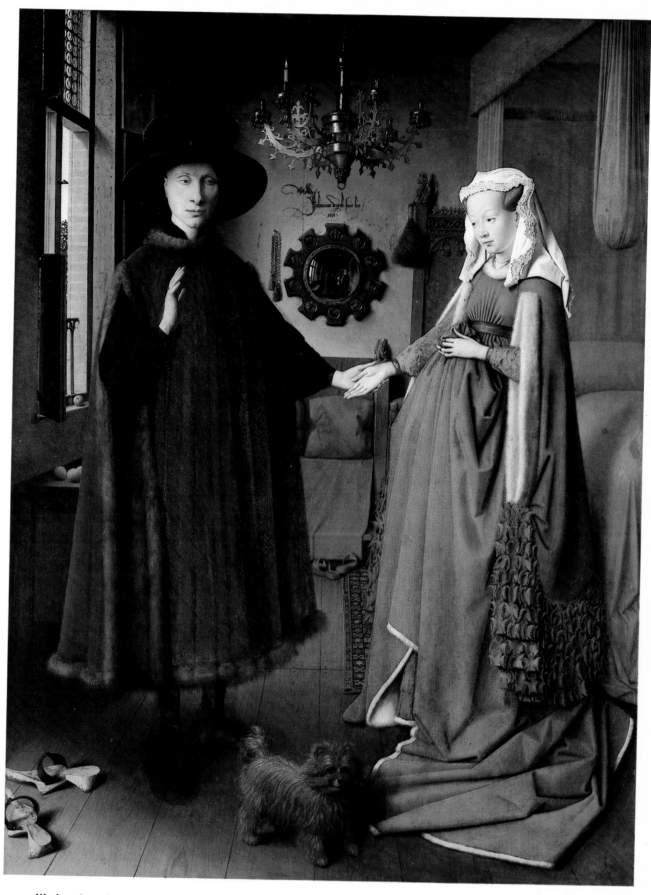

purity (and it is more likely that her voluminous dress was the fashion than that its folds conceal her pregnancy, as has been suggested). On the wooden chair beyond the canopied bed is the tiny carved figure of a saint, possibly St Margaret, the patron saint of childbirth; and even the small dog at the woman's feet is recognized as a symbol of fidelity.

An informal atmosphere is created by the presence of the dog and the man's clogs lying askew on the floor, which adds to the astonishing realism of the painting. Van Eyck has defined the relationship of marriage in both worldly and spiritual terms in this unidealized portrait, and reveals his extraordinarily accomplished technique in its accuracy, clarity of colour and perception of the realities of life.

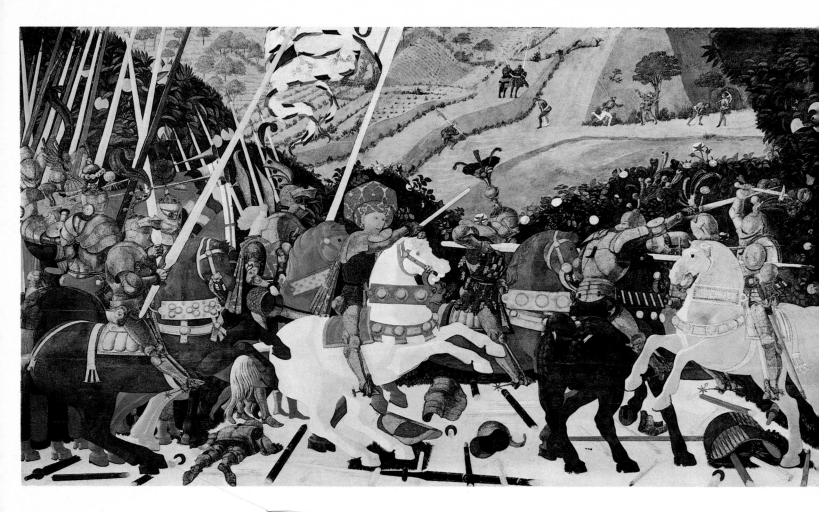

Paolo Uccello (1397–1475)

The Battle of San Romano (*c. 1455*)

The National Gallery, London

Paolo Uccello was born in Florence, where he trained in the workshop of the sculptor and goldsmith Ghiberti, and entered the Painters' Guild. He worked in a variety of media: on wood panels, on canvas, and even in mosaic; he designed stained glass windows for the cathedral in Florence, and produced a famous wall painting of an equestrian figure, Sir John Hawkwood, an English soldier who served the Italians with conspicuous success.

In his strange, highly individual and lively paintings, one of the most notable features is his interest in foreshortening and perspective. The effects that could be achieved with them were a constant source of fascination to him. His colours were not true to life but were used to create a decorative design; and his paintings were filled with charming and delicate detail made up of patterns of lines and spirals.

Uccello had another powerful gift – he could tell a story – and the Rout of San Romano, a battle in which Florence was

victorious over Siena in 1432, provided an ideal subject. It was commissioned by the great Medici family for their new palace in Florence, and Uccello painted three episodes from the event. They would have been hung as a continuous frieze, providing gorgeous propaganda for Florentine courage and success.

The hero of the battle was the Florentine warrior Niccolò da Tolentino, who recklessly pursued the Sienese and held them until reinforcements arrived to save the day. Here he can be seen on a powerful white charger in the centre of the action. He is in fact directing operations rather than actually fighting; his face is exposed, and in his magnificent hat and elegant short cloak, more like ceremonial than battle dress, he makes an impressive sight. His young page rides behind him carrying his helmet, and another soldier holds a banner bearing his heraldic device.

The composition is divided into two sections: the colourful and dramatic foreground, with its convincing portrayal of figures in action (including the foreshortened knight prostrate on the ground); and the steeply sloping hill behind, which is little more than a decorative backdrop where Uccello could indulge to the full his love of perspective.

The division is emphasized by the orange trees at either side and the hedge of wild roses in full bloom, which indicate the luxuriance of the surrounding landscape. The diagonal lances, the rearing horses in their fine coloured bridles, and the helmets and lances scattered on the ground, all increase the impact of this vigorous and captivating scene.

Uccello provided not only a highly decorative and interesting painting for his aristocratic clients but one that was designed to stir the blood with patriotic pride.

RIGHT Detail from *The Battle of San Romano*

16

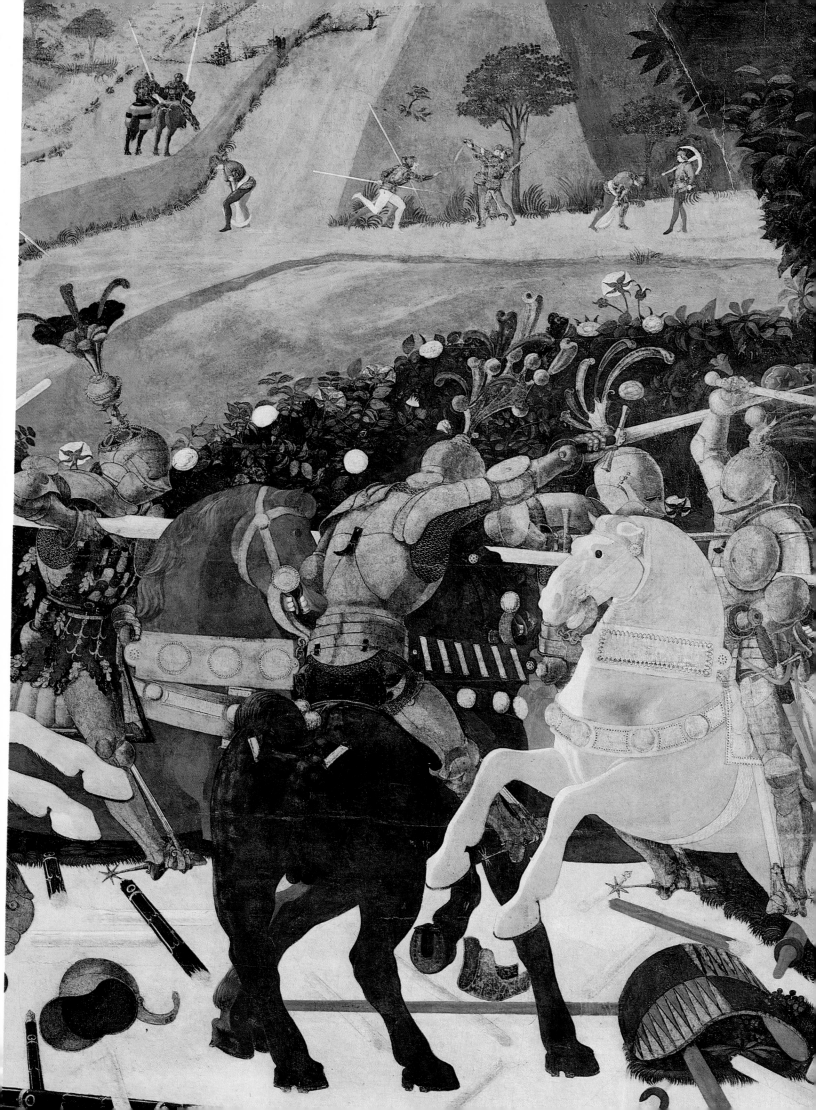

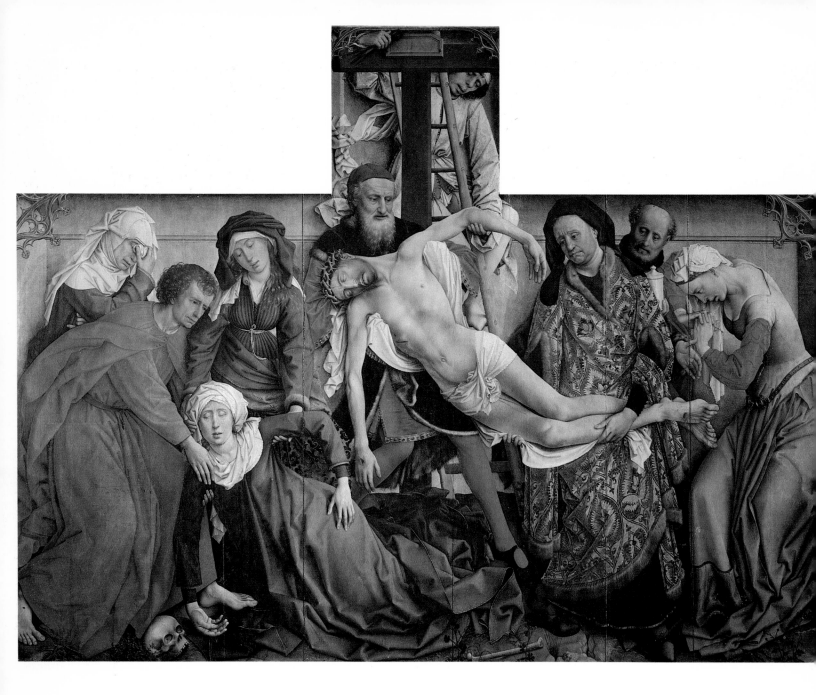

Rogier van der Weyden (c. 1399–1464)

The Deposition, or The Descent from the Cross (1435)

The Prado, Madrid

Little is known about van der Weyden's early life and the information we have is based largely on circumstantial evidence. We do know that most of it was spent in Brussels, where he had become city painter by 1436. He acquired a considerable reputation and a large fortune, and is considered to be, with van Eyck, the greatest Flemish artist of the first half of the fifteenth century. Their styles are very different: van der Weyden is especially renowned for his use of pale bright colours, particularly gold, and for the emotional quality of his religious paintings, in marked contrast to van Eyck's worldliness.

This major work was bought by Maria, Queen of Hungary, who left it to her nephew Philip II of Spain, and as a result it entered the Spanish Royal Collection.

The shallow space of the composition recalls early relief sculpture: the figures are symmetrically arranged on either side of the body of Christ, giving a perfect balance to the painting. But at the same time they are portrayed with all the realism and energy that was sweeping through Western painting at the time. The shape of the cross is repeated in the shape of the painting itself, and its sharp vertical line emphasizes the limpness of Christ's pale figure. The line of his body is echoed by the attitude of the Virgin Mary, fainting in her distress and supported by Mary Magdalene and St John.

The colours are clear and luminously beautiful. The materials fall in softly gathered folds. Joseph of Arimathea is richly robed in gold brocade, and is plumper than the other figures, indicating his affluent and influential position in life. It was he who received permission from Pilate to lay the body of Christ in his own tomb.

The rise and fall of the figures creates a flowing rhythm across the painting, and links one to another so that they are held together physically as well as emotionally in their despair. This passionate expression of deep religious feeling makes *The Deposition* one of the great works of Northern fifteenth-century painting.

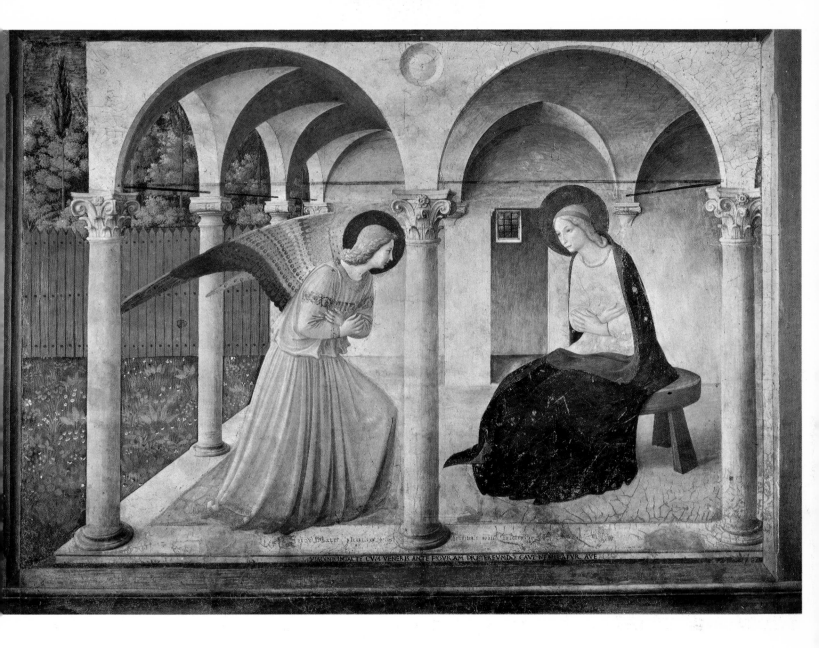

Fra Angelico (*c.* 1400–55)

The Annunciation (*c. 1436*)

Fresco

Museo di San Marco, Florence

Fra Angelico was both a Florentine painter and a Dominican friar. He made several trips to Rome to execute papal commissions; and he was prior of San Domenico in Fiesole from 1449 to 1452. He was known as the Blessed Angelico, and during his lifetime both his gentle, disciplined personality and his art were held in the highest esteem. The tenderness and delicate beauty of his work were ideally suited for the specific religious purpose for which it was produced.

With the help of many assistants, Fra Angelico decorated the cloister, the cells, the common rooms and the corridors of the convent of San Marco in Florence with some fifty frescoes. Of them all *The Annunciation* is probably the most famous. It was painted on a wall of the convent cloister, and the receding vaulted arches of the outside loggia, in which the Virgin sits, reflect the fresco's surroundings as well as giving space and depth to its composition. Inscribed on the border of the loggia's stone floor is a quotation in Latin from a twelfth-century hymn: 'Hail Mother, noble resting place of all the Holy Trinity.' Along the edge of the floor is a reminder to the friars of the convent: 'When you come before the image of the spotless Virgin, beware lest through carelessness the Ave be left unsaid.'

The soft pale colours and comparatively simple structure give the painting a sparkling serenity, and a directness that is charming, if a little naive. If Mary and the Angel were to stand up, their heads would no doubt touch the ceiling; yet the springtime scene is convincing, and painted with great care and attention to detail, particularly in the intricate decoration of the Angel's robe and the colourful patterning of his wings.

The figures have a weightlessness and stillness about them which makes them seem more spiritual. It is a painting about the communication of faith, and as the friars walked in the cloister of San Marco the event depicted must have seemed very real to them.

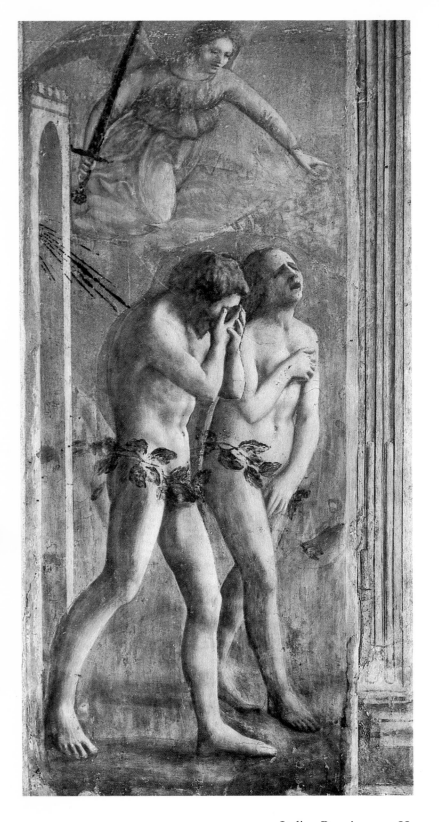

an angel flourishes a sword, both to urge them on and to guard the gates of the Garden. The angel is amply clothed in flame-coloured draperies, accentuating the vulnerable state of the figures of Adam and Eve, naked but for a garland of leaves. Eve's hands, one covering her groin, the other her breasts, are in the traditional pose of female nudes derived from classical statues of Venus.

Her mouth is open in a scream of anguish; perhaps she already anticipates the pain she must soon suffer in childbirth, now that the gift of immortality has been taken away from them. Adam holds his hands to his eyes, his shoulders bowed and his whole attitude expressing his despair.

The figures are real, and not idealized in any way. They are made of flesh and blood, substantial and entirely three-dimensional. Adam's feet are placed firmly on the ground, and they are bearing his weight. Light falls on the scene in a natural manner, and shadows define the shapes of the human figures. As a result of accurate observation and scientific study, Masaccio was able to convey human emotion in an astonishingly convincing manner, and he reveals the agonizing plight of Adam and Eve in a painting of powerful simplicity.

Piero della Francesca (1410–92)

The Baptism (c. 1442)

The National Gallery, London

Piero della Francesca was born and lived most of his life in the small town of Borgo San Sepolcro in Umbria. From Uccello he learned the new science of perspective, and he may also have studied with Fra Angelico.

He was well known in his own time, and worked for celebrated patrons. His art was long neglected, but in the nineteenth century his reputation began to soar, and today he is one of the most popular Italian painters of the Early Renaissance.

He was passionately interested in mathematics and problems of perspective, and there are several books by him on these topics. His paintings were constructed with great precision, and this, combined with his use of pale colours, gives them the timelessness and serenity for which he is best known.

Masaccio (Tommaso di Ser Giovanni di Mone) (1401–29)

The Expulsion of Adam and Eve (c. 1425–7)

Fresco

The Brancacci Chapel, Santa Maria del Carmine, Florence

The tragically short-lived Masaccio was the first great Florentine painter of the Italian Renaissance. He created dramatic effects by his use of space, light and perspective; and in the twenty-seven years of his life he developed an austere realism and economy of style which influenced many other artists.

He was responsible for several of the frescoes in the Brancacci Chapel in Florence. One of these, *The Expulsion*, shows the figures of Adam and Eve as they leave the Garden of Eden after their banishment. There seems to be a physical force behind them, driving them through the gates of Paradise; and over their heads

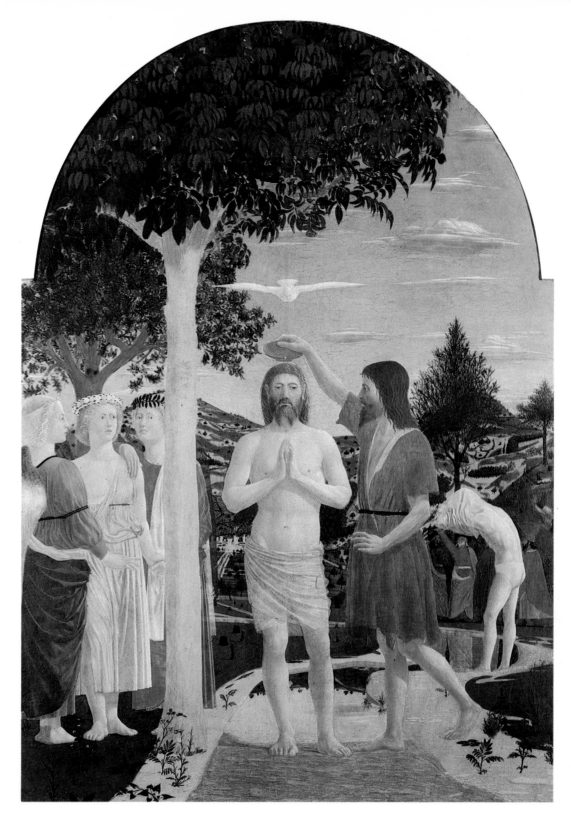

The Baptism is an early work and was created as part of an altarpiece for the priory church of San Giovanni Battista in his native town. From the nave of the church the eye would have been drawn directly to the central figure of Christ, with the dove of the Holy Spirit above his head, and the scene framed by the rounded arch.

The calm and statuesque figures bathed in brilliantly clear light are set against a background of Umbrian valleys and hills, Piero's own native landscape. The composition, although not symmetrical, has an exceptionally satisfying sense of balance. Dominating it are the figures of Christ and John the Baptist, who is anointing Christ's head with water from a shallow bowl. Their two heads, and John the Baptist's outstretched arm, are outlined against the clear blue sky, and this device effectively focuses our attention on them both.

The scene is framed by the dark leaves of a tree, whose pale slim trunk repeats the vertical lines of the figures. To the left are three angels, and in the middle ground other people can be seen preparing for baptism. The winding river Jordan, transposed to Umbria, reflects the sky, the scenery and the background figures. The arrangement may look simple, even random, but in fact the distribution of the figures and the spaces between them is carefully calculated to create an atmosphere of stillness and tranquillity. The drawing is definite and exact, and the figures solid and rounded, their feet accurately foreshortened. The soft clear colours stand out sharply in the light, and accentuate the peace and calm of this inspirational painting.

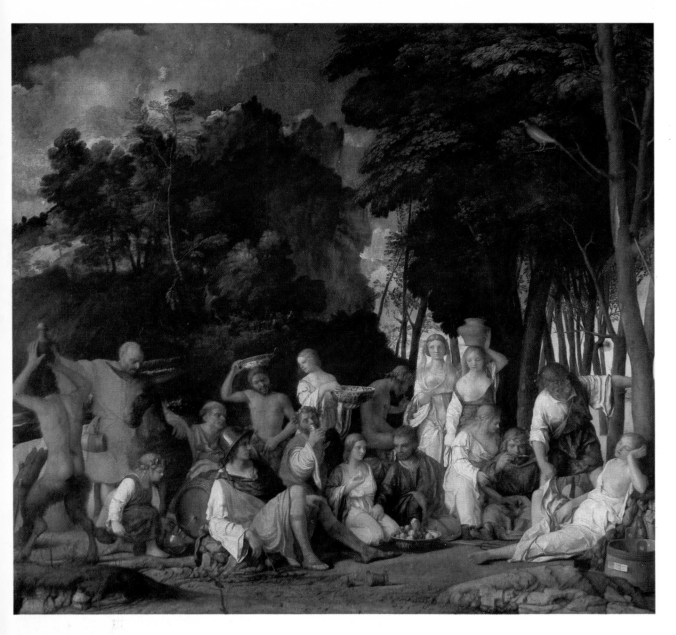

Giovanni Bellini (c. 1430–1516)

The Feast of the Gods (1514)

National Gallery of Art, Washington DC

The art of Venice is radiant with colour. In the island city itself brilliant clear light, intensified by the reflections from the water, exaggerates outlines and colours; and for Giovanni Bellini, and for other Venetian painters after him, colour and light were supremely important.

Bellini came of a family of painters: his father Jacopo worked in Florence and Verona as well as Venice; and his brother Gentile was a very successful portrait painter, and a recorder of ceremonial occasions. But it was Giovanni who set his mark most significantly on Venetian painting.

He painted portraits and religious subjects, devising beautiful landscape settings for them, and near the end of his long life he extended his repertoire to include episodes from ancient myths. *The Feast of the Gods* was painted when Bellini was in his eighties, and was commissioned by the Duke of Ferrara (aristocrats liked to keep the company of the gods). The story comes from the Latin poet Ovid's description of a banquet in the country, an ideal subject in that it enabled the artist to paint flesh, clothing, landscape and still life together, as well as mastering a complex group composition.

At the extreme right, resting against a tree, is a sleeping nymph, and Priapus, the mischievous god of fertility, is preparing to pounce on her. To the left is a satyr – a spirit of the woods and mountains – and the boisterous country god Silenus, with a keg at his belt and his arm round the ass at his side. In between them, serving and being served at the feast, are a host of other nymphs and gods: at the keg of wine is the young Bacchus in a wreath of vine leaves; helmeted Mercury, messenger of the gods, watches Priapus's preparations for seduction with cool indifference; next to him Jupiter, king of the gods, wreathed with laurel, raises a wine goblet to his lips. His wife Juno is at his side, and in the tree on the right is a peacock, a symbol of Juno. Seated in the centre is Neptune, god of the sea, with his trident at his feet.

Musical instruments, platters of fruit, water jugs, elaborately decorated dishes, and the magnificent landscape setting make an extravagant and fascinating composition. It would be hard to imagine a richer or more luxuriant feast. The subtle blends of colour, used in unusually imaginative combinations, and the wonderful clarity of light are superb examples of Bellini's work, and of the art of sixteenth–century Venice.

Andrea Mantegna (1431–1505)

The Martyrdom of St Sebastian (c. 1460)

The Louvre, Paris

For over half a century Andrea Mantegna was probably the most influential painter of Northern Italy. His work is characterized by decisive line, subdued colour, and a highly skilled use of perspective, which gives it depth and reality. He was a master of the foreshortened figure. His father was a carpenter, but at an early age the boy was apprenticed to and legally adopted by a painter in Padua, a highly cultured city with one of the oldest universities in Europe. By 1448, aged seventeen, Mantegna had become an independent master.

There are three surviving paintings by him on the subject of St Sebastian, a Roman soldier who was sentenced to death by the Emperor Diocletian for his belief in Christianity. Sebastian was topical because he was traditionally appealed to for protection from the plague, which was rife in Mantegna's time. His martyrdom was a popular subject as it allowed the artist to concentrate, with all due piety, on the near naked male figure. For Mantegna it was also an excuse to demonstrate his scholarly passion for the ruins of ancient Rome.

The figure of Sebastian is stone-like and sculptural, reminiscent of ancient Roman statues, and in spite of the arrows piercing the flesh, and the rivulets of blood, it has a feeling of strength and dominance. Parallel to his feet is a remnant of a Roman statue, a carved stone foot in a stone sandal. Sebastian's arms and feet are tied to a fluted column, part of an ancient Roman temple.

There is a wealth of detail in the imaginary classical background: magnificent ruins perched precipitously on rocky crags, with a fortified town on the topmost peak, and fantastic stylized clouds floating overhead. The painting has an austere but undeniable grandeur, and it is easy to understand why princes and potentates vied to own the work of Mantegna.

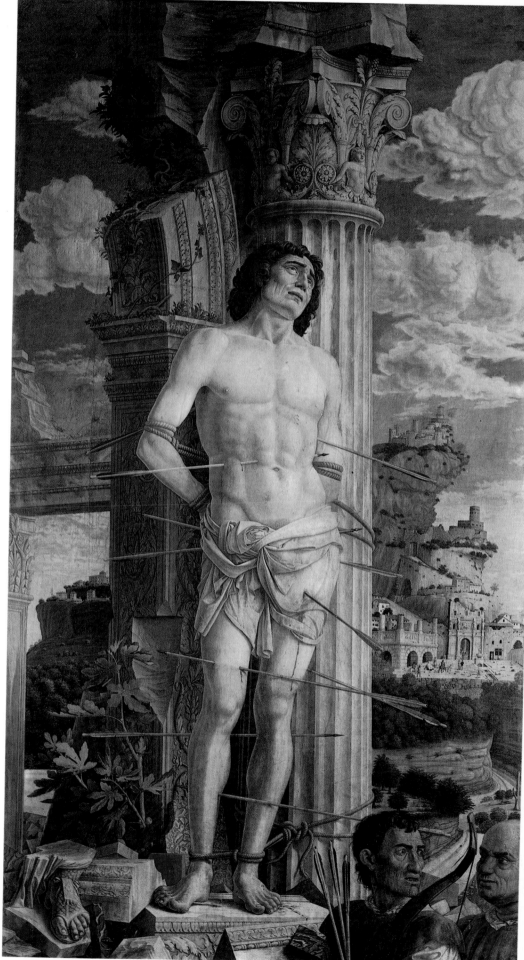

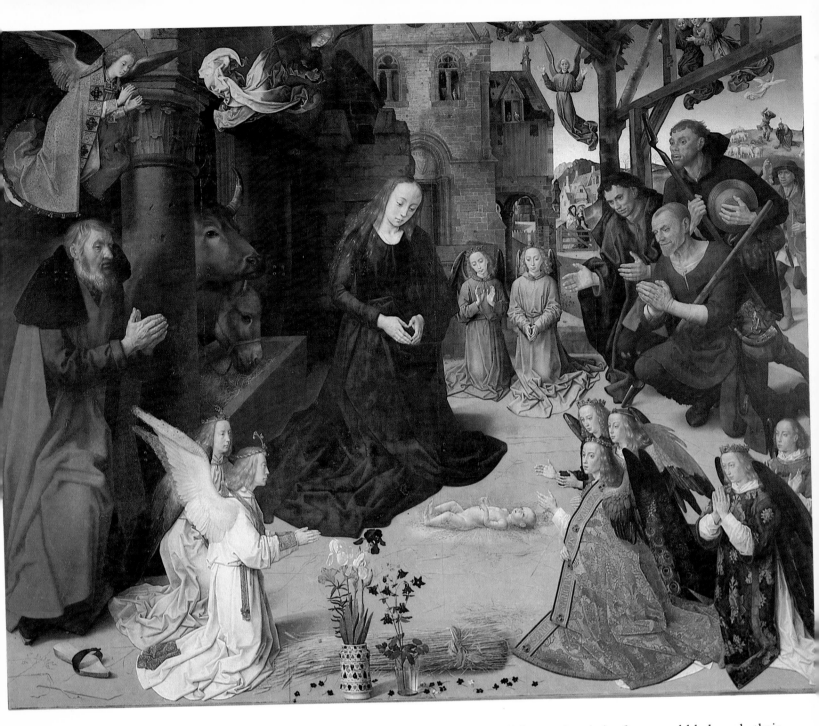

Hugo van der Goes (c. 1440–82)

The Adoration of the Shepherds (from The Portinari Altarpiece) (1474–76)

The Uffizi Gallery, Florence

Hugo van der Goes was Flemish, and one of the most gifted of all the early painters of the Netherlands. He worked in Bruges, its richest city, and by 1474 he was Dean of the Painters' Guild.

The Portinari Altarpiece is one of some sixteen of his surviving paintings. It is very large – over eight feet high and nineteen feet wide – and was commissioned around 1474 by Tommaso Portinari, a banker and agent of the powerful Medici family of Florence. When it was finished it was shipped to Italy and placed over the high altar in the Portinari family chapel. It is a triptych, a three-panelled painting with folding outer wings. The side panels depict the Portinari family in attitudes of prayer, surrounded by their patron saints. (Religious paintings of this period often included their commissioning patron to indicate his piety.)

The centre panel, illustrated here, has at its focal point the new-born Christ, small, naked, and radiating light. The ground is tilted towards us to draw attention more closely to his figure. Dressed in dark blue and gazing down at him in adoration is the Virgin Mary, and on the right are three shepherds, kneeling or standing, their hands rough from hard work, their faces stubbled and their clothes tough and simple. In the distance the hovering white figure of an angel is giving the news of the holy birth to shepherds in the fields. All around and above the group are more angels, crowned and richly dressed, and all quite small to emphasize the importance of the human figures.

In the foreground is a sheaf of wheat, a symbol of Jerusalem, and vases of iris and columbine. The iris is the flower of the Virgin Mary and columbine a symbol of the Holy Ghost, because it was thought the outline of the flower was like a dove in flight. The arch of the tower behind the stable yard bears the harp of the House of David, denoting the ancestry of Christ.

Curiosity and wonder can be seen in the faces of the adoring shepherds, and Mary,

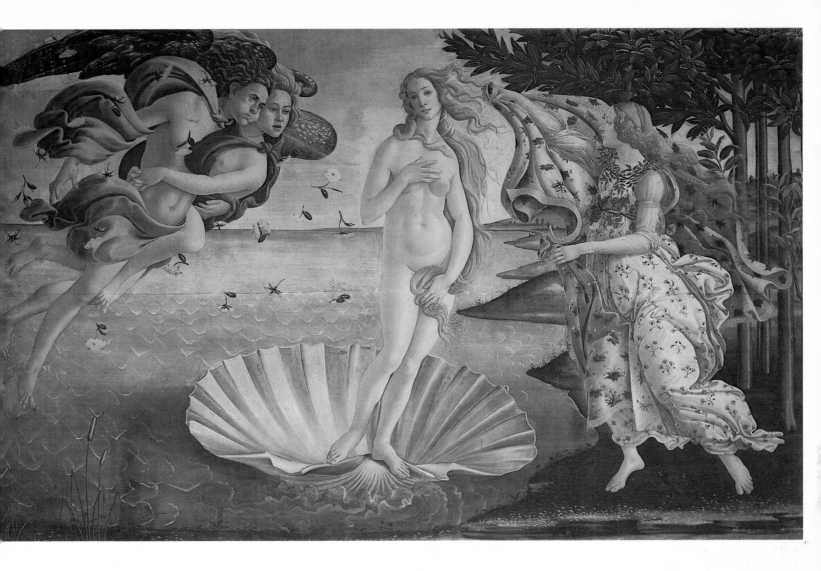

Joseph and the angels are grave and dignified, conveying to us a feeling of awe and reverence at this strange and wonderful birth.

The ambitious and dramatic scale of the work, its exalted spirituality, and the superb handling of the oil technique then being developed in the North ensured van der Goes's fame in both Florence and the Netherlands.

ABOVE

Sandro Botticelli (*c.* 1445–1510)

The Birth of Venus

(*mid-1480s*)

The Uffizi Gallery, Florence

Botticelli was born in Florence and spent most of his life there. Many of his paintings have devotional subjects and were designed for specific settings in churches and other religious buildings. But he was also the first painter of the Renaissance to use classical myths as central subject matter in his work. *The Birth of Venus* was almost certainly executed for Lorenzo di Pierfrancesco's Villa di Costello near Florence.

Botticelli was unaffected by the passion for realism that was current in his day. In *The Birth of Venus* he makes little attempt to persuade us of the reality of the scene, but we are completely convinced that we are witness to a splendid moment in the world of ancient myth.

Legend tells us that Venus, the Roman goddess of love and fertility, was born from sea-foam, and here she is seen slowly floating on her shell-boat in to the shore. The navigation of her journey is undertaken by two intertwined figures, male and female, representing the winds. The male, Zephyr, the west wind of springtime, supports the female, who is probably Flora, his wife. Just where the sea touches the shore, a young woman adorned with leaves and flowers steps forward to envelop Venus in a flowered cloak.

Venus herself, her wide grey eyes gentle and a little pensive, embodies here not sensual love but perfect beauty. The draperies of the winds, the flowing clothes of Venus's welcoming attendant, and her own glorious golden hair flickering through the painting like flames, are not naturalistic, but are used to create a feeling of movement about to be resolved.

With one arm Venus partly covers her breasts, and with the other she artfully arranges her hair as a modest covering in the traditional pose of classical statues of the goddess of love. Her left leg bears most of her body weight so that her hip is thrust gently forward, giving a sinuous S curve to her body. There is flowing, curving line throughout the composition, in the sharply defined, highly stylized shoreline, the beautifully arched feet of the human figures and the movement of drapery and hair.

The landscape is decorative rather than realistic: the waves of the sea are indicated by little white V shapes; the tree trunks are slim brown rods, and the wings of the winds and the sharp spiky leaves of the trees are outlined in gold. There is no physical depth or perspective in the painting; but this heightens the feeling that we are present at a mysterious and magical event, depicted with the delicate beauty which characterizes Botticelli's work.

Domenico Ghirlandaio (1449–94)

An Old Man and his Grandson (*c. 1480*)

The Louvre, Paris

Domenico Ghirlandaio was a highly successful fifteenth-century Florentine painter. He ran a flourishing workshop with his two younger brothers Davide and Benedetto, in which the young Michelangelo was apprenticed for a term of three years to learn the fresco technique.

Ghirlandaio was responsible for the fresco decorations of the library of Pope Sixtus IV in Rome, Santa Maria Novella in Florence, and part of the Sistine Chapel. He painted scenes of Florentine ceremonial and biblical episodes, sometimes featuring his patrons quite prominently in the role of a servant or attendant.

One of his most tender portraits is *An Old Man and his Grandson*. It is painted on a wood panel in tempera, a mixture of powder colour, egg yolk and water which was the conventional medium of painting before the invention of oils. It dried rapidly, and was then coated with an oil varnish. (In this portrait, the varnish has unfortunately cracked, causing the 'scratches' on the old man's forehead.)

An existing drawing shows us that the man was originally drawn not from life but with his eyes closed in death, and that the painting was skilfully adapted from the drawing. Even the grotesque deformity of the nose (which the artist modified a little) cannot detract from the gentleness of his expression. His face is full of affection and interest as he looks down at the little boy and embraces him. The child's small hand on his grandfather's chest and the look of trust in his eyes imply a strong emotional bond between them. The man's face reveals the wisdom and understanding as well as the physical deterioration of old age, whereas the boy has all the beauty and innocence of youth. His gaze, attentive and expectant, suggests that he is listening to a story at his grandfather's knee.

The romanticized landscape through the window, painted in fine detail, contrasts with the plain interior and gives distance and light to the composition; and the soft blue-grey and black of the wall and window frame, and the man's silver hair, set off the rich red robes of the two figures magnificently.

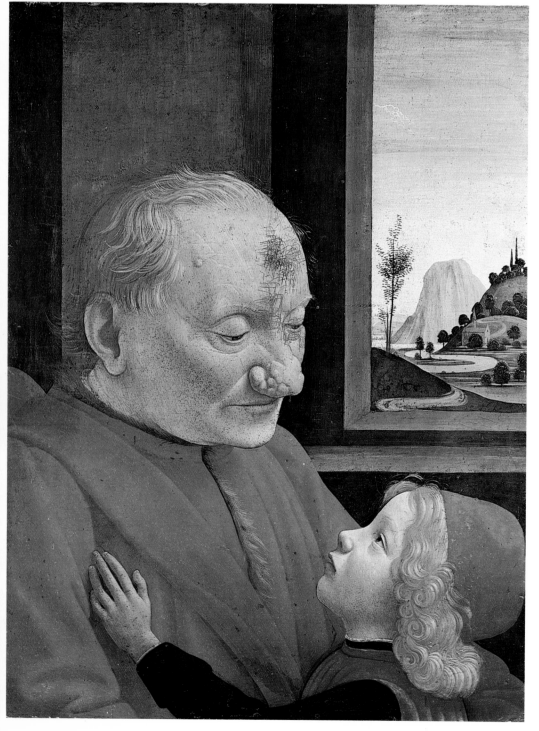

Leonardo da Vinci (1452–1519)

Mona Lisa (*1503?*)

The Louvre, Paris

Leonardo, born in the small village of Vinci in Tuscany, was the illegitimate son of a Florentine notary. He studied under Verrochio, who is said to have given up painting almost entirely as a result of his pupil's outstanding ability.

He was the greatest universal genius of the Italian Renaissance, when intellectual and artistic supremacy were admired above all, and the ideal man was accomplished in almost every sphere. Apart

from his skill as a painter and sculptor, he was a brilliant scientist, musician, poet, military engineer and inventor, with one of the most versatile minds in history. He came near to discovering the circulation of the blood, made preliminary designs for several aircraft, a submarine and the first armoured vehicle; he made intense studies of anatomy, the formation of rocks and the fall of drapery, and produced endless notes and drawings that reveal his curiosity and inventiveness. His working methods were slow and his interests so varied that he rarely completed a project – it was abandoned as soon as he felt he had 'solved the problem'. As a result very few finished paintings by him exist.

He worked on the *Mona Lisa* for nearly four years, and it was completed around 1503. Mona comes from madonna meaning madam, and the woman is thought to be the wife of the silk merchant Francesco del Giocondo (the picture is also known as *La Gioconda*). She would have been about twenty-four when Leonardo began her portrait. Her identity is not entirely certain – the painting itself has few specific clues – and the power of the picture has probably been enhanced by the mystery surounding it.

We know the figure was framed originally by two stone columns as well as by the parapet behind her. Her body is turned at a slight angle and her eyes gaze directly towards us. Her strangely enigmatic expression has fascinated the world for hundreds of years. Her lips show the trace of a smile and her penetrating eyes under heavy lids appear to be studying *us* rather than the other way around.

A wide forehead, and eyebrows plucked to the point of invisibility, were marks of beauty in the Renaissance world, and her hair parted in the centre and drawn away from her face accentuates these features and heightens her air of composure. Chestnut curls falling to her shoulders are covered by a veil of fine gauze. Her hands are folded in her lap, and her long delicate fingers rest on the shining folds of her dress.

An imaginary landscape provides a muted backcloth. Its jagged bare mountains, dissected by a river and a winding road, tower starkly over the sea, and its wildness and hostility provide a marked contrast to the calm face of the woman.

The paint is applied with fine detailed brushwork that reveals the textures of drapery, hair and flesh. The evening light and the sombre colours of the woman's classically simple dress throw her face and neck into relief. Leonardo believed that

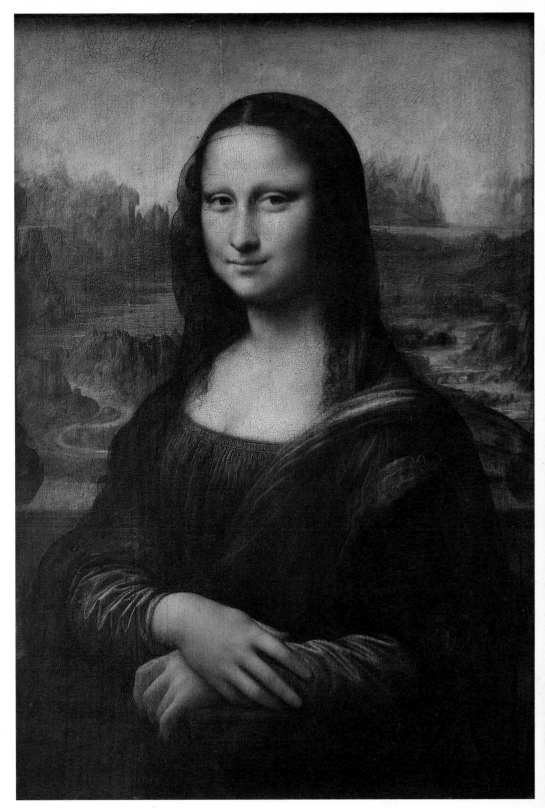

twilight provided the perfect atmosphere for portraits, warming skin tones and softening the contours of a face.

By the time he painted the *Mona Lisa* Leonardo's reputation was firmly established. He reached unequalled heights in an age of great artistic achievement, and his paintings and drawings have been copied and circulated ever since. The *Mona Lisa* has undoubtedly become the most famous picture in the world.

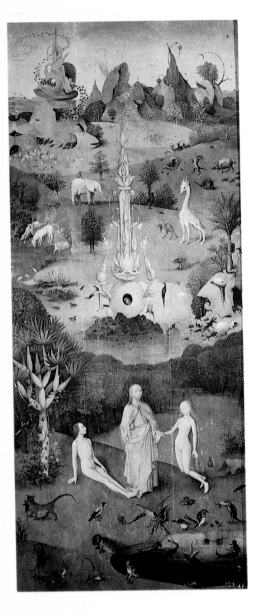

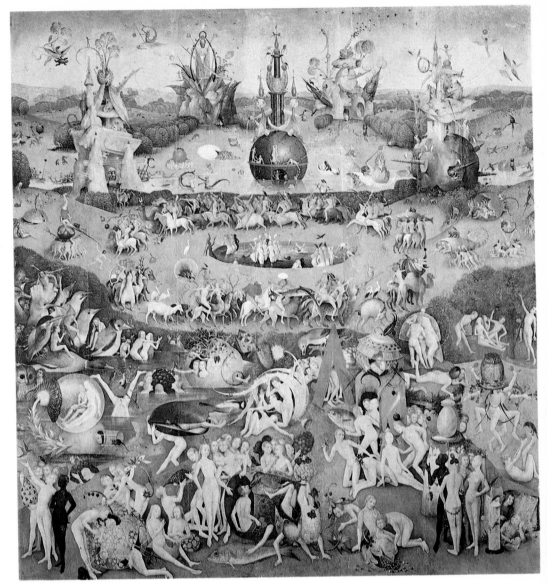

Hieronymus Bosch (1450–1516)

The Garden of Earthly Delights (after 1500)

The Prado, Madrid

The Flemish painter Hieronymus Bosch was one of the world's greatest masters of fantasy. His haunted work, full of monsters and devils, reflected the superstitious and religious beliefs which had survived from the early Middle Ages. He fathered no school of followers in his own time, although he was a distinguished artist, but his influence has continued for nearly five hundred years, and is easy to detect in the work of the Surrealists of the twentieth century (see pp. 110, 111).

Four paintings on a series of folding panels make up *The Garden of Earthly Delights*. When the outer wings are closed we see the Third Day of Creation (or, according to a recent interpretation, the destruction of the earth by flood). When the wings are opened they reveal astonishing scenes in subtle colour and mesmerizing detail. On the left is the Garden of Eden, in the centre the Garden of Earthly Delights, which is thought to depict the world before the Flood, and on the right a terrifying vision of Hell.

The meaning of the work as a whole is uncertain, but the sense of a powerful allegory is beyond doubt. Over half of Bosch's surviving paintings have religious subjects, and his work can only be interpreted in a religious framework; his art was, as a Spanish cleric remarked, 'a painted satire on the sins and ravings of man'. It studied those human feelings which in the Middle Ages were thought to be the result of divine or devilish inspiration. Bosch was painting at the climax of a period when people firmly believed in the existence of grotesque demons; it was also a time of robust, even cruel humour.

This great work, with its imaginary buildings, landscapes of parks and gardens and dark firelit inferno, exposes humanity in a truly terrifying light. In the central panel a wild sexual orgy is depicted showing every imaginable aspect of lust, the cause of man's downfall, and revealing his ignorance and corruption.

Writhing human bodies are dwarfed by massive birds, fish and fruits: one figure carries off another on his back in a huge mussel shell; a man and a woman are encased in a bubble on the back of a strange sea creature; strawberries, fish, flowers, exotic birds and animals are all involved with men and women in the act of love. People can be seen riding an assortment of animals in a ring in the middle distance: pigs, camels, horses, goats, unicorns and strange unrecognizable creatures that are part-animal, part-bird. In the work as a whole there are something like a thousand human figures.

Bosch's dazzling inventiveness seems

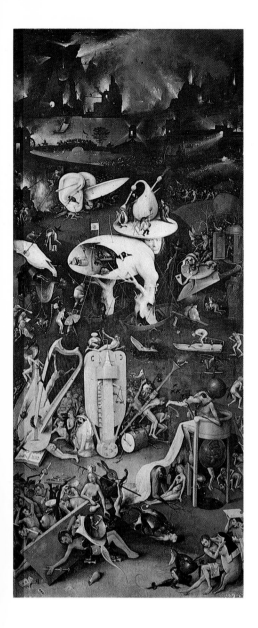

endless. He has created an extraordinary, fascinating fantasy world, full of weird exaggerations and distortions, but he has done it with such care and detail that he has turned its nightmarish terrors into reality.

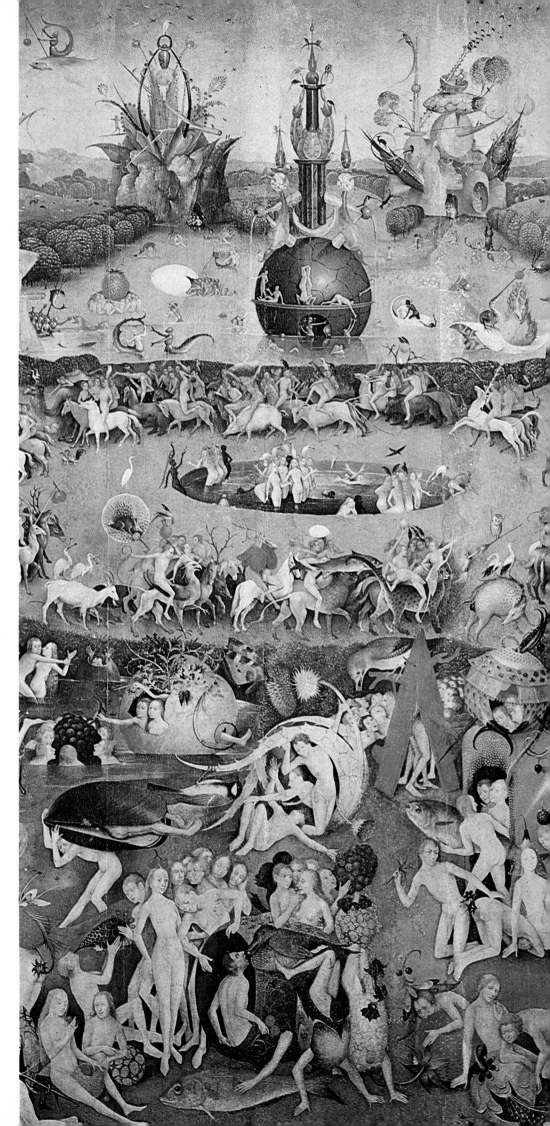

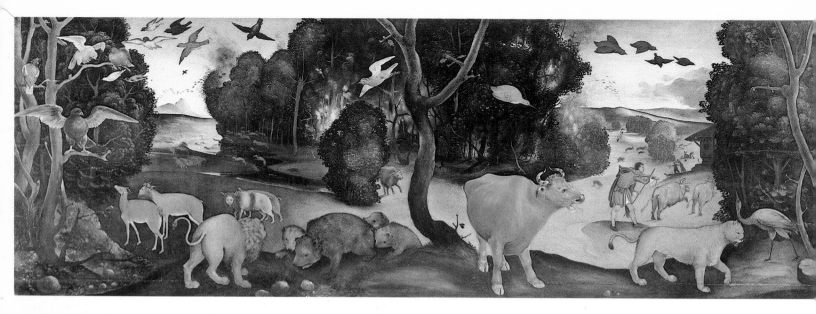

Piero di Cosimo (1462–1521)

The Forest Fire (*1480s*)

The Ashmolean Museum, Oxford

The Florentine painter Piero di Cosimo was an original and eccentric man. In his later years he lived as a recluse, and Vasari, the sixteenth-century author of *The Lives of the Artists*, tells us that, when boiling up the glue for his paintings, Piero di Cosimo would also boil a huge quantity of eggs, perhaps fifty at a time, which he ate as hunger moved him. He found artistic inspiration all around him, even in the stains and textures on the walls, and some of his work seems to be as bizarre as his life, but it has a delightful innocence and charm.

The Forest Fire, once known simply as *Landscape with Animals*, is one of the first landscapes in Western art in which man features incidentally and not as the principal subject. It is one of four panels illustrating the life of primitive man, and it is part of Piero di Cosimo's search for an acceptable explanation of the early history of the world and man's part in it. The subject, taken from the writer Vitruvius, is man's accidental discovery of fire.

The painting shows the flight of animals, birds and men when fire sweeps through the forest in which they live. Amongst them are strange mythical creatures, some with human faces, as well as a variety of recognizable animals and birds. Movement is suggested rather than accurately portrayed, and the rather stylized leaps of the figures reveal the problems experienced by painters of the Early Renaissance in showing movement convincingly. United by a common danger, lions, cattle, deer, pigs, a family of bears crawling over a grassy bank, and several different types of birds are all fleeing for their lives across every open space. In the distance on the right a man and a woman are rushing down a hill from a small hut, and a little nearer a man with a yoke on his shoulders strides after his cows.

Piero di Cosimo has caught beautifully the light and heat of a forest on fire, with the flames leaping up through the leaves, and smoke billowing out through the stark bare branches. Glimpses of distant mountains, framed by two groups of trees, give a great feeling of space, as though we are seeing vast stretches of the world, and all the creatures that inhabit it.

Albrecht Dürer (1471–1528)

Self-Portrait (*1498*)

The Prado, Madrid

Dürer was born in Nuremburg, the son of a goldsmith, and he received early training in the art of drawing from his father. His first self-portrait, drawn when he was thirteen, reveals his precocious genius; its self-analysis is remarkable. Success came early, for by his twenties he was renowned throughout Europe and acknowledged as Germany's leading artist. Vasari tells us that 'the entire world was astonished by his mastery'. Dürer's output was enormous, and many of his meticulously detailed woodcuts and drawings – *The Praying Hands, The Young Hare* – are known universally. His genius lay mainly in his draughtsmanship, and he has been described as 'the greatest mind that ever expressed itself in line'.

From 1490–94 he travelled widely, and after his marriage made his first major trip to Italy. He was the first important German artist to do so; and it was largely through him that the academic ideas and artistic achievements of the Italian Renaissance were introduced to the North.

In this half-length self-portrait, painted when he was twenty-six, Durer has portrayed himself as a perfect example of the Renaissance 'universal man'. Not only is this one of the first self-portraits in Northern European art in which the artist is shown in an individual study rather than as part of a group, but it also makes a bid for the status of the artist as gentleman. (The profession of painter at that time ranked fairly low in the social scale.) Dürer's success had made him a rich man; and here his hair is elaborately curled, his clothes are fine, and his hands immaculately gloved in grey kid. A cloak is draped round his shoulders with a casual, stylish air, and over his shirt of bleached and gathered linen, trimmed with gold brocade, is an elegant white doublet edged in black, with separate oversleeves and a dashing tasselled cap. The serious intelligence of his character can be seen in his dispassionate objective gaze. The snow-covered mountains through the window are reminiscent perhaps of Dürer's travels across the Alps.

It is a portrait of self-scrutiny, maybe even self-promotion, and it embodies a great deal of the artist's character and attitudes as well as his genius as a draughtsman.

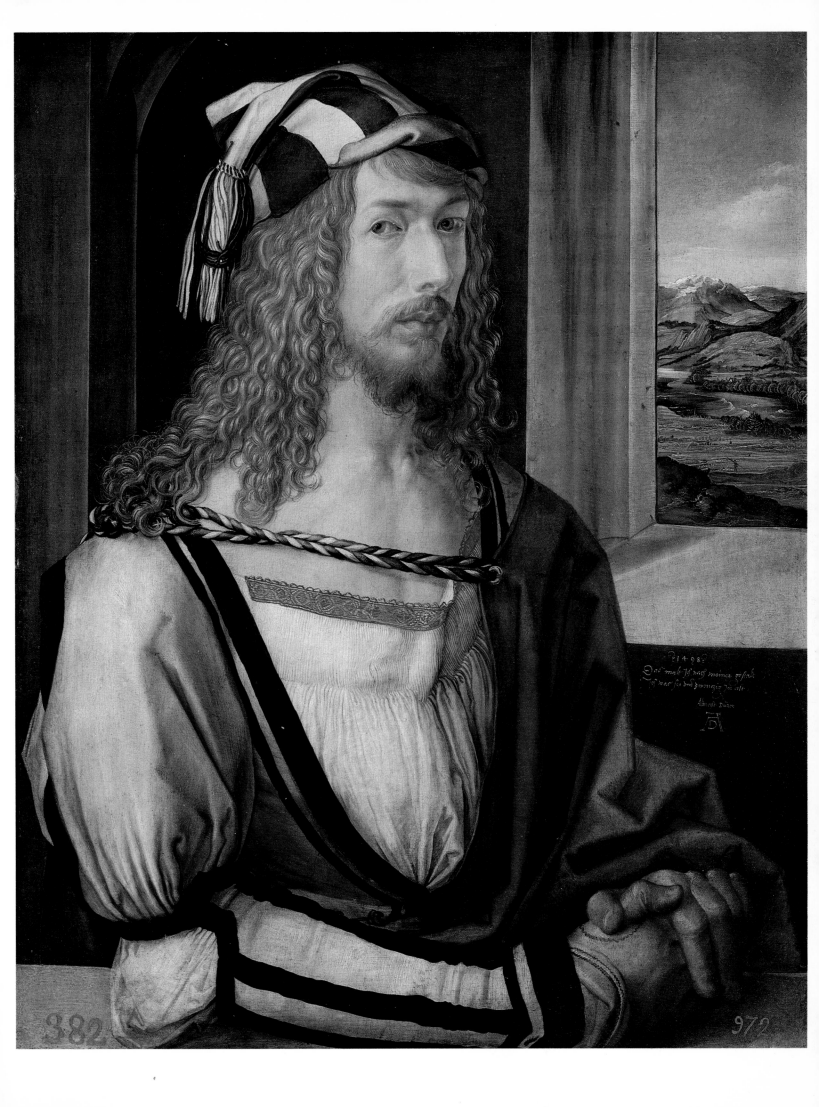

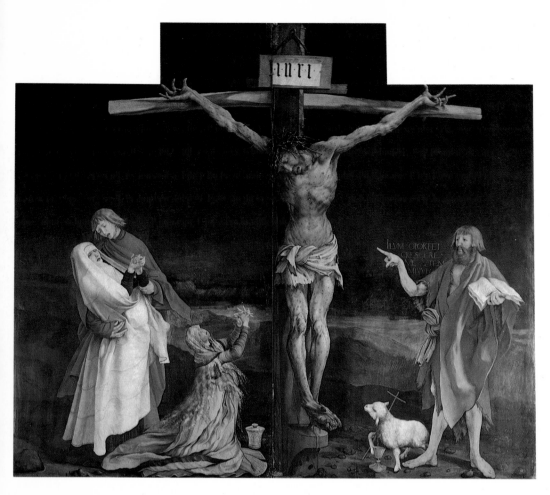

Matthias Grünewald (*c.* 1470/80–1528)

The Crucifixion (from The Isenheim Altarpiece) (*c.* 1510–15)

Unterlinden Museum, Colmar

Grünewald was, with Dürer, one of the greatest German painters of the sixteenth century. Little of his life was recorded and few of his works have survived, but *The Isenheim Altarpiece* is undoubtedly a painting of genius. It was commissioned by the monastic order of St Anthony for their hospital church at Isenheim, near Colmar. The altarpiece has two themes: the narration of the stories of the Annunciation, the Nativity, the Crucifixion, the Lamentation and the Resurrection; and the depiction of scenes from the lives of the patron saints of the monastery. It is made up of an elaborate series of folding wings, and *The Crucifixion* can be seen on the outside when all the wings are closed.

Grünewald has created a truly terrifying painting, perhaps the most terrifying in Christian religious art. The scene is bleak and dark, and the cross is set in a rocky, barren landscape. To the left, in white, the swooning Virgin Mary is supported by St John, into whose care Christ had entrusted her; Mary Magdalene, her long golden hair rippling down her back, kneels at the foot of the cross, her hands raised in prayer; and to the right St John the Baptist points to the figure of the dead Christ. Framed by his arm is the inscription in Latin, 'It is fitting that He increase and I diminish.' The lamb at his feet holds a thin cross of reeds, and blood, representing the Holy Sacrament, pours from a wound in its chest into a golden chalice.

The most remarkable feature of this deeply disturbing painting is the nearly central figure of Christ himself nailed to the cross. The placard above his head bears the letters INRI, the initials for the Latin *Iesus Nazarenus*, *Rex Iudaeorum*, Jesus of Nazareth, King of the Jews. Blood still gushes from the sword wound in his side and his head has fallen limply on to his shoulder. His body is thin, and distorted with the stiffness of death; the fingers grope upwards like frozen claws. Splinters and thorns pierce his skin, evidence of the beating he received, and his flesh has a greenish pallor, the feet already turning black with putrefaction. The horizontal beam of the cross is dragged down slightly by the dead weight of his body.

The agony of the Crucifixion is depicted starkly and simply. There is nothing romantic about it; the harsh reality of the event is portrayed with a passionate accuracy that makes it all the more heartrending.

Lucas Cranach (1472–1553)

Cupid Complaining to Venus (*c.* 1530)

The National Gallery, London

Little is known of Cranach's early life; but by about 1500 he was living in Vienna, a successful painter of religious pictures and portraits. By 1505 he had become court painter to the Elector Frederick of Saxony in Wittenberg, where he prospered, twice became mayor, and was granted a coat-of-arms by his patron. He was extremely prolific, and his sons Hans and Lucas Cranach the Younger helped him in his busy studio.

Cranach's fame rests on three foundations: his detailed landscape work and the expressiveness of his figures; his numerous religious paintings, and portraits of his friend Martin Luther and his family; and his mythological scenes, which centred on the female nude and were enormously popular.

Cupid Complaining to Venus is signed with a winged dragon, a device taken by Cranach from his own coat-of-arms. The story comes from the Greek poet Theocritus, and several lines from the poem can be seen at the top of the painting; the work of Theocritus had only recently been translated into Latin, and might not have been wholly familiar to Cranach's patrons. Cupid is stung by a bee while stealing a honeycomb, and he comes whiningly to complain to his mother Venus, the goddess of Love. But she reminds him that his arrows inflict even greater pain. To this moral tale Cranach has added at the top of the painting a sentiment of his own: 'So in like manner

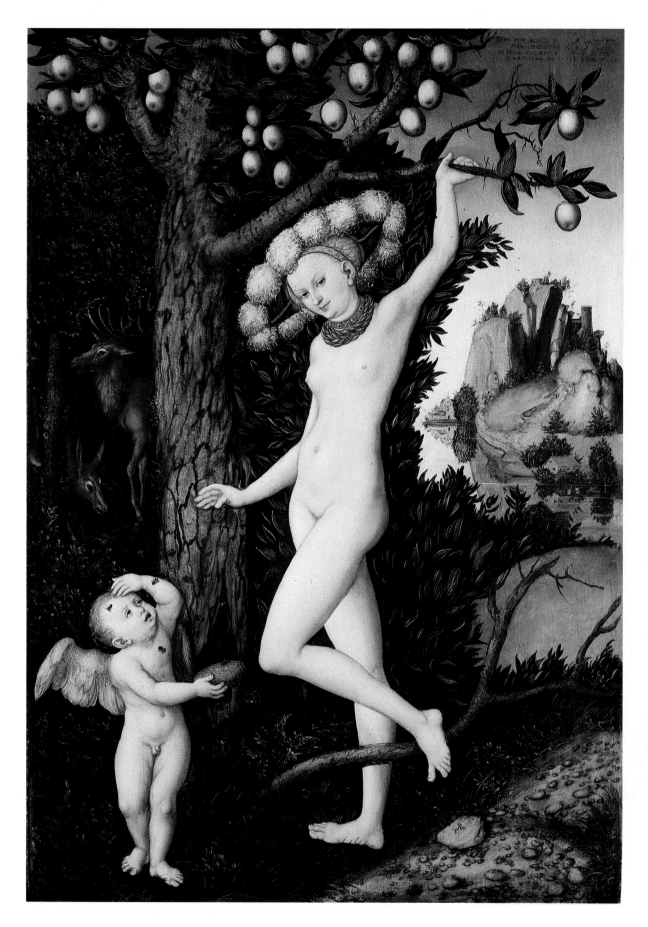

the brief and fleeting pleasure which we seek injures us with sad pain.'

The landscape is sharply etched; the rough bark of the tree, the dark, pointed leaves and the stony ground provide a strong contrast with the smooth flesh of the naked figures. Venus is a temptress, with her tilted head and seductive half-smile, her leg raised in a gesture full of sexual invitation. Her allure is enhanced by the flamboyant hat and heavy necklace which emphasize her nakedness. She is wonderfully lithe and graceful as she rests her hand on the branch above her, from which the large fruits look ready to fall. The sexuality in every line of this slender Venus must have been as appealing to Cranach's clients as it is today.

Michelangelo Buonarroti (1475–1564)

The Creation of Adam (1508–12)

The Sistine Chapel,
The Vatican, Rome

The phenomenal genius of Michelangelo has been praised consistently since the start of his unparalleled career. He worked for princes and popes and was pre-eminent in the High Renaissance as an architect, a sculptor and a painter. More than anyone else, he raised the crafts of painting and sculpture to the status of Fine Arts.

He was first apprenticed in the Florentine workshop of Domenico Ghirlandaio, and shortly afterwards transferred to a school set up under the patronage of Lorenzo de' Medici, who was known as *Il Magnifico*. After the death of Lorenzo, Michelangelo went to Bologna and then to Rome, where he first made his name with his *Pietà* (a sculpture of the Virgin with the body of Christ after the descent from the cross) in St Peter's Cathedral. The Medici of Florence and the Popes of Rome – Julius II, Leo X, Paul III – were his patrons, and he produced work for them that won him public acclaim and adulation. Vasari tells us simply that the work of Michelangelo 'transcends and eclipses that of every other artist, living or dead . . . supreme not in one art alone but in all three . . .' Probably his greatest achievement, which can be seen in both sculptures and paintings, was his extraordinary ability to express all the human emotions through the beauty of the naked body.

The Sistine Chapel was built in the Vatican by Pope Sixtus IV (hence its name); his nephew, who became Pope Julius II, commissioned the ceiling frescoes from Michelangelo to complete its decoration (the walls already bore many famous paintings by fifteenth-century Italian artists).

The chapel is 133 feet long, 43 feet wide, and 68 feet high, and it required a brilliant imagination to devise a scheme in which the whole vast ceiling was united. Michelangelo achieved it through a series of narrative paintings which tell the stories of Genesis until the Great Flood, and the stories of the life of Christ from the Gospel of St Matthew. He was determined to carry out the scheme virtually on his own, and, while Julius II agitated for its completion, Michelangelo worked for nearly four years under appalling difficulties, most of the time lying flat on his back on the scaffolding and unable to get a clear view of what he was doing. There are nearly 350 figures in the ceiling as a whole, in a wonderfully rich variety of poses which has been drawn on by artists ever since.

The Creation of Adam shows with extraordinary power and subtlety the

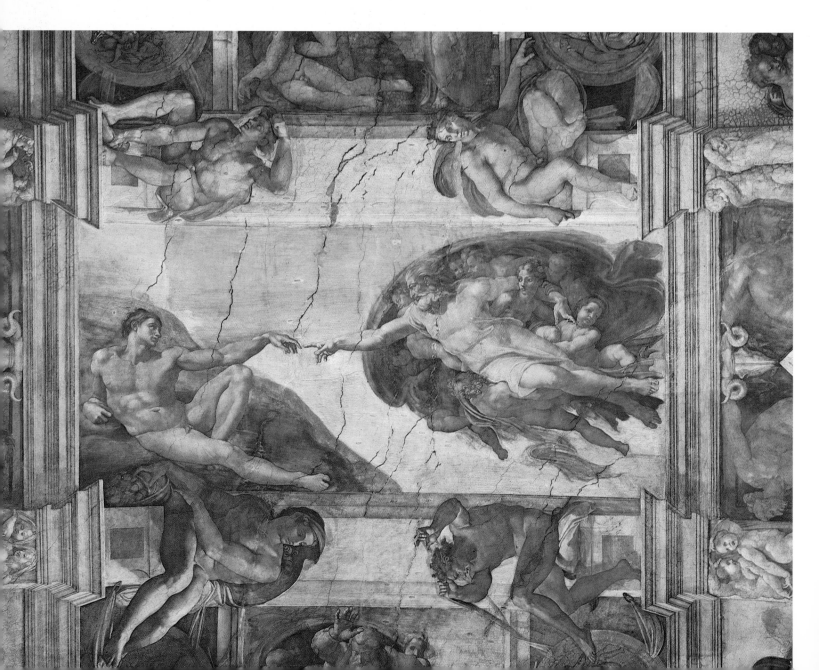

moment when the hand of God gave life to Adam, and symbolically to the human world. The Creator's flowing mantle encloses some eleven figures, angels or beings that existed before man, and they support him as he stretches out his arm to touch the finger of Adam. Reclining in a superbly graceful attitude, Adam's perfect, muscular body reveals his latent strength. The hands just touching provide an emotional tension as well as a physical link between God and man. The magnificent sculptural figures, dominating the spaces around them, express in Michelangelo's vast and dramatic conception the full significance of the moment of creation.

At its unveiling the ceiling of the Sistine Chapel was hailed as a supreme work of art, and it earned its artist the name *il divino Michelangelo*.

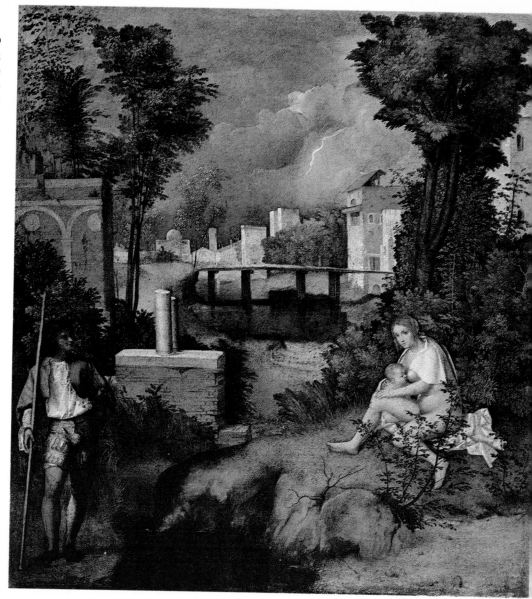

RIGHT

Giorgione (*c.* 1477–1510)

The Tempest (*c. 1500*)

Accademia, Venice

Giorgione, born in Castelfranco, some twenty-five miles from Venice, is one of Europe's greatest painters, yet practically nothing is known about him. It is thought that he worked with or was apprenticed to Giovanni Bellini in Venice, that in Bellini's studio he met the young Titian, and that Titian in his turn became Giorgione's pupil.

He died of the plague in his early thirties, and some of his paintings may have been finished by other artists after his death. This has added to the considerable problem of deciding which works are entirely authentic and which are not.

As a result of his remarkable talent, and the fact that information about his life was invented because so little was known, a legend has grown up around him in which he has become a mysterious and almost mythical figure.

Portraits, religious scenes and landscapes were the themes of Giorgione's small oil paintings, and he was the first artist in Venice to produce work for collectors rather than for churches or public buildings. Like *The Tempest*, many of his pictures do not represent a real or even mythological scene in the way that most paintings had done in the past. Giorgione was ahead of his time in that his work was created to express a mood or an idea, much as modern art does today, and this had a profound effect on his Ventian contemporaries and the painters who followed him.

The Tempest is one of the very few paintings – about thirteen in all – that have always unanimously been attributed to Giorgione, but its subject has been disputed for over four centuries. X-rays have revealed that Giorgione first painted another female nude where the man now is, which indicates that he had no intention of illustrating a particular event, but was allowing his imagination entirely to guide him.

The scene is lit by the strange golden light of an approaching storm, and a streak of lightning pierces the heavy thunderclouds. On a grassy bank a plump young woman, naked but for a length of white cloth draped around her shoulders, cradles a baby to her breast, and a shepherd passing by stops to look at them from the water's edge. The overwhelming, elemental force of Nature, and the part man plays in the cycle of life are implied by the storm and the figures in the landscape, and evidence of man's creation of the civilized world is provided by the buildings along the river bank. In the distance are the dome of a church and the sunlit walls of battlemented palaces (on the roof of one a stork or heron is outlined against the sky). Behind the young man are the ruins of ancient buildings overgrown with trees, indicating perpetual change and the passing of time.

Giorgione has used intense colour and light to bind the composition together, and to pick out details of architecture, distant trees, the planks of the bridge, the shining foliage of bushes behind the two figures, and the beautiful naked flesh of the woman and her child. And he has reproduced superbly in this mysterious, emotional landscape the eerie light of a summer storm, and the electric tension it creates in the atmosphere.

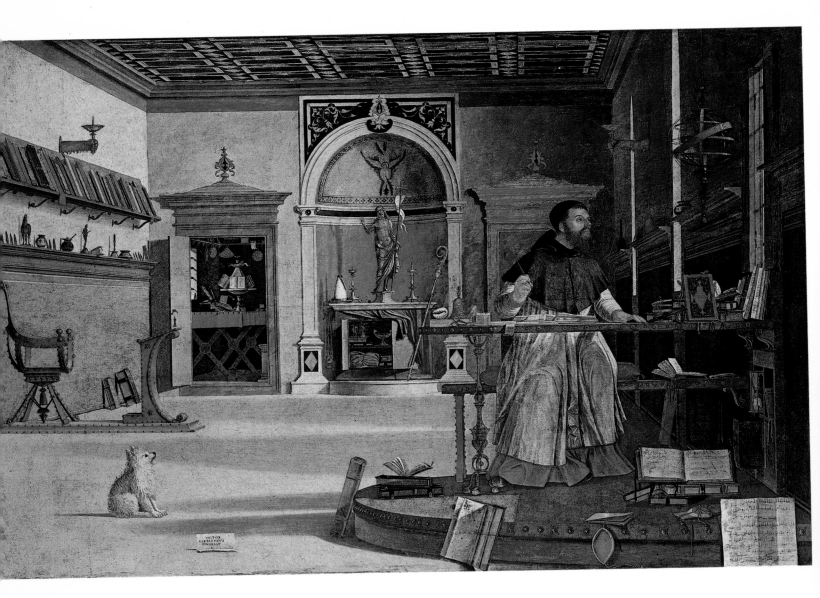

Vittore Carpaccio (*c.* 1470–1523)

St Augustine in his Study (*c. 1510*)

Scuolo di San Giorgio degli Schiavoni,
Venice

Vittore Carpaccio worked mainly in his
native Italy, and was a follower of the
great Venetian painter Bellini.

Most of his work was done on com-
mission for small societies. *St Augustine in
his Study* is one of the episodes from the
lives of St George and St Jerome with
which Carpaccio decorated the building
of the Society for Dalmatian Sailors in
Venice.

According to legend, Augustine of
Hippo was in his study writing a letter to
his friend Jerome when a shaft of brilliant,
unearthly light streamed through the
window beside him and filled the room.
He realized that this marked the moment
of Jerome's death, many miles away.

Both St Jerome and St Augustine were
Fathers of the Church, and both were
scholars. Augustine is shown here as
middle-aged, with a small dark beard, and
wearing the robes of a bishop. His study is
elaborately furnished and decorated, with
an ornamented ceiling, carved wooden
cupboards, and an elegant studded leather
chair and lectern. His bishop's mitre and
pastoral staff and a golden statue of
Christ rest on a private altar in the gilded
alcove behind him.

Augustine was enormously learned: the
vast array of books, documents and
scientific instruments in his study testify
to that, and they are depicted in fascin-
ating detail. On the floor in the right hand
corner is a long passage of music, a hymn
to St Augustine included by the artist in
reverence for the saint. There are books
everywhere, most of them with coloured
leather bindings and gold clasps, filling a
shelf on the wall, arranged on a table in a
cupboard, open on the floor, and sur-
rounding the figure of Augustine at his
desk; statuettes and vases, candlesticks, a
cowrie shell, and mathematical and scien-
tific devices cover every available space.

Action and time have been suspended,
and even the little dog seems transfixed in
wonder. Augustine himself is lost in
contemplation of his vision of the death of
Jerome. Carpaccio's portrayal of this
sensitive, spiritual man and of the details
of his religious and scholarly life, is
minutely observed and sympathetic.

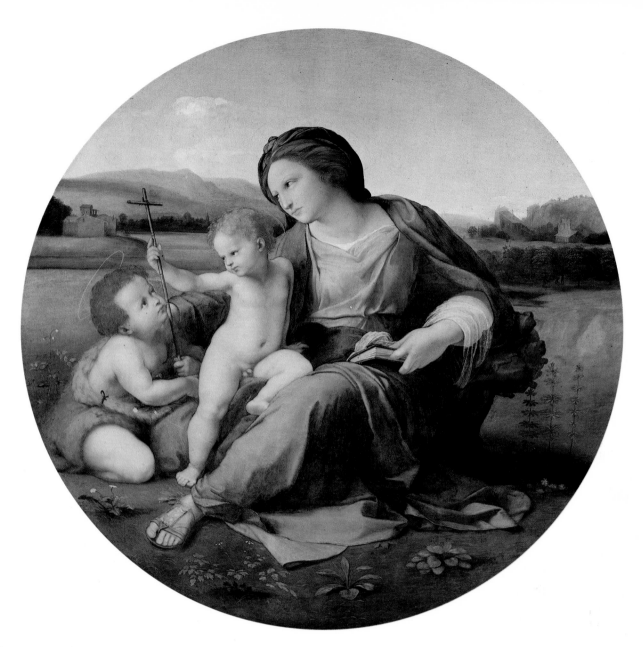

Raphael (Raffaello Sanzio) (1483–1520)

The Alba Madonna (1508–11)

National Gallery of Art, Washington DC

So remarkable was Raphael's talent that he became known as 'the boy genius'; his reputation grew rapidly, and his career throughout his short life seems to have been effortless.

He was born and brought up in Urbino, an important provincial centre of art and literature in the Italian province of the Marches. In 1504 he moved to Florence, where he quickly absorbed all that the Florentine masters could teach him. He was soon considered to be the equal of his two greatest Renaissance contemporaries, Leonardo da Vinci and Michelangelo, although they were both somewhat older than him, and already well established.

In about 1508 he was summoned to Rome by Pope Julius II, a great patron of the arts. Raphael produced a large number of devotional pictures and altarpieces for him and for his successor Pope Leo X, and he also painted portraits and designed interiors for many other wealthy Romans.

The Alba Madonna is so called because for over one hundred years it was in the collection of the Spanish Dukes of Alba. The painting is a *tondo*, a circular format that was popular at the time, of the Madonna with the Christ Child on her lap, seated serenely in the Italian countryside. The adoring infant John the Baptist, clothed traditionally in animal skins, holds out a cross of twigs to Christ. The Virgin Mary wears her customary blue cloak; the haloes are fine whisps of gold. The bright soft colours and delicate detail of the draperies and hair, and the circle of wild flowers round the feet of the three figures, make an unusually light and beautiful composition. It is remarkable

for its serenity and perfect calm, although the cross is a reminder of the suffering to come. The figures are grouped to the left, but the Virgin's arm and the billowing material of her cloak create a restful balance, its harmony emphasized by the shape of the painting.

The Alba Madonna reveals Raphael's genius in the solving of a difficult problem: the convincing portrayal of three-dimensional figures on a flat surface. It is interesting to compare this picture with the work of the very early masters represented here, and to notice how dramatically painting had changed by the time of Raphael, particularly in the representation of the human figure. The woman and the two young children are not only three-dimensional, they are entirely realistic in their movements and in the way they express feeling in their faces and their gestures. This humanism and vitality was one of the most significant features of High Renaissance Italian art.

Titian (Tiziano Vecelli) (c. 1487–1576)

The Venus of Urbino (c. 1538)

The Uffizi Gallery, Florence

Titian was one of the most successful and productive painters in history. He lived in Venice where he was trained in the studio of Giovanni Bellini. On Bellini's death, in 1516, Titian became official painter to the Venetian Republic, and dominated European painting for much of the sixteenth century. He worked for the ducal families of Ferrara and Mantua, for Francis I of France, Philip II of Spain, for the Holy Roman Emperor Charles V, and for Pope Paul III, who made him a count palatine. From his highly organized studio in Venice several thousand paintings emerged during his long and energetic career: mainly altarpieces, portraits and mythological scenes, many of the latter depicting the female nude.

His work exhibits a love of the dramatic and a radiant confidence and enjoyment of life. 'Life through coloured light' is the phrase often used to describe the glittering paintings of Titian. He helped to establish oil-paint as a widely accepted medium, and his colours are exceptionally rich and glowing. He applied them in free expansive brush strokes, sometimes using his fingers for the final touches.

Titian painted this Venus for the Duke of Urbino, hence its name. The painting is reminiscent of a pagan altarpiece: it worships female sexuality, and presents the goddess of love as an earthly woman, aware of her beauty and the physical pleasures of life.

The warm glow of her skin is enhanced by the gold and cream tints in the sheet and pillows of her couch, by her brown eyes, and her 'titian' hair falling in waves on to her shoulders. (This particular shade of red-gold hair appeared so often in Titian's paintings that it was named after him.) A crystal earring catches the light against her cheek. In her right hand she holds some small red roses, the flowers of love associated with Venus; in ancient legend roses originally were white, and became red when they were stained by her blood. Her left hand covers her groin, in the traditional pose. The expression in her dark almond-shaped eyes and curving lips is both provocative and knowing, as if she is confident of the power of her sexual attraction.

The emerald green curtain behind her acts as a cool dark foil to her skin, and its soft folds accentuate the voluptuous lines of her body. This deep green and the red of the roses and the couch are picked up in the colours of the background scene, where two maidservants are putting away their mistress's clothes for the night.

The light of a summer evening floods into the room, picking out the sheen on rich materials, the designs on the elaborately decorated chests and the tapestries on the walls. The maids, chests, tapestries, and little dog curled up asleep on the couch, fill the painting with interest; they also balance the long angled line of the naked goddess in the foreground, and provide a contrasting activity to her languorous pose.

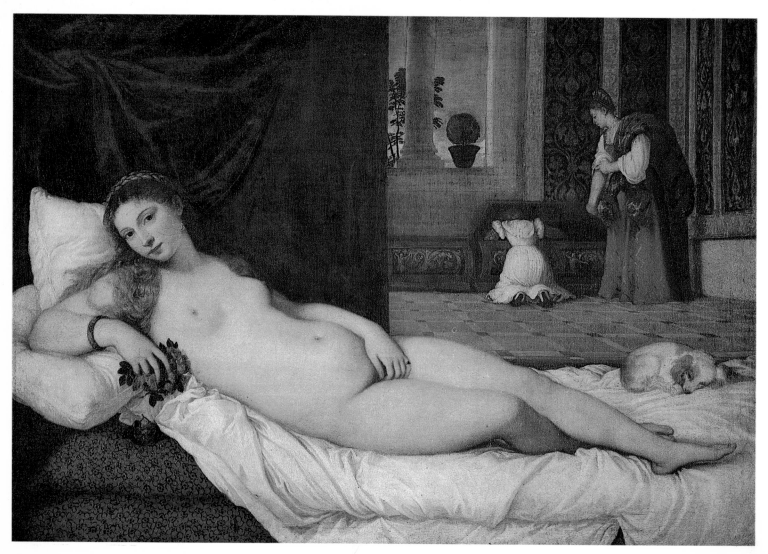

Hans Holbein the Younger (1497–1543)

The Ambassadors (1533)

The National Gallery, London

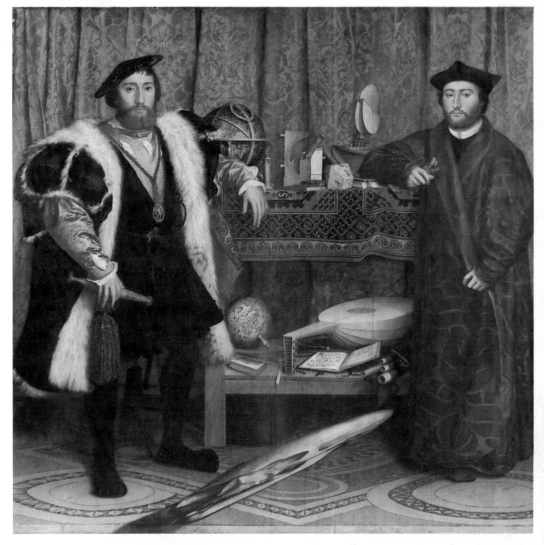

Hans Holbein was born in the rich commercial city of Augsburg, where his father Hans the Elder was a well-known painter. He trained in his father's workshop and then moved to Basel, where he started on his own successful career.

Eventually he was to seek his fortune in London, and to this circumstance we owe the greatest paintings of the Tudors and their circle: Henry VIII and his wives; Edward VI as a child; Sir Thomas More before his fall from favour; and Thomas Cromwell. He became Henry VIII's court painter, with a studio in the Old Palace of Whitehall. It was during his stay in London, and probably shortly before he entered the king's service, that he painted this magnificent portrait.

The Ambassadors is one of the first full-length, life-size portraits in the North, and it shows two richly dressed, dignified young men, conscious of their office, their responsibilities and their positions in life. The robes they wear are fur-trimmed and made of shining, elaborately decorated materials. Both young men are surrounded by objects – terrestrial and celestial globes, mathematical instruments, books both religious and worldly, a lute, a piece of Turkish carpet – all of which indicate their high education, their

knowledge and understanding of the world about them and their interest in science, art and religion.

The man on the left is an aristocrat Jean de Dinteville, aged twenty-nine, the French Ambassador in London; his friend and visitor is Georges de Selve, the twenty-five-year-old Bishop of Lavaur, who also undertook diplomatic duties. These men are in the prime of life, but Holbein is anxious to show that death is never far away, and he has included several symbols of death as a reminder of this. In the top left hand corner a crucifix is just visible, the tiny skeletal figure of Christ almost covered by the rich green damask of the curtain; Jean de Dinteville wears on his tip-tilted hat a badge decorated with a skull; and at the very front of the painting there is a strange object, which can only be deciphered if the spectator moves to the right and views it from the side. It is a human skull, possibly painted in this distorted way because the painting was to hang on a staircase, and would be seen from the side.

Two mathematical instruments on the

top shelf of the table show the exact time when the portrait was supposed to have been completed: 10.30 on the morning of 11 April. Time is frozen; and this illusion paradoxically underlines the knowledge of time rushing on and age approaching. A string on the lute is broken, another symbol of how things end.

With great penetration Holbein has painted something of the lives of these two young men as well as revealing their accomplishments. Several of his great group portraits have sadly been lost; but *The Ambassadors* combines in the richest possible measure his insight into character, his range of intellectual interests, and his genius in portraying the world with perception and accuracy.

As was typical of a hard-working artist of his period, Holbein turned his hand to many things besides painting; he designed costumes, stained glass, objects in silver, and even themes for festivals. But his ability as a portrait painter brought him an international reputation, and he was certainly one of the greatest Northern Europe has ever produced.

39

Bronzino (1503–72)

An Allegory (1540s)

The National Gallery, London

Most of Bronzino's life was spent in Florence, where he began his artistic career as student and assistant to the Florentine artist Pontormo. His flawless technique has its roots in a movement known as Mannerism, a courtly, decadent and contrived style of painting which followed the Italian Renaissance. Figures were refined into icy perfections, stylish and elegant, and set in exaggerated poses conveying ideas or emotions rather than a realistic representation.

All this can be found in *An Allegory*, an elaborate, highly artificial painting whose subject is based on ancient Greek myths.

With its vibrant super-charged colour, especially the deep hypnotic blue, it makes a fascinating composition.

Its alternative title is *Venus, Cupid, Time and Folly*. Venus is the central figure, holding the golden apple awarded to her at the Judgement of Paris, when she was chosen as the most beautiful of all the Greek goddesses. Her hair is decorated in the Florentine style of the day; her delicate features, long toes and tapering fingers have all the aristocratic distinction of the ideal beauty of the time.

Her winged and curly-haired son Cupid embraces her, and she seizes the opportunity to lift his arrow from its quiver. Venus is the goddess of love and fertility, but Cupid also is a god of love, and because of the mischief caused by his arrows, she sometimes punishes him by taking them away.

Bronzino's painting, however, is hardly innocent; it speaks quite openly of sexual love. So scandalous did it once appear that overpainting (now removed) in the shape of leaves covering Cupid's buttocks, and drapery modestly wrapped around Venus' legs was added at some time in the past.

Behind Cupid is an anguished figure most probably representing Jealousy, and a ferocious, energetic old man appears in the top right hand corner of the painting, the whites of his eyes gleaming and his muscles rippling. With his wings and the hour-glass he bears upon his back, he must represent Time. He is tearing away the blue cloak held by Fraud, a mysterious masked woman who faces him in the opposite corner, and his outstretched arm forms a vital link in the circular composition. A plump, naked boy with an anklet of bells looks as if he is about to throw a bunch of roses to the goddess of love. He is thought to represent Jest or Folly. Behind the boy is a figure with a female head, human arms, and a grotesque furred animal's body ending in a long scaly tail. She holds a honeycomb (often associated with Cupid) and displays the sting in her tail. She may be Pleasure both sweet and painful.

A Mannerist painter like Bronzino would have delighted in inventing this complex allegory of love, with its elaborate tangle of mythical characters; through them he examines the distress caused by love, in which Time, Folly, Jealousy and Fraud all play their parts. The picture is dazzling in its smooth elegance and electric colours, and in the disturbing eroticism and corruption it portrays.

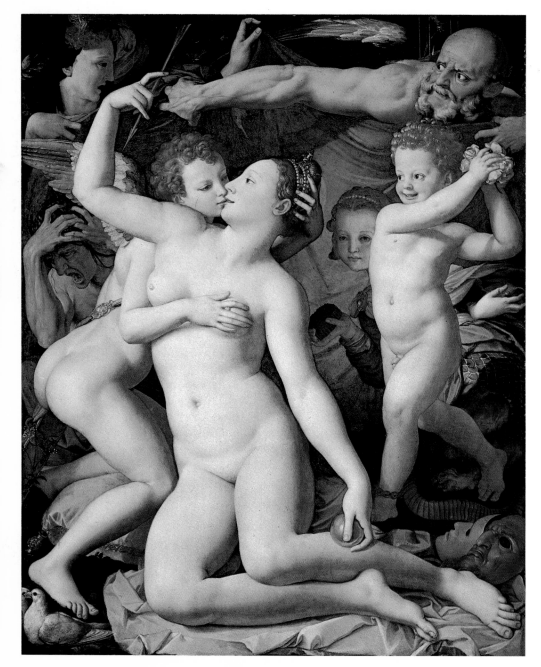

Jacopo Robusti Tintoretto (1518–94)

The Origin of the Milky Way (1570s)

The National Gallery, London

Jacopo Robusti's nickname of Tintoretto was derived from his father's trade as a dyer (*tintore*) in Venice. Tintoretto was prolific and exceedingly successful, partly as a result of his willingness to adapt his style to suit his patrons, and partly

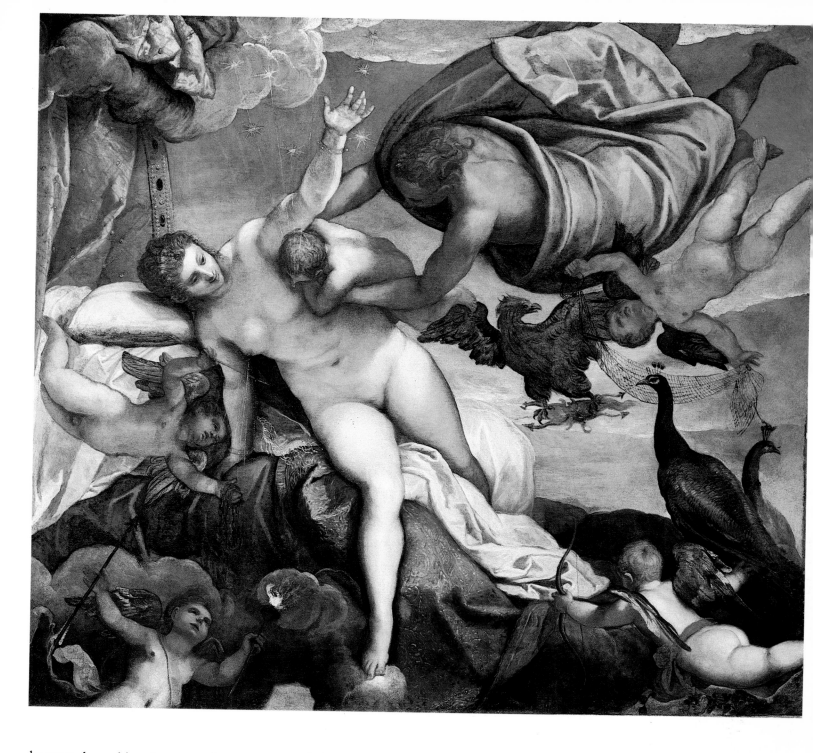

because he achieved a stunning combination of brilliant colour and dramatic outline.

His compositions often revolve around a central point, with foreshortened figures twisting and turning in radiating diagonal lines to the corners of the canvas, full of movement and drama in the Mannerist style. He had a very individual working method: he made wax models for the figures in his paintings, and arranged them under lamps or candles to study lighting effects, with the result that the light and shade in his pictures is extremely realistic, and it plays an important part in his work.

The Origin of the Milky Way may have been produced as one of a series of mythological scenes for the Roman Emperor Rudolf II. Its subject is the conferment of immortality on the infant Hercules by putting him to drink from the breast of the goddess Juno. Juno was the wife of Jupiter, who had fathered Hercules with the mortal woman Alcmena of Thebes. Hercules sucks so strongly at his foster-mother's breast that her milk spurts into the sky, where its droplets form the Milky Way; and the milk that falls to earth is transformed into lilies. (Surviving drawings and prints indicate that this entire scene may have been shown originally, and that a lower portion of the painting was removed and is now lost.)

Peacocks, traditionally associated with Juno, can be seen on the right. The naked winged boys bearing Cupid's bows and arrows are messengers of love, known as *putti*; one of them holds a net, a symbol of deceit, for Juno was sleeping peacefully when Jupiter surprised her by thrusting his child to her breast. Jupiter's sacred eagle hovers beneath his muscular figure, holding in its claws the dramatic emblem of a thunderbolt.

A flickering light picks out the colours and textures of drapery and flesh, highlighting Juno's breasts and thighs, and shadows accentuate the twisting movement of the figures. The originality of this work, with its dramatic structure based on a central axis, is typical of Tintoretto's highly decorative and elaborate style.

François Clouet (before 1510–72)

Lady Bathing with Children and Attendants (*c. 1571*)

National Gallery of Art, Washington DC

François Clouet, son and grandson of artists, was court painter to François I, Henri II and Charles IX of France, yet only three signed pictures are known to be entirely his. In part the problem of distinguishing his work from that of other artists is due to his success. Not only did he have a large studio of assistants, but he was also widely imitated. There is no doubt, however, that this painting was by Clouet; the woman has drawn back her bath-sheet and reveals his name inscribed on the side of the bath.

The story behind the picture is unknown, and the identity of the central woman has been the subject of much discussion. Most people now believe her to be Diane de Poitiers, mistress of Henri II, although this has still not been proved. Other suggestions have been Marie Touchet, mistress of Charles IX, Gabrielle d'Estrées, mistress of Henry IV, and even Mary Stuart. There are details in the painting too which are hard to interpret now, although no doubt they were clear to its aristocratic sixteenth-century audience. The pink carnation the woman holds in her hand, and the unicorn on the embroidered screen in the background, would have had a meaning in the French court which is unfortunately lost to us today. A unicorn is a symbol of purity and chastity, and the carnation indicates a betrothal; yet it seems the woman may be a mistress, not an intended wife.

An opulent style of living is indicated by the woman's jewels, the silver bowl with gold decoration, and the pictures and furnishings of the rooms, all painted with wonderful smoothness and clarity.

The woman's features are idealized, and her high forehead, arched brows, long straight nose and small carved mouth, as well as her surroundings, indicate her high birth. The other figures are entirely human and realistic: a small boy, his rich clothes probably indicating that he is her son, reaches greedily towards the bowl of fruit; to the left a wet-nurse suckles a baby at her breast; and, in the room beyond, a maid is bringing another pitcher of water for the bath, hot from the fire.

The rich red satin curtain, which frames the composition and increases its depth, seems as if it has been drawn aside to reveal a private scene, full of significance in the intrigues of the French court, and communicating an atmosphere of intimacy and comfort beyond the moment it portrays.

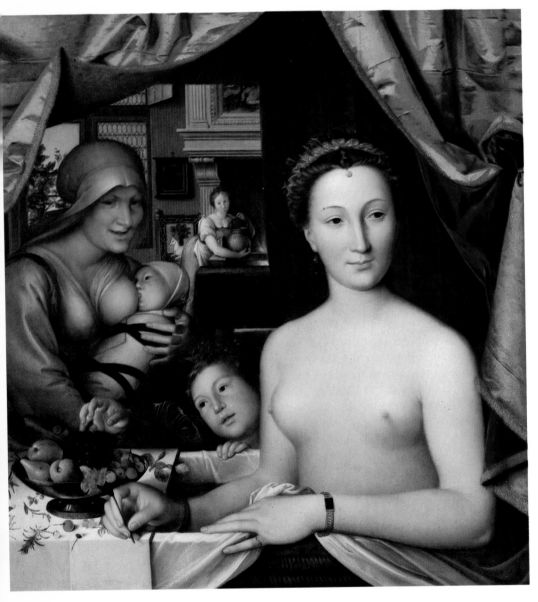

Pieter Bruegel, the Elder (1525/30–69)

The Return of the Hunters (*1565*)

The Museum of Art History, Vienna

Pieter Bruegel was born in Antwerp and spent most of his life there, with a two-year trip to Europe from 1552–4. He went over the Alps to Italy, travelling as far south as Sicily, and the scenery of the Alps had a marked effect on his landscapes.

He depicted man in natural surroundings, leading a simple life, and dependent on the earth and the seasons for survival. He earned the nickname 'Peasant Bruegel', not because he was uncultivated which was far from being the case, but because the lives of the Flemish peasants formed such a large part of his subject matter. He showed them working, feast-

ing and celebrating, and exposed their drunkenness, lechery and greed with a gently sarcastic wit. But a religious sincerity and understanding of happiness and suffering were as evident in his pictures as his eye for human weakness. He was interested in the peasants' customs and in every aspect of their daily lives, and his paintings tell us a great deal about them.

The Return of the Hunters, also known as *Winter*, is one of a series of landscapes representing the seasons of the year. Like the others in the cycle, it has a high vantage point in the foreground and a long vista receding into the distance. It combines elements of the alpine scenery that Bruegel saw on his travels with the countryside, houses and people of the Low Countries where he lived.

It is a snow scene, but the signs of companionship and domestic comfort give it a feeling of warmth. Three men are plodding back wearily through the snow,

their shoulders bent and their legs heavy, after a hard day's hunting with their hounds. The line of trees down the hillside emphasizes the steady tramp of their footsteps descending to the village. They pass an inn on the ridge where a group of people are roasting a pig over a blazing fire; and beyond it the roofs of houses follow the line of the ridge down to the valley.

A horse-drawn wagon trundles along a road bordered by feathery trees; and fields, copses and four churches are scattered over the flat landscape as far as the eye can see, with mountains like alpine crags towering over them.

A river winds its way through the valley, with a bridge crossing it in the middle distance. It has flooded several of the surrounding fields, and the water has frozen into hard green ice. The villagers are taking advantage of it, skating or playing games on the newly-formed frozen lakes. Just below the foreground

ridge an old woman trudges across a bridge with a load of twigs on her back for a fire, and a woman in a red skirt is pulled over the ice on a sledge.

The roofs of the houses are long and steep to shed the heavy snow, and icicles hang from the eaves. The bare branches of the trees are like the delicate bones of a skeleton, and the snow on them reflects the icy eerie light.

There is so much detail in the picture that one could look into it for hours in fascination, and its minute observations reveal Bruegel's familiarity with the countryside and the lives of the people.

Paolo Veronese (1528–88)

The Marriage Feast at Cana (1562–3)

The Louvre, Paris

Born in Verona, Paolo Caliari was called Veronese after his native town; but he moved to Venice in 1553, and his work is closely associated with the Venetian school. His greatest contribution was the creation of decorative schemes and paintings which reflected the rich pageantry and splendour of Venetian ceremony.

For the last thirty years of his life Veronese was, with Tintoretto, the leading painter in Venice. His gigantic works, some of them as much as thirty feet across, were carried out in a well-organized workshop with the assistance of his brother and several of his sons.

He specialized in biblical and historical subjects, and filled them with vast crowds of people of all sorts: aristocrats and peasants, fashionably dressed women and freakish buffoons, courtiers, musicians, soldiers and drunks, all gathered in settings of architectural splendour, rich tableaux in which fact and fantasy are merged.

This work was produced for the refectory of the convent of San Giorgio Maggiore, and it depicts Christ's first recorded miracle, when, at the wedding feast at Cana, he turned water into wine. The huge stone drinking jars can be seen in the foreground of the painting.

The only full face portrait is that of Christ himself, seated under the balustrade with the Virgin next to him; their expressions are tranquil and calm in the extravagant turmoil around them. Musicians in the foreground (with two elegant dogs) add to the mood of boisterous indulgence; one of them – dressed in a silver robe – is thought to be Veronese.

The composition is symmetrically balanced, with depth created by the classical colonnades at either side and the belltower in the distance. In the clear shadowless daylight, the teeming activity of the brilliantly choreographed crowd (132 figures in all) fills the vast canvas with life and energy.

El Greco (1541–1614)

Christ Driving the Traders from the Temple (c. 1600)

The National Gallery, London

El Greco, the Greek, was the name given by the Spanish to Domenicos Theotocopoulos, who was born in Crete but spent most of his working life in Toledo. He was a Baroque painter, but he was influenced by both the Mannerist and the Renaissance masters. His style is very individual and easily recognizable: elongated figures, harsh surprising colours in brilliant contrasts, and an abundant use of white.

The patrons for whom he worked were taking part in a fervent religious revival, and El Greco painted mainly for churches and buildings belonging to religious orders.

Christ Driving the Traders from the Temple is a subject he painted many times. The energetic and graceful movement of Christ's right arm, and the angle of his elbow as he raises his whip, are pivotal parts of the entire composition. They are echoed in the bent arm of the man to the left, and both he and the man stretching upwards repeat the angle of Christ's twisting central figure. A piece of upturned furniture, possibly a trader's stand, testifies to the vigour with which the merchants are being urged to leave.

The two crowds of people are sharply separated: on the left are the traders, and on the right a group of elderly bearded Pharisees, talking among themselves. The two groups are further defined by the small reliefs on the wall. Behind the Pharisees is the sacrifice of Isaac, a symbol in the Old Testament of purification and redemption, and behind the traders is the expulsion of Adam and Eve from the Garden of Eden.

The paint is almost slapped on to the canvas, making strong, rough textures. The strident, acid colours, the streaks of white emphasizing the elongated limbs, the nervous tension and dynamism of the strange distorted figures, all express El Greco's personal and passionate Christian beliefs.

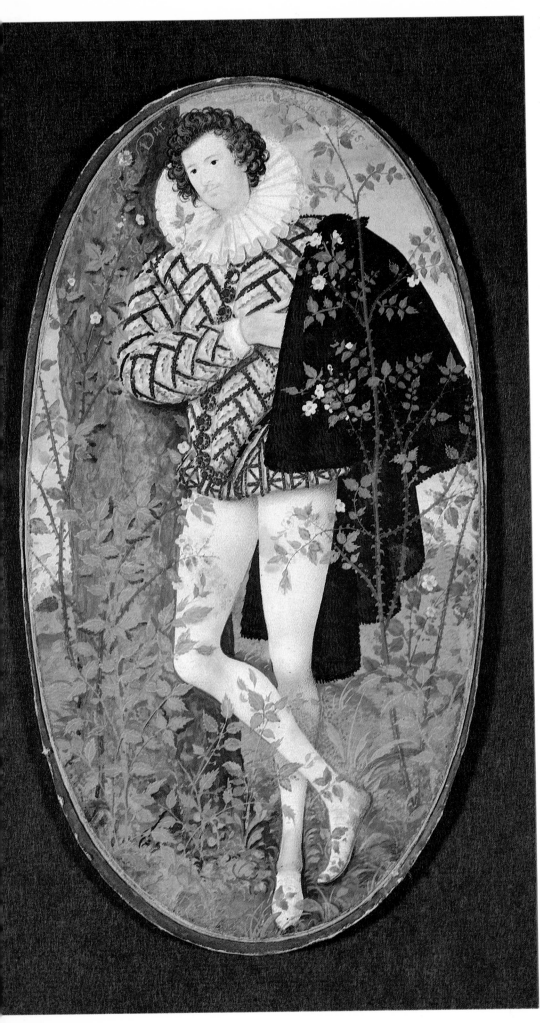

Nicholas Hilliard (1547–1619)

Portrait of an Unknown Man (c. 1588)

The Victoria and Albert Museum, London

Holbein was the chronicler of life at the court of Henry VIII, but it is to Hilliard that we owe our conception not only of Queen Elizabeth herself, but also of the delicacy, courtly grace and melancholy lyricism of the Elizabethan Age.

Hilliard was the son of a goldsmith, a respectable public figure in the English West Country town of Exeter, and he trained and worked for a while as a goldsmith himself. He was educated in the household of John Bodley of Exeter, and then in Geneva. In 1562 he was apprenticed to the Queen's goldsmith and jeweller Robert Brandon, whose daughter he married. From the start of his career Hilliard had practised as a limner (a painter of portraits in miniature) and, until overtaken by his own pupil Isaac Oliver, he was the most successful limner in England. When Hilliard was fifty, the great poet John Donne remarked of his art,

'. . . a hand or eye
By Hilliard drawn, is worth a history
By a worse painter made . . .'

Miniatures were portable tokens of love and admiration, and they were usually mounted in lockets or worn at the end of jewelled chains. The unknown man in this portrait may have commissioned the miniature as a love token in a difficult courtship; the inscription in Latin which encircles his head translates as, 'My praised faith causes my sufferings', which suggests perhaps that his love was unrequited. He leans in languid melancholy against a tree trunk, with his right hand over his heart and an elegant cloak hanging from his shoulder. In Elizabethan times the beauty and the pain of love were symbolized by the flowers and thorns of the rose, and here they weave a delicate tracery on his cloak.

The art of the limner was essentially precise and intricate, with fine brushwork and an eye for detail. Hilliard combined these qualities with great imagination and sensitivity to produce the jewel-like perfection of this miniature, which evokes the poignancy of love in a highly romantic composition.

Michelangelo Merisi da Caravaggio (1573–1610)

Bacchus (c. 1593)

The Uffizi Gallery, Florence

Caravaggio was a stormy and excitable man, and his tempestuous life was surrounded by controversy. He stabbed a man to death after a violent quarrel in Rome, was imprisoned, but escaped and fled to Sicily. From there he was pursued to Naples and nearly murdered in a brawl with a group of cut-throat mercenaries.

The vivid and sensational quality of his temperament is reflected in his art. People were shocked by his work, but it was widely admired and extremely influential.

When he died at the age of thirty-seven he was generally recognized as one of the most exciting painters and innovators of the Baroque age.

In particular his use of *chiaroscuro* (strong light contrasted with deep shadow) and dramatic foreshortening are the characteristics of his work for which he is best known. His technical methods were unusual for the sixteenth century: he painted directly on to canvas instead of working from sketches and squared-up drawings in the accepted fashion, and this gave his style a remarkable zest.

Bacchus was the god of wine and fertility, and he was a common subject in paintings of the period. This portrayal of him, executed when Caravaggio was barely twenty years old, may well be a

self-portrait; and the young god in his crown of grapes and vine leaves certainly has some of the artist's passion and vitality in his gaze. Although his pose is indolent and relaxed he has an air of repressed energy.

His foreshortened arm is thrust forward so that it breaks the flat surface of the painting and draws us in towards him. It is a powerful pose, and its directness is very arresting. A strong light silhouettes his figure against the dark background, and this *chiaroscuro* device heightens the effect of his gesture. The bowl of fruit and carafe of wine underline his sensuality and the mood of indulgence. *Bacchus* is a superb example of the effects of lighting, foreshortening and vivid realism achieved by Caravaggio.

Sir Peter Paul Rubens (1577–1640)

The Descent from the Cross (1611–12)

Antwerp Cathedral

The Prince of Painters was the name given to the Flemish artist Sir Peter Paul Rubens. He was the son of a high-ranking official in the Flemish government, and combined an astonishingly successful artistic career with missions of diplomacy for the Governors of the Netherlands. He was well-educated, good-looking, charmed everyone he met with his courteous manners, and spoke several languages. He visited many European countries including Italy, where he studied the High Renaissance masters – Titian and Michelangelo in particular. He was also deeply influenced by the work of Caravaggio.

His paintings were executed with great confidence and control in rich and intoxicating colour, which is one of the most important features of his work. His rapid preparatory sketches in oils show the freedom and verve of his style. Commissions poured in, and he produced, with the help of assistants (the young van Dyck among them), countless portraits, landscapes, mythological scenes with voluptuous nudes, religious pictures and altarpieces.

This major work formed the central panel – some fourteen feet wide and ten feet high – of an altarpiece for Antwerp Cathedral. It depicts the descent from the cross, and shows Christ's pale body being gently lowered into the arms of St John the Evangelist. The Virgin, in a billowing blue robe, reaches up to him, and Mary Magdalene supports his feet. On the left the bearded Joseph of Arimathea anxiously clasps the white shroud in which the body will be wrapped in the tomb, and Nicodemus descends the ladder on the right. The nine figures are arranged in such a way that they form a single diagonal line, with Christ at the centre of the group. This device effectively and dramatically focuses attention on the main subject, and at the same time expresses the concern and protective care felt by Christ's friends and family.

The perfectly harmonized colours glow against an ominously dark sky. Joseph's hat and the robe of St John reinforce the red of Christ's blood. The flesh tones and the dazzling white shroud, which accentuates the structure of the composition, provide the main sources of light.

The Descent from the Cross is a supreme work of art, showing the vision and dynamism of Rubens's imagination. It captures the attention of worshippers in the Cathedral now as it did three centuries ago, and magnificently fulfils the purpose for which it was intended – to encourage the faithful.

The side panels of the altarpiece depict, on the left, the Virgin's visit to her cousin Elizabeth to celebrate their pregnancies, and, on the right, the presentation of Jesus at the Temple of Jerusalem.

Rubens was an exceptionally talented, energetic and prolific painter, a favourite at the court of Philip IV of Spain, knighted by Charles I of England, and court painter first to the Duke of Mantua in Italy, and later to the Spanish rulers of the Netherlands in his native Antwerp. He held this appointment until his death, and became the most important Baroque artist in Northern Europe.

The Descent from the Cross, which forms the central panel of the Antwerp Cathedral altarpiece

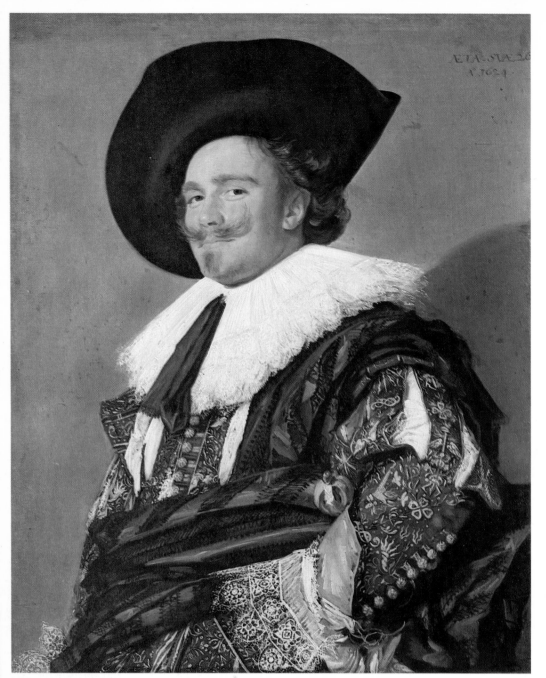

Nicolas Poussin (1594–1665)

A Dance to the Music of Time (c. 1637–9)

The Wallace Collection, London

The greatest of French seventeenth-century painters was Nicolas Poussin. He amplified and passed on the classical artistic tradition, frequently using the themes of Greek myth and legend as his subjects. He believed that painting should appeal more to the mind than the eye. He was a painter of ideas, an artist who praised the rational rather than the intuitive, who sought to impose order rather than reflect chaos. To this end, form and composition are paramount,

Frans Hals (c. 1580–1666)

The Laughing Cavalier (1624)

The Wallace Collection, London

Almost exclusively Frans Hals was a painter of portraits. He introduced an air of informality and naturalness into his pictures of the affluent society of Holland. He painted people as they were, accurately revealing their well-being and prosperity, and even their satisfaction – the militia after they had all settled down to a good meal, for example.

He had a rapid technique and a perceptive eye, and could catch a fleeting expression with a few confident strokes. Yet he was always analytical, recording at times old age or emotional uncertainty with an unerring hand.

Many people most admire his vivid group portraits, but one painting above all has captured the public imagination – *The Laughing Cavalier*.

The name of the young man is unknown, but he was clearly aristocratic: his clothes are made of the finest materials and richly embroidered (some of the emblems on his coat and sleeves may be clues to his identity). Everything about him contributes to his air of assurance: his vigorous upswept moustache, prominent stomach, curling hair, and his hand resting confidently on his hip.

In spite of the painting's title, the young man does not appear to be really laughing, although a century ago it was thought that his eyes were alight with amusement. Today, his half-smile is generally interpreted as one of determined confidence and even shrewd calculation; he looks as though he is weighing up the situation, and is also in control of it. He is a young man on his way – the world belongs to the 'Laughing Cavalier'. It is easy to see why the Victorians found his air of prosperity and boldness so appealing. The impression of ease and even suppressed gaiety which this masterly portrait conveys, combined with the sheer skill of the artist in conveying the textures and colours of skin, hair and clothing, stands out as a triumph of virtuosity.

emotion subordinate. His paintings are smooth, highly finished and controlled; and this very discipline led paradoxically to a kind of visual poetry.

Poussin spent most of his life in Rome, and *A Dance to the Music of Time* was painted for Cardinal Giulio Rospighosi, later Pope Clement IX. Its composition is thought to be of the Cardinal's own devising. In an idealized landscape reminiscent of the country around Rome, four large – indeed hefty – figures form a circle. They are dancing in a rather lumbering manner, and looking towards the bearded, winged figure of Time, an old but muscular man playing his lyre.

The dancing figures probably represent Pleasure (garlanded with roses), Wealth (with pearls entwined in her hair) and Poverty (wearing a simple white linen headdress). Wealth holds hands with Pleasure, but barely touches the hand of Poverty. The man with his back towards us is crowned with laurel, the victor's wreath; perhaps he is Fame.

At Time's feet a cherubic naked boy sits contemplating the sand running through an hour-glass; balancing him on the left another boy blows soap bubbles. Both infants represent change and fragility: what could be shorter-lived than a soap bubble, what more evocative of time running out than an hour-glass? The stone column on the left bears the double head of youth and age.

This splendid earthbound scene is crowned by a fabulous group in the sky. Borne upon sunlit grey clouds, Apollo the Sun God rides in his golden chariot, drawn by four powerful horses. He is escorted by dancing maidens representing the Hours, or maybe the Seasons. Leading the way is Aurora, goddess of the Dawn and sister to the Sun God, scattering flowers as she banishes Night.

The circular form of the dance itself implies a never-ending cycle, echoed by Apollo's journey through the air as the sun crosses the sky. It is a powerful allegory of the ceaseless ebb and flow of human history, in which the dancers represent the quality of human life, and the rise and fall of fortune is in the hands of Time.

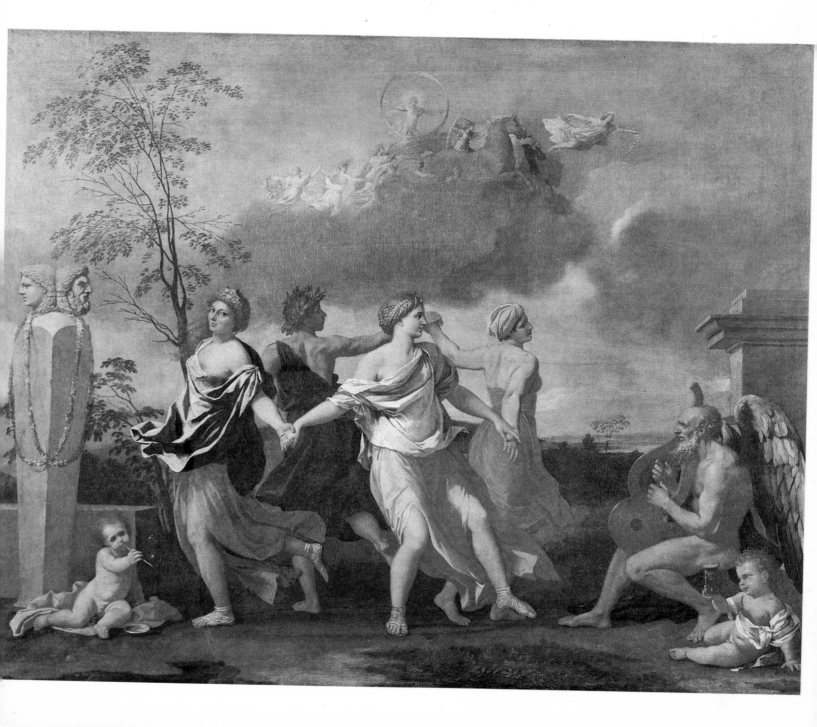

Sir Anthony van Dyck (1599–1641)

Charles I with an Equerry and Page (1635)

The Louvre, Paris

Anthony van Dyck was born to a merchant of Antwerp, and at the age of ten his formal art training began. While still in his teens, he became one of Rubens's chief assistants and quickly began to make a name for himself.

His ability was recognized by a major English connoisseur, the Earl of Arundel, and in 1620 van Dyck made a brief visit to London, to the court of James I. For seven years he travelled around the cities of Italy, established his reputation as a portrait painter, and returned to Antwerp in 1625. By 1632 he was again in London, where he was given a studio in Blackfriars, a position as 'principalle paynter' to Charles I and Queen Henrietta Maria, and a knighthood.

Although van Dyck had a wide range of subjects – landscapes and mythological scenes among them – he is known chiefly for his portraits. He painted Charles I, his family and his court, many times, and these portraits are highly accomplished artistically and fascinating historically. They are sensitive and elegant, and revealing both of the sitter's personality and appearance and of life at court.

Among his most famous pictures are his equestrian portraits of Charles I. Here the king stands with his hand on his hip as an equerry and page prepare his horse for a day's hunting. His pose is one of grace and distinction. He is proud and commanding, but not arrogant, and his face expresses intelligence and sensitivity. His clothes are stylish, but, apart from his regal garter, he is not richly dressed. He is portrayed, in a moment of relaxation, as a gentleman rather than as a king.

Van Dyck preferred the informality of situations such as this to the stiffness of state occasions, where character and individuality were often overshadowed. His ability to penetrate and expose the personality of his sitter sympathetically as well as skilfully made him one of the greatest of royal portrait painters. The unusual gentleness, charm and informality which characterizes his work was to lead to the great tradition of English portrait painting continued by Reynolds and Gainsborough in the eighteenth century.

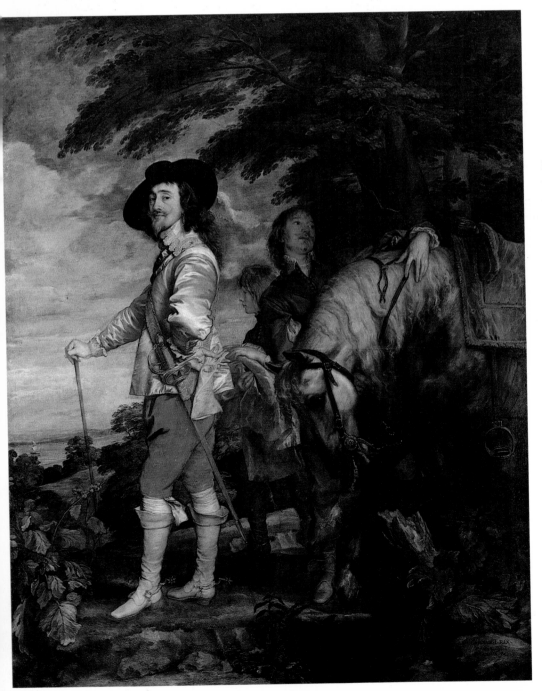

Diego Velázquez (1599–1660)

Las Meninas (1656)

The Prado, Madrid

Diego Velázquez was born of Portuguese parents in the Spanish town of Seville. He trained in the academy of Francisco Pacheco, whose daughter he married, and by 1617 he had set up as an independent master. At the age of twenty-four he became court painter to Philip IV in Madrid, a position he held for the rest of his career. He was twice released for visits to the artistic centres of Italy (a necessary pilgrimage for any painter), which resulted most notably in a remarkable portrait of Pope Innocent X. Most of his work was bound by his court appointment, and his paintings of the Spanish royal family and the life of the court reveal an insight into human relationships that communicates beyond their own time and culture.

Las Meninas (the title is Portuguese and means Maids of Honour) was painted towards the end of his life. Its audience would have been the royal family, their courtiers and servants. Ingeniously

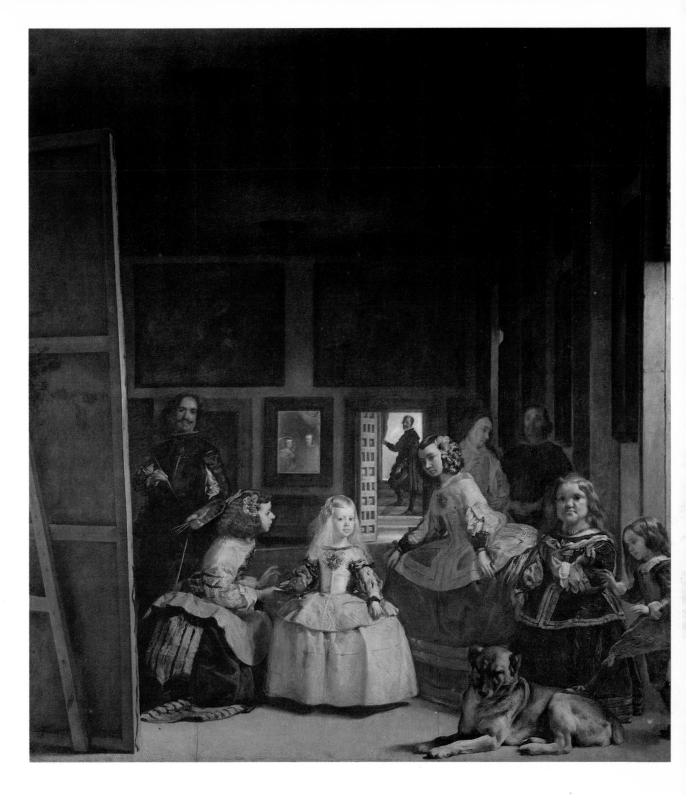

Velázquez has included in the composition a large portrait of the king and queen on which he is working, which is reflected in a mirror at the back of the room. This device may have been based on the reflection used by van Eyck in *The Arnolfini Marriage* (see p. 14), which was then in the Spanish Royal Collection.

Standing beside the painter, and no doubt talking to the royal couple who are posing for him, is the Infanta Margarita Teresa, their flaxen-haired five-year-old daughter. She is surrounded by a retinue of maids of honour and dwarfs, playmates for the royal children, who provided Velázquez with unusual character studies.

Behind them, in a nun's cowl, is the Infanta's duenna (or chaperone) talking to a male attendant, and on a stairway at the back the superintendent of the old palace pauses to look through the open door. He is outlined against the brightly lit wall at the top of the stairs. In the room the shutters are closed against the brilliant sun, and the daylight falling on the figures in the foreground fades very gradually into shadow at the back, deepened by the greys and ochres of the pictures, ceiling and walls. The colours throughout the painting are limited to subtle, closely related tones, and they merge together in the silvery light.

The paint has been applied thinly with rapid brushstrokes, yet the result is detailed and accurate: there is a silky bloom on the young girls' skin, and the artist has caught exactly the way the light gleams softly on their hair and their crinolines, and on the thick close fur of the dog.

Hands and facial features are so finely observed and portrayed that they reveal the relationship within the group superbly. In this work Velázquez achieved perhaps his greatest heights in combining realism, atmosphere and insight into character.

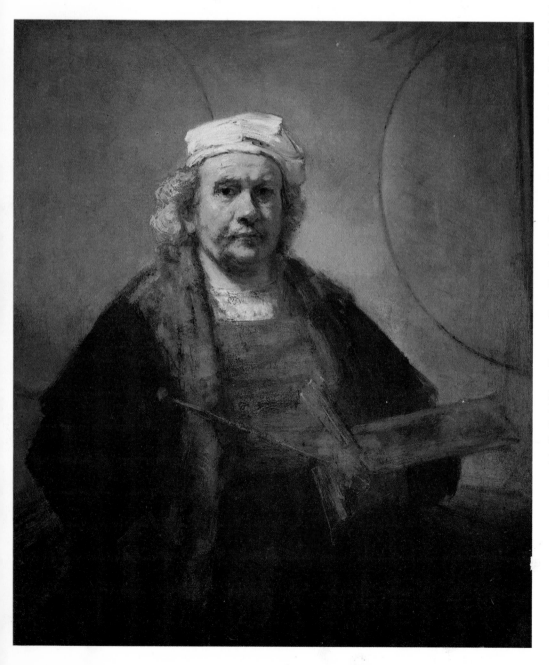

Rembrandt van Rijn (1606–69)

Portrait of the Artist (c. 1665)

The Iveagh Bequest, Kenwood, London

Rembrandt ranks with the greatest artists of all time, outstandingly gifted as a painter, a draughtsman and a print-maker. He was born in Leyden, Holland, the son of a miller, and trained in Amsterdam. Holland at the time of Rembrandt had recently emerged from the yoke of Spanish occupation, and the Golden Age of Dutch painting reflected this new-found freedom. It had become a major sea-power and its people were commercially successful and eager for celebrations of the good life. Hundreds of artists were drawn to its cities and made good livings.

In 1632 Rembrandt set up in Amsterdam as a portrait painter, and made his name with a group portrait of the Amsterdam Guild of Surgeons. He soon acquired scores of pupils and followers (at least fifty pupils are known by name). Once established, he refused to specialize, and his subject matter is immensely varied. But he never strayed far from his central concern: human beings, their spiritual aspirations and worldly realities. He produced no sea paintings, but there are landscapes, group portraits, religious, mythological and still life pictures, scenes of contemporary life and domestic scenes. He exploited to the full the effects of *chiaroscuro*, and has been called the most dramatic painter in history.

Rembrandt produced a long series of self-portraits, which reveal every stage of his life and career in an ever-deepening analysis. One of his first recorded paintings contains a portrait of himself, and something like a hundred self-portraits, both drawings and paintings, have survived. As a result of living well beyond his means, he was bankrupted in 1656, but he kept a mirror from the creditors so that he could continue to paint himself. In some of the portraits he appears with a confident air in fancy dress, acting the part of a swaggering young man, a romantic, or a man of substance and responsibility. But later in his life he reveals increasingly his disillusionment, suffering, doubts and need for reassurance. Taken together, the self-portraits are the finest, broadest and most moving visual autobiography ever created.

This one was painted near the end of his life, and is probably the most famous. He is in working clothes, with a white cloth round his head, and a thick warm coat to keep the cold at bay in the studio. The sombre colours show the typical Rembrandt palette of browns and black, contrasted with flesh tones and touches of white.

He holds his palette, a handful of brushes and a maulstick, a rigid slender rod used by painters to keep hand and brush steady when carrying out detailed work. The slant of the shoulders and spreading arms creates a wide pyramid shape, which gives the figure a solid, rock-like quality. The face is heavily furrowed, the skin pouchy, and the bulbous nose is shown with no attempt at disguising its prominence. The expression in the mouth and eyes shows a lifetime's experience. It is a remarkably self-penetrating study which reveals his sensitivity and imagination as a man and as an artist.

Through capturing an outward appearance accurately and completely, Rembrandt exposes the inner landscape of the human character, and it is this understanding of humanity and his skill in portraying it that sets his art so high.

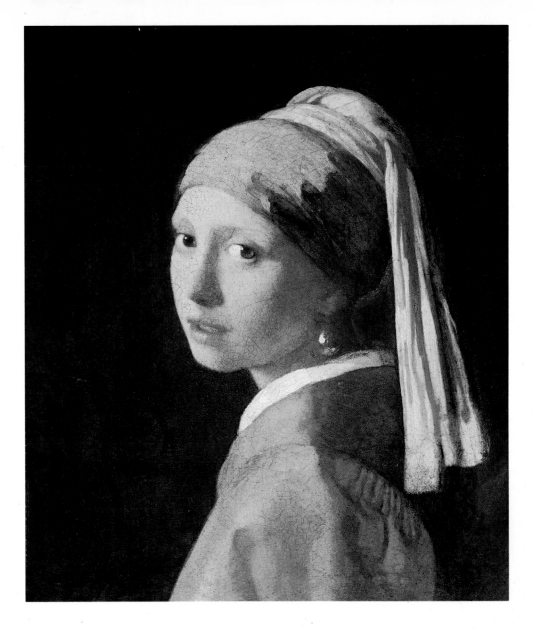

Johannes Vermeer (1632–75)

Head of a Girl (c. 1665)

The Mauritshaus, The Hague

On the basis of some thirty-six small surviving pictures, Vermeer is now thought to be one of the greatest painters Northern Europe has ever produced. He lived during the Golden Age of Dutch painting, perhaps the most productive period of painting there has ever been, yet on the evidence available he seems to have worked slowly, produced little, and not achieved spectacular fame in his lifetime. He was almost entirely overlooked until the 1860s, when his work was studied by French critic and art historian Théophile Thoré, who realized its genius.

Vermeer was born in Delft and spent his life there. In the tradition of Dutch painting, most of his small pictures are concerned with domestic interiors, in which everyday life is portrayed with a great feeling of intimacy. Everything is bathed with light, for the play of light on domestic objects and furnishings, and above all on people, fascinated Vermeer. He used it to brilliant effect in bringing out the depth and clarity of his colours.

Whereas other masters concentrated on official portraits, still life and scenes from stories, Vermeer became one of the world's greatest painters of women. He captured them at private moments, writing letters or poised to play a musical instrument, as though they were unobserved, and showed their strength and vulnerability, straightforwardness and mystery.

The identity of Vermeer's models is uncertain, but he did have eleven children, and it is thought that this may be one of his daughters. Her turban may be part of the Turkish-style costumes, probably dressing-up clothes, which were among the effects left by Vermeer on his death.

The girl is painted in an unusual and arresting pose, as if she has turned to look at a companion, and the artist has caught the movement of her head. She is very young and seems a little shy and uncertain, yet her gaze is cool and steady. Her wide dark eyes with their opalescent whites, her slightly parted lips, and her creamy skin reflect the strong light shining on her face. A large pearl gleams in her ear, a device often used by Vermeer in his portraits of women as an additional source of light, and her white collar heightens its effect.

She wears a beautiful turban of blue and gold, and the ends of it hang down her back and balance the upward tilt of her head. The extraordinarily luminous colours of the turban and the girl's pale skin are accentuated by the deep shadow of the background, which seems to recede and throw them into relief in an almost mesmerizing way.

Vermeer was one of the greatest masters of light and colour there has ever been, and his small calm paintings shine with a wonderful intensity.

Pieter de Hooch (1629–84)

The Courtyard of a House in Delft (1658)

The National Gallery, London

In *The Courtyard of a House in Delft* the mood is quiet and calm and the scale small and intimate, as is characteristic of Pieter de Hooch's best work. He was a master of the Dutch school, famous for his paintings of domestic interiors lit by natural light. His subjects were similar to those of Vermeer – people playing cards or engaged in household tasks – often in a dimly-lit room with sunlight flooding through an open door at the back.

Here he has painted a private courtyard, where a woman, most probably the maid of the house, holds a small girl by the hand, and looks down at her with gentle affection. In the open hallway another woman stands with her back to us.

The small enclosures give a sense of comfort and peace; and the open doors and shutters make the scene airy rather than claustrophobic. The woman and child have probably come out together to visit the outdoor larder. The light in the courtyard is even and bright, and the shadowy hall opens on to bright sunlight beyond, so that the figures are silhouetted against contrasting light and shade. The mellow bricks, the red skirt of the woman in the hall and the open shutter, fill the painting with warmth, and light green leaves add a delicate haze of pale colour at each side. On the courtyard wall, underneath an oval window, an engraved stone tablet tells us 'This is Saint Jerome's Vale. Enter if you wish to repair to patience and meekness. For we must first descend if we wish to be raised.'

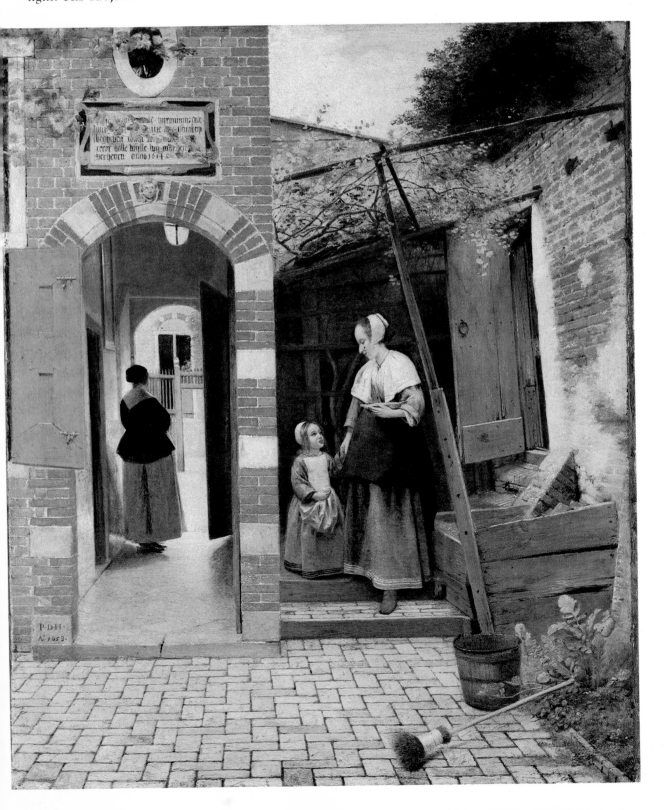

Every detail of the courtyard is rendered with meticulous care: textures of clothing, brickwork, stone, metal, wood and human flesh are made almost magically real. The wooden bucket and the broom of twigs indicate domestic duties in a well-ordered day, and everything looks fresh and clean. The painting is in praise of domestic virtue and family feeling.

This impression seems simple and straightforward, but it is achieved in quite a complicated way: the open doors and shutters and the storage container and wooden beams provide a number of sharp angles; the bricks form a complex linear pattern; and the steps and different levels accentuate the receding planes of the composition as well as the attention to detail which creates an atmosphere of domestic privacy and contentment.

Meyndert Hobbema (1638–1709)

The Avenue, Middelharnis (1689)

The National Gallery, London

The Avenue is one of the most hauntingly memorable landscapes of European art. Distant buildings punctuating the sky at the horizon, avenues of trees, and a road or path cutting through the picture are devices often used in landscape composition, but here Hobbema has welded them together in a painting that is far greater than the sum of its parts.

Middelharnis, the village on the horizon, is in South Holland on the mouth of the River Maas. The scene has changed little in the last three hundred years, and the view he made famous is still recognizable today. The flat Dutch landscape speaks of prudence and careful cultivation, the canals and fields of ordered agriculture. The avenue of young poplar trees and the road they border are extremely foreshortened, enticing us into the picture; and the canals and the deep ruts in the surface of the road also draw the eye irresistibly inwards. A man and his dog walk towards us, and in the distance are more people and the masts of boats on the horizon. The poplars rise into the sky forming a sharp V-shape against the clouds, which is repeated on the ground by their receding trunks along the roadside.

The image of a path or road, prominent in poetry and dreams as well as in painting, is a beguiling one, and here the avenue, as it opens wide towards us, has an almost hypnotic attraction.

Hobbema's work was very highly sought after by English collectors of the eighteenth and nineteenth centuries, and it had a profound effect on English landscape painting. The finest collection of his pictures is in London's National Gallery.

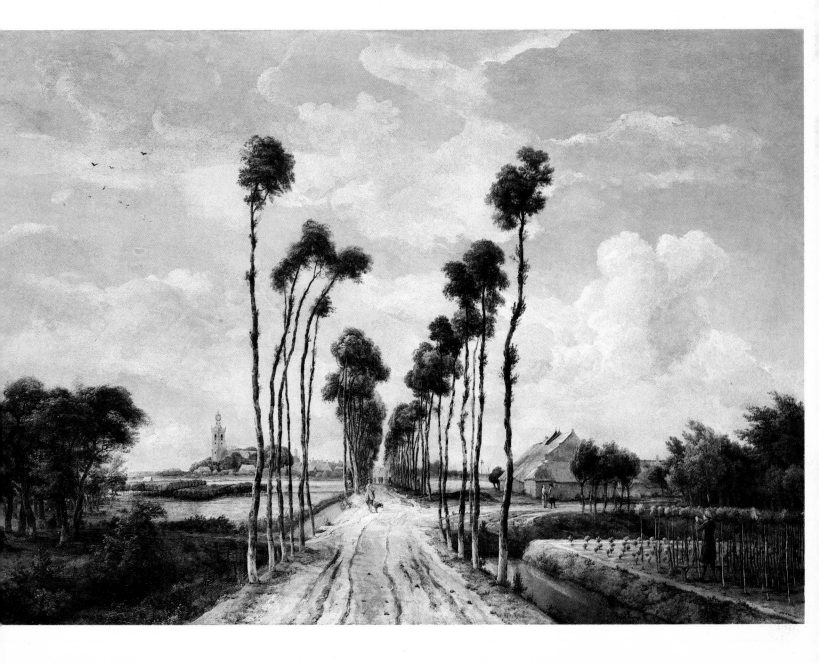

BELOW

Jean-Antoine Watteau (1684–1721)

The Embarkation for Cythera (1717)

The Louvre, Paris

Watteau was born in Valenciennes, a town near the Flemish border which had recently become French. From a very early age he was passionate in his love of drawing and studied art in his native town. In about 1702 he moved to Paris, where he earned a meagre living as a hack painter, and a few years later went to work for Claude Audran, the curator of the Luxembourg Palace; through him and subsequent connoisseurs and collectors he had access to some of the work of Rubens, for whom he developed an enormous admiration, although his own style was always more introverted and poignant than that of the energetic Rubens.

Watteau's paintings have all the delicacy and prettiness of the Rococo movement of the early eighteenth century, which followed the age of Baroque. It began in France after the death of Louis XIV in 1715, and spread to Southern Germany and Austria in the next forty years.

He disliked working for patrons on commission, and most of his pictures seem to have been created at his own whim, and paid for by clients in advance or bought by art dealers. Even the subject of this painting, *The Embarkation for Cythera*, which he was asked to create for his formal admission to the French Royal Academy, was left to his discretion, instead of being stipulated as was generally the case. As a result, Watteau was able to add a new classification to French art: the *fête galante*, pictures which, like Giorgione's, take a mood as their subject. It was a romantic mood in which the pleasures of the senses and the fulfilment of the emotions were pursued with a gentle ardour in idealized country settings.

It is thought that *The Embarkation for Cythera* was inspired by a play in which two lovers make a pilgrimage to the island of Cythera off the coast of Southern Greece, the island which Venus may have reached at the moment of her birth from the sea. In Watteau's painting the statue of Venus is garlanded with flowers, and the shell motif on the golden barge is another reminder of her birth. Little winged *putti*, symbols of love, drift over the sea. Peasants, villagers and courtiers are wending their way down to the water's edge to board the barge, and others on the bank are rising to join them. In the centre a woman looks back with a tender smile, and her elegant, amorous cavalier, his arm about her waist, gently urges her to join the procession.

The hazy landscape is idyllic in the evening sun, and filled with an atmosphere of love and flirtation. We cannot be sure if the couples are embarking on the journey to Cythera, or if the mood is one of sweet regret that the day on the island of love is over and they must return; but this exquisite painting has an atmosphere of wistful melancholy, implying the transitory nature of happiness and life itself. It reflects the restlessness of Watteau's temperament and his strivings after perfection; and it is one of the most haunting and delicate examples of French eighteenth-century art.

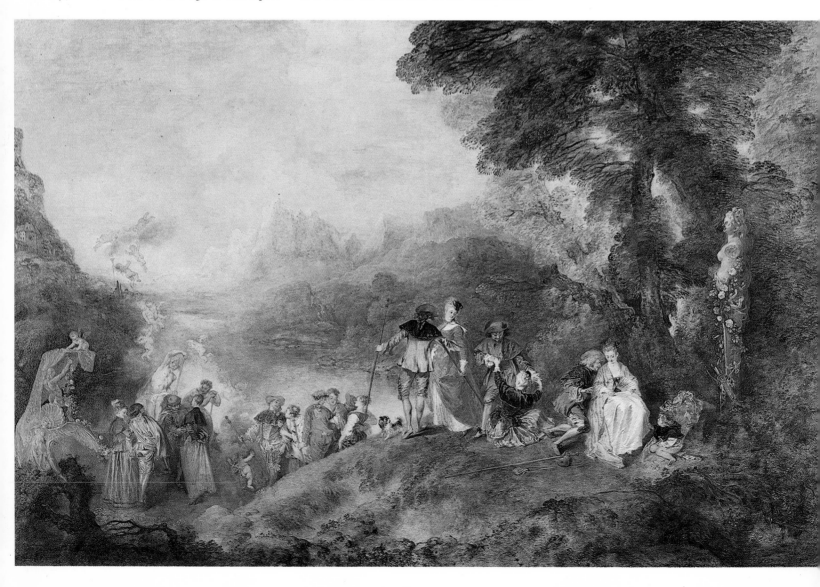

RIGHT

**Giovanni Battista
Tiepolo** (1696–1770)

Detail from Kaisersaal, Episcopal Palace, Wurzburg (1751–4)

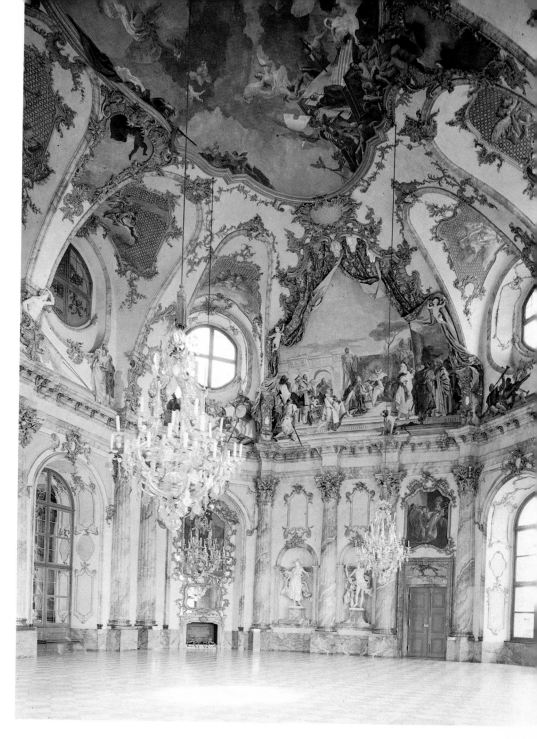

Tiepolo was probably the greatest genius of eighteenth-century Venetian painting. He studied art in Venice, a city with an immense artistic inheritance, and earned his fame as a painter of vast frescoes in the highly decorative Rococo style of which he was the finest Italian exponent. Rococo took the art of decoration to its furthest point in the architecture and paintings of southern Germany and Austria in the mid-eighteenth century. Churches, palaces and villas were being filled with gilded scrollwork and a riot of pastel-coloured ornament, and Tiepolo's frescoes were in constant demand.

In 1750 he was invited to Germany to produce frescoes for the Residenz of the ruling prince-bishop at Wurzburg. This huge episcopal palace had taken six reigns to complete, and its architecture is the height of German Rococo. Tiepolo was commissioned to decorate the superb ceremonial staircase and the Imperial Salon, known as the Kaisersaal, a vast octagonal room two stories high. In the course of his career, Tiepolo's colours had become increasingly light and airy, and his use of perspective and space more adventurous and dramatic, and these two enormous central areas of the palace are among his most delightful and accomplished flights of fancy. He created an unreal theatrical world, full of gaiety and enchantment, with great imagination and style. His subjects were mainly allegorical,

and often expressed enormous concepts. Crowning the huge staircase is a female figure representing the continent of Europe, surrounded by representatives of Church and State, to whom the Arts are paying homage.

In the Kaisersaal, illustrated here, the subjects are largely based on episodes from the history of Germany, and of Wurzburg in particular. They include scenes from the life of the twelfth-century Emperor Frederick Barbarossa; the conferment of the dukedom of Franconia on the Bishop of Wurzburg by Barbarossa in 1168; Apollo conducting Beatrice of Burgundy to Barbarossa; and the marriage of Barbarossa and Beatrice. The figures cluster in corners and float

through the air on clouds of gorgeous draperies. Some, high on the walls, are brilliantly foreshortened in scenes painted in such steep perspective that the immense space is exaggerated, and the effect quite dizzying from below.

Tiepolo completed the massive task in three years, with the help of his two sons and a number of assistants. These magnificent decorations are a reminder that most art of the past was produced for a specific purpose, and intended to be seen in a particular context. They are the perfect complement to the architecture of one of the most splendid palaces in Europe, and probably the greatest achievement even of Tiepolo's impressive career.

Antonio Canaletto (1697–1768)

The Harbour of San Marco with the Customs House from La Giudecca (*c. 1726*)

National Museum of Wales, Cardiff

In his youth the Venetian artist Canaletto worked in Venice and Rome with his father as a theatrical scene-painter. He became known as a *vedutista*, a painter of views, mainly of the canals and magnificent architecture of his home town. He was a master of perspective and composition, and had an amazing talent for depicting city scenes with life and accuracy. The beauty and the art of Venice were attracting more and more visitors, particularly from Britain, and it was rapidly becoming a centre of the European art market. The wealthy upper classes, travelling before the invention of the modern camera or the picture postcard, delightedly snapped up Canaletto's paintings to remind them of the unique and beautiful city, and he found that he could sell his work as fast as he could produce it.

His early paintings in particular have a spontaneous freedom, while his later work is smoother, brighter and more detailed. As an aid to accuracy he sometimes used the *camera obscura*, a sixteenth-century invention which reflected a view seen through its lens on to paper by means of a series of mirrors.

Canaletto explored every corner of Venice, and no other painter succeeded so superbly in portraying its ceremonies and the scenes of its daily life.

This typical scene shows the harbour of San Marco from the island of La Giudecca. On the left, on a promontory jutting into the water, is the Customs House; on the far side of the canal, in the centre of the view, is the bell tower in the Piazza San Marco, with the cathedral domes just visible to the right of it; and in front of the cathedral, on the water's edge,

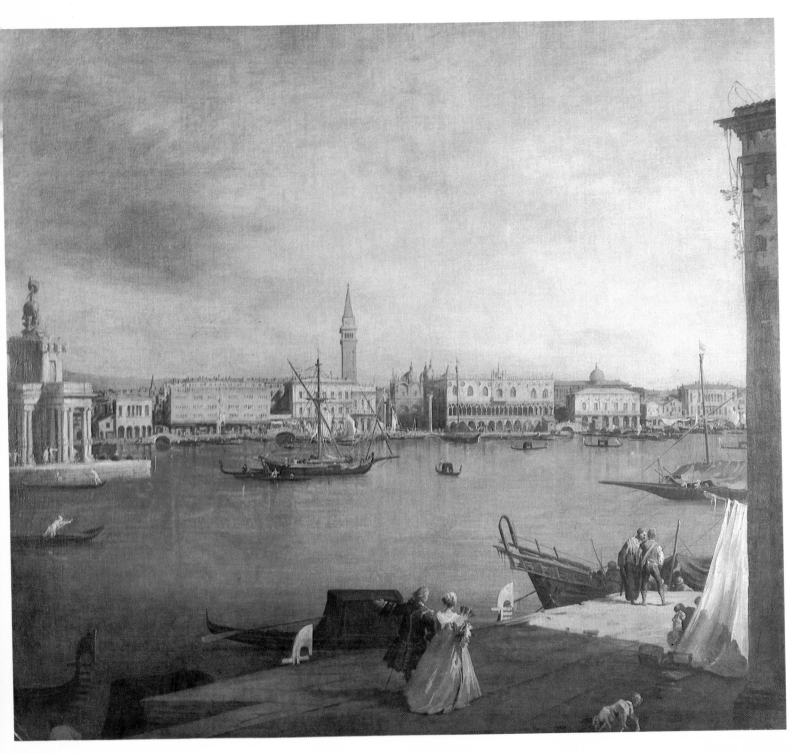

is the magnificent Doges' Palace, with its two tiers of arcades. Assorted boats are scattered over the wide stretch of water, mostly elegant sailing ships bringing merchandise to the city, and gondolas ferrying its inhabitants from one place to another. On the quay in the foreground fishing nets have been hung out to dry; and a fashionable lady with a fan strolls along on the arm of her escort.

Only the corner of the tall building in the foreground is visible, but its height and shadow exaggerate the space and light in the long view across the water. The scene is observed in minute detail, yet Canaletto has caught its freshness and life. The people, the rich textures of old buildings, with their subtle and endless variations of colour, the long shadows and the warm Venetian light, are depicted with exceptional realism.

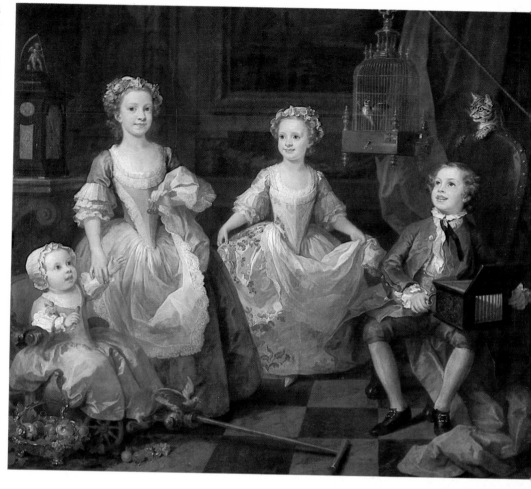

RIGHT

William Hogarth (1697–1764)

The Graham Children (1742)

The Tate Gallery, London

The arts of both painting and print-making were equally important features in the long and active career of William Hogarth. He was apprenticed to a gold and silver engraver, and studied painting with the decorative artist Sir James Thornhill, whose daughter he married.

He is often called the father of British painting; certainly he was the first native-born artist to produce work that was innovative. His paintings and engravings satirizing contemporary morality were an entirely new venture in art, and they became immensely popular. Prints were widely circulated, and so many of them were copied without his consent that Hogarth promoted the Copyright Act of 1735 to protect both painters and engravers from piracy.

Portraits, informal groups and occasional decorative schemes were his other chief subjects. He thought of himself as a dramatist in paint: 'My picture is my stage, and men and women my players'. *The Graham Children* has a highly theatrical quality: the children look as if they are about to take part in a play, and even the cat, the birdcage, the furniture, the bowl of fruit and the go-cart adorned with a dove, seem to be part of a stage set.

On the right is Richard Robert, who succeeded his father as apothecary to the Chelsea Hospital. He is playing a bird-organ to the caged goldfinch above his head. Henrietta, next to him, is dancing to the music, and their elder sister is tantalizing the baby, Anna Maria, with a small bunch of cherries. A tabby cat behind the boy's chair has its eyes fixed firmly on the bird with a look of determination and menace.

The domestic interior is richly furnished with a lacquered side-table, a large painting on the wall, and a fine clock surmounted by the golden figure of Cupid holding a scythe, the symbol of time. The floor is made up of squares of marble and the receding perspective gives depth to the composition.

The details of the girls' delicate dresses, the flowers in their lace caps, and their sparkling eyes give the painting enormous life. It is full of movement and one feels that at any moment the cat might spring towards the bird or the baby reach the cherries. Reality and the symbols of music and time suggesting the flow of life have been brought together.

This richly painted group portrait is a superb example of Hogarth's ability to extract the social implications of his subjects. He was a perceptive commentator on the manners and customs of his time, and *The Graham Children* provides a revealing picture of the security and comfort of their middle-class eighteenth-century lives.

Jean-Baptiste-Simeon Chardin (1699–1779)

The Kitchen Maid (1738)

National Gallery of Art, Washington DC

Chardin, the son of a cabinet maker, lived and worked in and around Paris all his life. His father regarded painting as a craft, similar to his own, with the result that Chardin never received the full academic training required by a wide-ranging professional painter. This, combined with a lack of money, led him to opt principally for still life subjects, for which there was a ready market.

His success in his lifetime was not spectacular but steady and assured: his work was bought by distinguished international connoisseurs, he became a member of the French Royal Academy, and Louis XV not only bought some of his paintings but gave him a pension and an apartment at the Royal Palace of the Louvre.

Chardin's pictures are thoughtful and quiet. His domestic scenes and animals, still lifes with stone jars, glass bottles, flowers, eggs and cooking pots are all painted with such feeling for texture that one could reach out and touch them.

The Kitchen Maid shows a young woman pausing for a moment in her work. In one hand she holds a kitchen knife, in the other a turnip she is peeling. She is dressed in simple earthy colours – cream, terracotta, indigo and brown – underlining the quiet, peaceful mood of the painting. On the floor are more vegetables; and pots, pans, a huge chopping-block with blood stains and a blue glazed earthenware bowl containing the already peeled vegetables surround her.

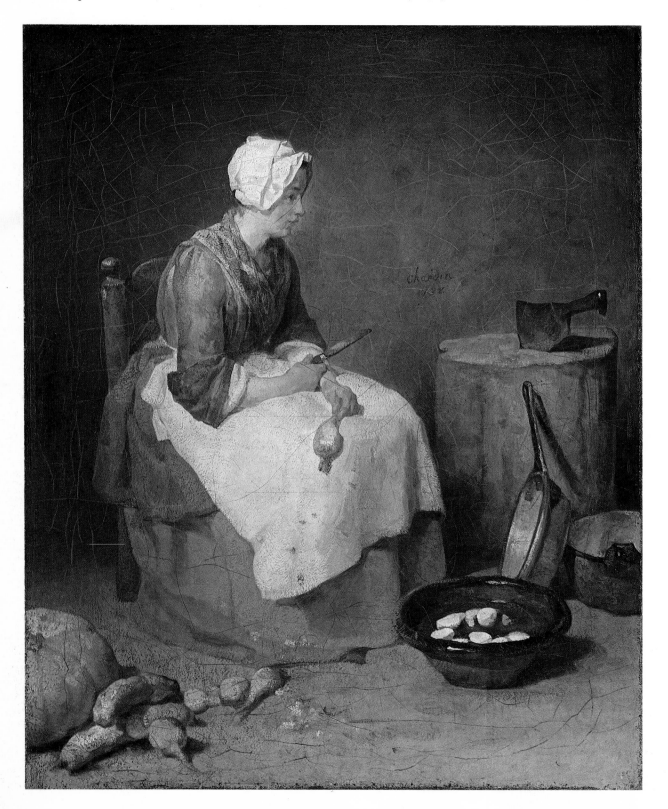

Every object is painted in the finest brushwork and gently pointed with delicate, gleaming touches of reflected light. The plump shapes of the vegetables are echoed by the rounded kitchen utensils and the chopping block. The human figure and the domestic objects blend together to suggest a life of simple activity in a style of painting of which Chardin was a master.

François Boucher (1703–70)

Reclining Girl (*1752*)

The Alte Pinakothek, Munich

Boucher, the son of a Parisian painter and lace designer, was taught by the French artist Lemoyne, and worked as a draughtsman and engraver. He also studied for several years in Italy, and on his return to Paris embarked on a triumphantly successful career. He became, with Watteau, the greatest Rococo painter in France.

The protégé, and also teacher, of Madame de Pompadour, the most famous mistress of Louis XV, he became the king's official court painter in 1765. He was immensely versatile and designed interiors, tapestries, theatrical, operatic and dance productions, fans, porcelain and even slippers. Boucher was a highly decorative artist, and he admired above all the work of the great Italian Rococo painter Tiepolo.

One critic, disgusted with frivolity and artificiality, declared that Boucher had everything – except truth. But his work was intended to please, not to instruct.

'Nature', said Boucher, 'was too green and badly lit'; he painted things as he wished them to be, charming and uncomplicated.

Reclining Girl is probably a portrait of one of the king's many mistresses, Louise O'Murphy. She is small and rounded, stretched out naked on her stomach like a baby after a bath; but her childishness is belied by the glimpse of a rounded breast, and her pose is anything but innocent: it emphasizes her voluptuous curves and provocative sensuality. Her delicately flushed skin, reflecting the pink silk draperies, and the velvet-covered couch, the incense burner to sweeten the air, the cushions and curtains, all contribute to the atmosphere of luxury and seduction.

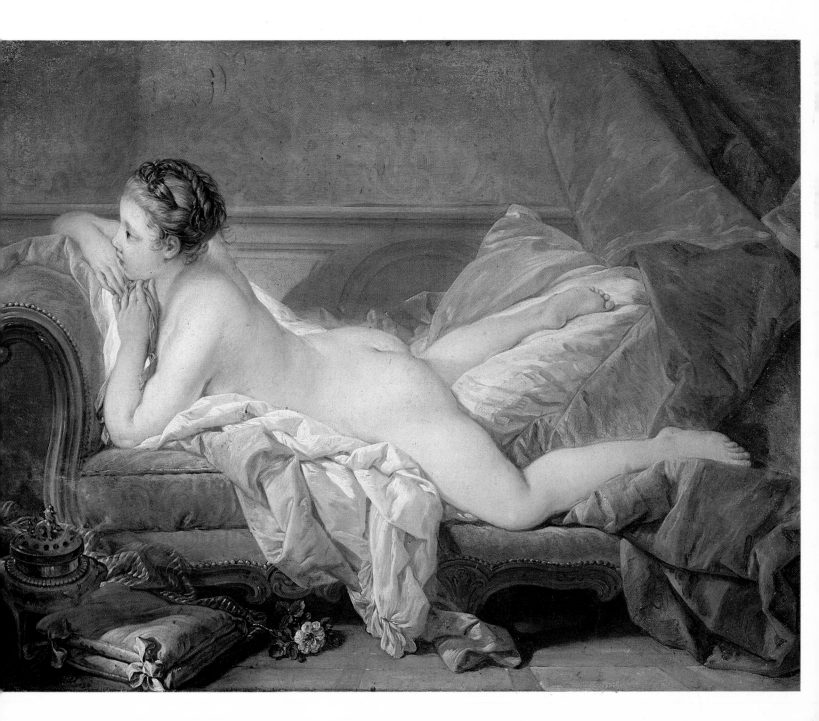

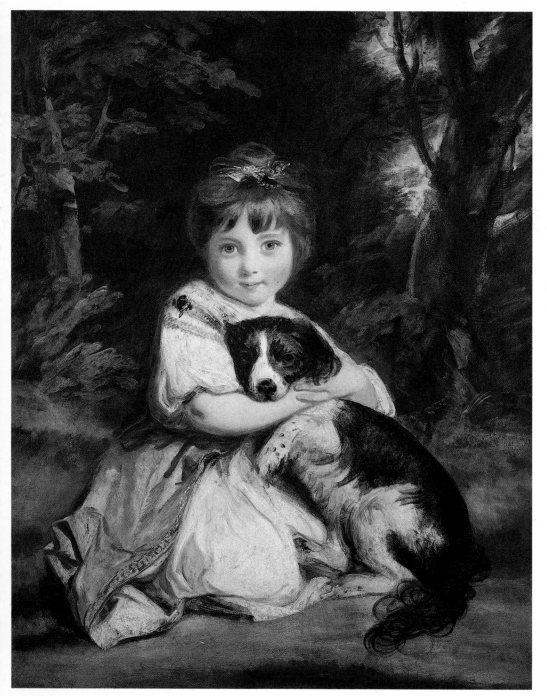

George Stubbs (1724–1806)

The Milbanke and Melbourne Families (c. 1770)

The National Gallery, London

This small, smooth and exquisitely finished painting captures all the apparent ease and assurance of grand English country life. Stubbs, painter to the sporting aristocracy, made an intense study of animal anatomy, which is now one of the most famous chapters in the history of British art; and he devised spacious landscapes which acted as superb backdrops to the animals and people who were his principal subjects.

Sir Joshua Reynolds (1723–92)

Miss Bowles and her Dog (1775)

The Wallace Collection, London

Sir Joshua Reynolds, born in Devonshire, is perhaps the most significant figure in British painting. He came from a cultured family at a time when most English painters were impoverished and ill-educated, and, through his association with the literary and intellectual figures of the time, brought about a radical change in the status of the artist in Britain.

He was a writer and lecturer on art as well as a highly accomplished portrait painter, and first President of the Royal Academy, where his statue may be seen in the courtyard to this day. He became Painter-in-Ordinary to George III, and ten peers of the realm were his pall-bearers when he was buried in St Paul's Cathedral.

His success was achieved by tremendously hard work, and he made the very most of his skill. He ran an extremely active studio, where he employed other artists for the specialist work of painting backgrounds and draperies.

He was as gifted in portraying the likeness of a child as an adult, and this portrait of Miss Bowles with her dog is an irresistibly appealing composition. Miss Bowles's parents had ensured that she and Sir Joshua should meet the day before, and the painter had so amused the little girl that when she came to sit for him she was relaxed and ready to enjoy herself. Her cheeks are pink with pleasure and excitement, and, as children do, she is squeezing the dog on her lap so hard that it lifts its paw in mild protest.

The artist would have worked directly on to the canvas, without preparatory drawings; and the confidence of his style can be seen particularly clearly in the flourishing swirl of the dog's tail. The warmth and vitality of Reynold's work, and the informality of his compositions, made him the most popular portrait painter of his day.

men and a young woman, two
three horses are casually ar-
with brilliant artifice, under an
ading oak tree, with a hazy lake
in the distance, and, on the right,
ve outcrop of rock. The middle-
n leaning on his daughter's pony
ir Ralph Milbanke, landowner
of an old Yorkshire family. (One
alph's grand-daughters married
Byron, with whom his grand-
-in-law, Lady Caroline Lamb,
was to have an affair.) On the right, on a
chestnut horse, is Peniston Lamb, Lord
Melbourne, by all accounts a weak and
self-indulgent man, and Stubbs's likeness
confirms that description. His wife, the
former Miss Elizabeth Milbanke, only
twenty years old at the most, is poised and
dignified. She was said to be a beauty and

a wit, highly intelligent, ambitious, sen-
sual and altogether formidable. John
Milbanke, Elizabeth's brother, is the
rather foppish young man with an elegant
dapple-grey horse, standing between his
father and brother-in-law. Although the
landscape is invented, a sort of general-
ized all-purpose slice of English country-
side, it suggests a certain kind of country
life.

Stubbs brought to horses, dogs and
people a kind of passionate accuracy. The
characters of the different animals – the
carriage horse, the nervy high-flying
chestnut – are as well observed as the
people, whom Stubbs did not flatter
although they were his patrons. He clearly
shows the large noses of the two young
men and the papery look of Sir Ralph
Milbanke's skin, typical of the middle

aged and elderly, and the family re-
semblance between father and son.

A clump of pink hollyhocks on the
right, framed by the legs of Lord
Melbourne's chestnut horse, picks up the
pink in the clouds and the delicate shade
of Lady Melbourne's fine dress. These
light colours, and the coats of the horses
and spaniel, balance the shadows and the
deep greens of the overhanging tree.

The three horses are sharply silhouet-
ted in an elegant frieze, arranged in such a
way as to provide continual interest across
the picture; none of them blocks the
spectator's view of another, yet the skill
this requires is unobtrusive. The energy
and flow of line across the entire canvas
give life to what is essentially a formal
group portrait, and that Stubbs was able
to achieve this is part of his genius.

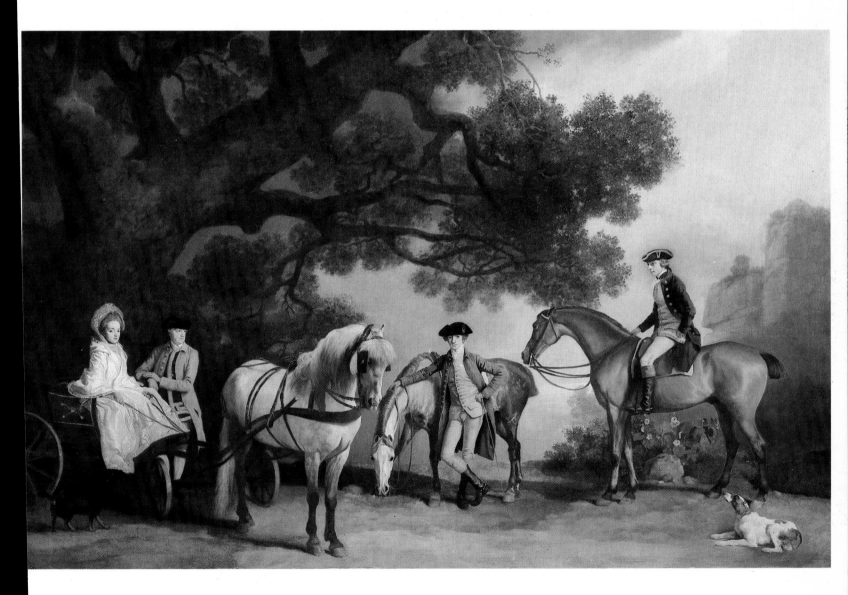

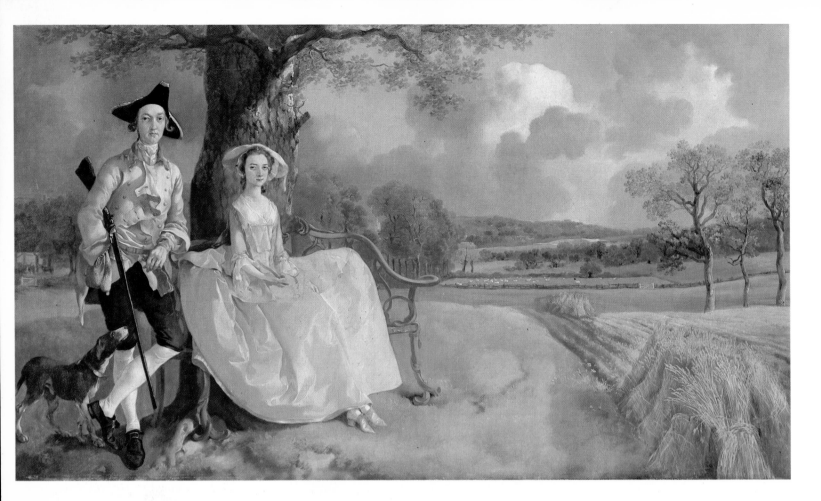

Thomas Gainsborough (1727–88)

Mr and Mrs Robert Andrews (*c. 1748–9*)

The National Gallery, London

Thomas Gainsborough may well have been even younger than his subject, Robert Andrews, when he painted this double portrait of the young squire and his wife near his own birthplace in Suffolk. It is a young man's painting, not completely resolved in all respects, but *Mr and Mrs Robert Andrews* combines simplicity, psychological insight and genuine feeling for landscape in full measure. In some respects it is thus more satisfying than the romantic, fullblown, and sometimes contrived portraits of Gainsborough's maturity, when he, with Reynolds, was one of the most fashionable and successful portrait painters of his day.

The young couple are newly married, and the girl, who is only about sixteen, wears a grand blue satin dress – possibly part of her trousseau. Her husband, aged about twenty-three, rests his elbow on the elaborate iron scrollwork of the bench on which his wife is sitting, his hand in his pocket, and his flintlock gun held casually but correctly in the crook of his arm. Its

long barrel points downwards, echoing the trunk of the massive oak tree behind. A hunting dog eagerly looks up at him, and completes the accessories of the country squire.

The spreading view shows to perfection the fertile farming country of East Anglia, with sheep in the middle distance, sheds for the cattle, and fields well fenced and hedged. The corn in the fields is not fully gathered, and the stooks may well be used here as a symbol of fertility. The sky is overcast, but a weak sun flickers through the rather stylized clouds.

The composition of the painting rests on two separate areas, each given equal weight: one is the exquisitely detailed landscape, which in the far distance has a freedom and ease in the brushwork, and in the foreground portrays each blade of grass with delicate clarity; the other is the young couple themselves. They are in sharp focus, and their characters are well defined in their appearance. He is a little arrogant and complacent perhaps, but a man with responsibilities, who cares for his land and possessions; she is prim, unsure of herself and rather self-conscious. Their elegant clothes, and the peaceful country scene surrounding them, provide a realistic picture of their stable, prosperous lives.

Gainsborough regarded himself as a

landscape painter above all, and was much influenced by the work of the seventeenth-century Dutch masters, particularly Hobbema; but his combination of exceptionally fine landscapes with skilled portraiture make clear the reasons for his fame and enormous success in his own lifetime.

Jean-Honoré Fragonard (1732–1806)

The Swing (*1768–9*)

The Wallace Collection, London

At the age of fifteen Fragonard was clerk to a lawyer in Paris, but he showed more talent for art, and in 1752 he went to the French masters of the day, Chardin and Boucher, to train as a painter, followed by five years at the French Academy in Rome. He worked with all the accepted subjects of the time: history, portraits, and scenes set in landscape.

He more or less abandoned a public,

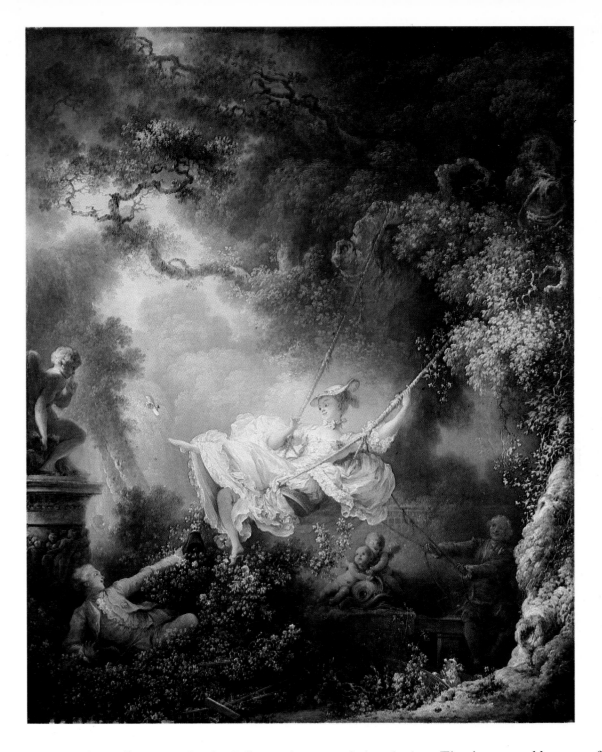

official career to work for private clients as decorator and artist. Love, courtly and otherwise, love as a grand game, became his speciality. He decorated rooms for several of Louis xv's mistresses, among them Madame de Pompadour and Madame du Barry. In spite of his associations with the court, Fragonard managed to survive the French Revolution and worked as curator at the Louvre; but he finally fell from official favour under Napoleon, and he died poor.

The Swing is an enchantment, and it sums up the reasons why Fragonard's art has always pleased. It shows a charming, exquisitely dressed young woman, the mistress of the reclining man who is gazing at her and up her skirts with such languid, affected ardour. He is the Baron de St Julien, who commissioned the picture; and he and the lady are portrayed in the garden of the house where she lives. The intention of his look is obvious, recollecting past love and dwelling with delight on the thought of love to come. In control of the swing is an older man, possibly the lady's acquiescent husband.

The painting centres on the trim and joyful young woman, her legs in their white stockings kicking out from a froth of petticoats; one of her tiny shoes flies through the air as though she were sending a favour to her lover. The lighting cleverly conveys the impression that we are not looking in at a real garden, but at a theatrical scene, in which the lovers are playing parts, both for their own enjoyment and for ours.

The elegant marble statue of Cupid on the left, the fine clothes of the actors themselves in this romantic, amorous moment, and the filtered sunlight, all contribute to a sense of luxury in a natural setting, manicured so finely that not a leaf is out of place. The Baron, reclining in a shrub it seems, would perhaps in real life have felt a little uncomfortable; but here all is ease and joy in a setting of formal frivolity. The painting sums up a mood not of ideal love but of ideal flirtation.

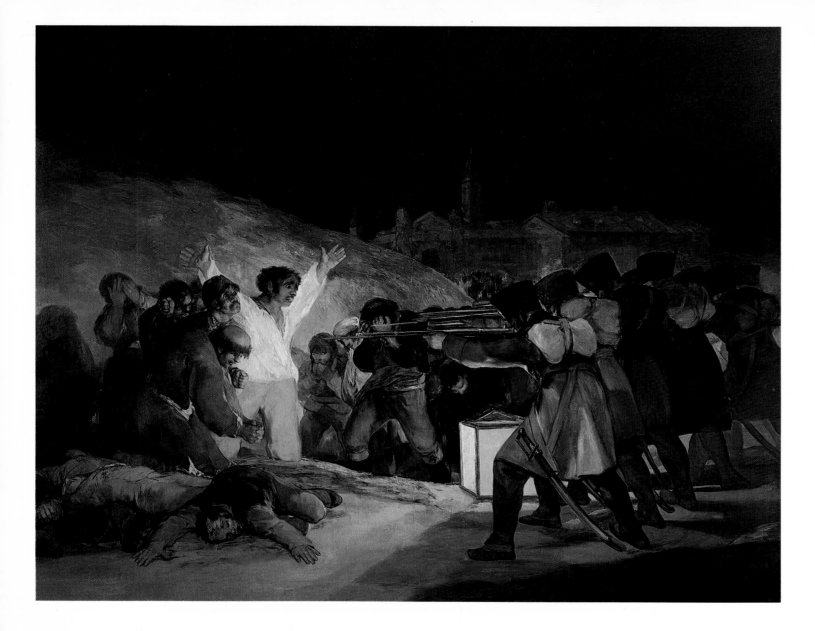

Francisco Goya (1746–1828)

The Third of May, 1808 (1814–15)

The Prado, Madrid

The artistic career of the Spanish artist Goya was long and successful. He was principal painter to King Charles IV of Spain and director of the Spanish Royal Academy, and prodigiously gifted as a draughtsman, print-maker and painter. He was born in Saragossa, had a conventional apprenticeship in art, and became known principally as a painter of portraits and of the horrors of war.

His portraits are often devastatingly candid, and so caustic in their portrayal of the corruption and arrogance of the Spanish monarchy that it is surprising his commissions continued. He criticized violently the cruelty, hypocrisy and stupidity that surrounded him; and in a series of prints called *The Disasters of War* he revealed the savage brutality of Napoleon's forces when they took over Spain in 1808. But he had another side which came to the fore in his sensual and subtle portraits of women, indicating the immense scope of his talent. He became the greatest Spanish painter between Velázquez and Picasso, and one of the greatest artists in Europe.

The Third of May is one of a pair of paintings which together depict two days in the shortlived uprising of the people of Madrid against the French troops in the Napoleonic Wars. The paintings were commissioned a few years after the event, with the command to the artist to 'perpetuate with his brush the most notable and heroic actions or events of our glorious insurrection against the tyrant of Europe'; and Goya has produced two of the most electrifying and dramatic works in European art.

This painting depicts the second day, when Spanish civilians were executed by the invading army in the aftermath of the fighting. The group of Spaniards cowering in panic in front of a French firing squad are depicted with horrifying realism: the dead body slumped on the ground, the pool of blood and the expressions of the victims are all shown with a shocking intensity. They are portrayed not as heroes of war, but as ordinary frightened men, pleading for their lives and showing disbelief, terror and even a sort of crazed bravado in the face of death.

Our attention is focused on the central figure by means of various devices: Goya has painted him, and the figures surrounding him, considerably larger in proportion to their executioners than they would be in reality; the massacre is taking place at night by the harsh light of a lantern and the kneeling man's white shirt reflects its glare; the soldiers are shooting at point-blank range; and the man's pose, with arms outstretched, is extremely eye-catching and dramatic. These tactics of composition and lighting heighten the drama and fear, and reveal Goya at his most passionate.

Jacques-Louis David (1748–1825)

The Death of Marat (1793)

Les Musées Royaux des Beaux-Arts, Brussels

From early childhood, Jacques-Louis David wanted only to draw, and his skill as a draughtsman can be seen in all his work. He was part of an eighteenth-century movement known as Neo-classicism, which was a new return to the classical art of ancient Greece and Rome. He firmly believed the arts should educate the public and give expression to their ideals. Although he later supported Napoleon, he was in his early years a political activist. In 1789 the Paris mob stormed the Bastille, and much of David's work reflects the aims and ambitions of the French Revolution.

Jean-Paul Marat was a leader of the Revolution and a friend of David's. He suffered from a painful and irritating skin disease, which it is thought he contracted in the Paris sewers when he was in hiding from his political enemies. This required him frequently to immerse himself in a medicinal bath, and it was during one of these baths, on 13 July 1793, that Charlotte Corday, a revolutionary in a rival group, gained admittance to his presence and stabbed him to death.

It is with the utmost sympathy that David depicts the poverty and simplicity in which Marat lived and worked. Above the sad and gruesome scene, the background is dark and sombre, its deep shadows drawing our attention more closely to the main subject. The figure has a ghostly, compelling quality, and was intended to keep alive the memory of a great revolutionary martyr.

David has portrayed Marat's death with an uncanny fidelity. Blood has dried on the sheet and on the knife itself, which lies on the floor where it has fallen. The letter by which Charlotte Corday gained admittance is still resting – in a grip of death – in Marat's hand. On the simple wooden box, its shape reminiscent of a tombstone, are Marat's writing materials, and on its side the artist has added a dedication to him. The subtle colours, contrasting light and shade and meticulous detail combine in a work that has all the dramatic horror of the event itself, and is full of compassion for the victim.

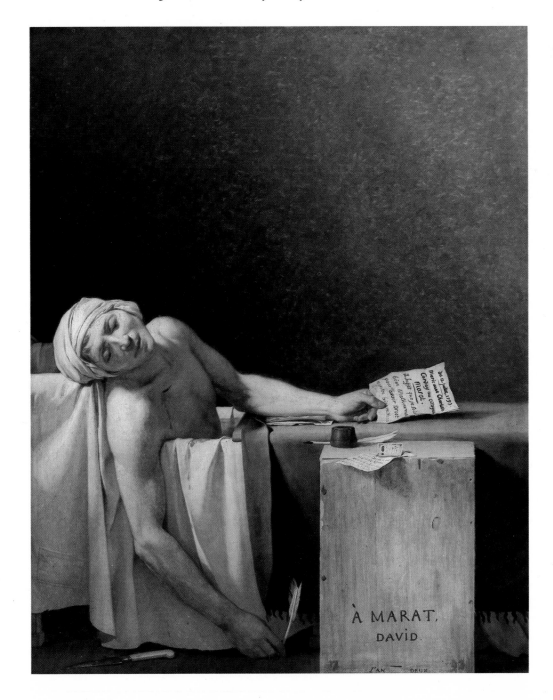

William Blake (1757–1827)

The Ancient of Days, or God Creating the Universe (1794)

Fitzwilliam Museum, Cambridge

William Blake, the English poet, artist and mystic, was first apprenticed to an engraver and went on to study at the Royal Academy Schools. He reacted strongly against conformity and conventional realism in art, and was profoundly influenced by Michelangelo, as can be seen in his muscular figures and in the enormously dramatic concepts behind much of his work. The scenes he depicted were of his own invention, often illustrating his own poems, or linked to imaginative interpretations of Dante, Milton and the Bible.

Deeply if unconventionally religious, he was subject to visions; and his figures, although evidently muscular, are strangely insubstantial and unearthly, often surrounded by a supernatural light. Blake invented a highly personal and mysterious mythology, verbal and visual, to express his view of the world.

The Ancient of Days, or God Creating the Universe, is one of his best-known images. It may have come to him complete in a vision; and it was an image to which he frequently returned. It formed the frontispiece to one of his prophetic books, *Europe,* from which this print is taken, and Blake was engaged in hand-colouring a copy of it on his deathbed. Urizen, the Creator, kneels in the orb of the sun, and reaches out into the void with a pair of golden compasses, with which to measure and plan the universe and its creatures. His long hair, and even longer beard, stream in the wind to his right, and rays of brilliant light burst through the clouds surrounding him. His powerful body is composed of finely balanced horizontal and vertical lines, framed by the disc of the sun, and linked to the diagonal lines of the compass. The left arm of the compass corresponds to a line taken through the kneeling figure from right knee to left and contributes to the wonderfully satisying harmony of the composition.

It is a work of tremendous elemental strength and energy, revealing something of the force that inspired Blake's visionary mind.

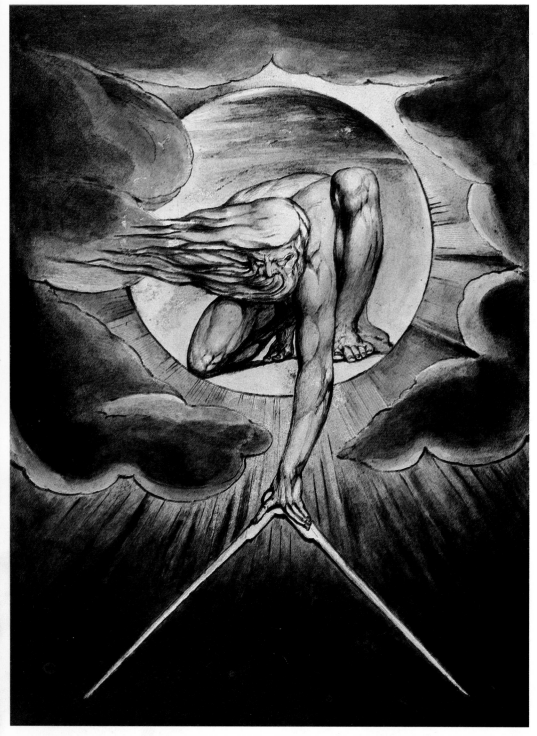

Caspar David Friedrich (1774–1840)

The Stages of Life (1835)

Museum der Bildenden Kunste, Leipzig

Romanticism was a movement in painting, poetry and music in which the imagination was given free rein to conjure up moods and emotions from beautiful dramatic landscapes. It reached its height in Germany, France and Britain in the early part of the nineteenth century. The German painter Caspar David Friedrich was one of the greatest of all the Romantics. Born in Griefswald (then Swedish Pomerania), he studied at the Copenhagen Academy from 1794–8, and

settled in Dresden for the rest of his life.

He expressed with a brilliant clarity something of the mystery of nature through his magically beautiful landscapes. They combine a number of landscape features, painted with meticulous care and accuracy, in a largely imaginary composition designed to reveal something of the meaning and spirit of life, rather than to represent an actual scene. As Friedrich himself put it, 'The artist should not only paint what he sees before him, but also what he sees within him.' In his own time he was called a 'genius of gloom', but his contemplative paintings are calm and hopeful, and they frequently have a religious significance, if not a religious subject.

He often chose the glow of dawn, sunset or twilight for his paintings, and in *The Stages of Life* the scene is set against a golden evening sky, streaked near the horizon with violet clouds. The graceful silhouettes of five sailing ships are outlined in the clear light as they drift in to shore on a calm sea. At the edge of the water are five people. A strange figure with his back to us, representing the artist himself, walks towards the others; he looks old and feeble and leans on his stick for support. An unknown man beckons him on, and with his other hand points to Friedrich's children on the bank, who are playing with a small Swedish flag. Their mother sitting next to them also points towards their two central figures.

There is an implication of an imminent voyage, although no sign of well-wishers on the shore. A boat approaching to carry someone out to sea is an ancient symbol of death, and the five ships corresponding to the five figures suggest the journey will be to another world. Eventually a ship will come to collect each one of them, but it seems the artist's journey is about to take place. He has passed through the stages of life.

The strange clear colours are striking and highly individual, and the elusiveness of the subject and atmosphere makes it an intriguing and mysterious painting.

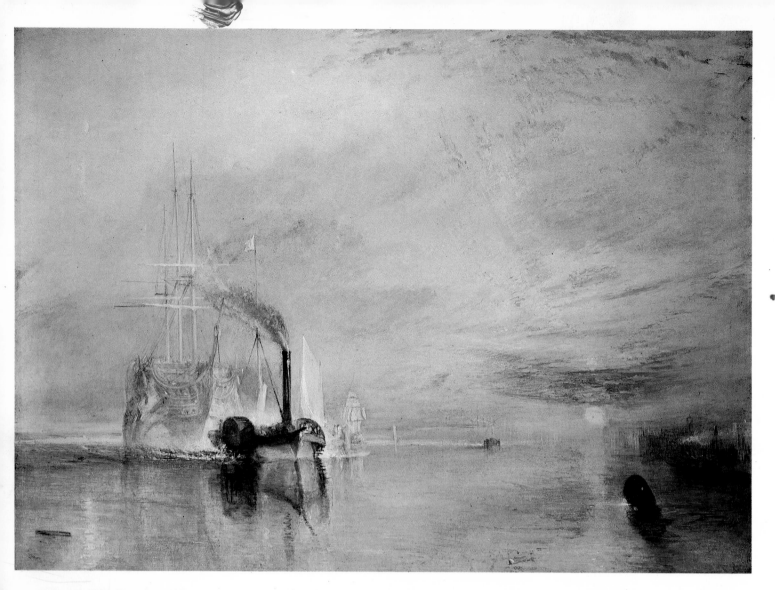

Joseph Mallord William Turner (1775–1851)

The Fighting Temeraire (1838)

The National Gallery, London

Turner was one of the two outstanding geniuses of British painting (the other was Constable). His characteristics even fit the dictionary definition of genius: unusual capacity for imaginative creation, intellectual power, unusual energy and precocity.

He was born and brought up in Covent Garden, London, where his father was a barber and wig-maker. It was in London that he received his early training and employment, and he spent most of his life there, yet he was to develop into the most original landscape painter of the nineteenth century. By the age of fourteen he had enrolled at the Royal Academy Schools, and a few years later he was employed as a copyist, with a handful of other young artists, by a famous connoisseur and collector Dr Munro. Turner

explored Britain with great zeal, and he went abroad to Venice, Switzerland, and notably to Paris where he saw the Old Masters looted by Napoleon from all over Europe.

He was short, stout, an eccentric, and latterly a recluse. He was also ambitious and outstandingly productive: sketchbooks, thousands of drawings and watercolours (nearly 20,000 in the British Museum alone) and over five hundred oil paintings survive. Almost his entire artistic life was devoted to landscape painting in all its guises; formal and informal, seascapes, city scenes, historical and architectural scenes of dazzling accuracy and fidelity to the real world. In his book *Liber Studiorum*, landscape is categorized as Historical, Mountainous, Marine and Architectural, not to mention Epic, Elegant and Elevated Pastoral. When dealing with real landscape (rather than imaginary) he painted what he actually saw, and never added what he knew was there but could not see.

The *Temeraire* was a warship of ninety-eight guns, launched in 1798 and active at the Battle of Trafalgar; but by 1838 she was outmoded, her days of

employment over, and she was towed up the Thames to be broken up. Turner witnessed this event, and his painting captured the imagination of critics and public alike. It was generally thought that the picture connected the Temeraire's last journey to the waning of British sea power, symbolized by the dying sun.

The painting has an enormous variety of texture: Turner used not only conventional brushes and palette knife, but often his hands, paint rags and the ends of his brushes.

The tall ship without her sails is ghostly and mysterious, and she is shepherded up the river by a squat tug belching fiery steam from its funnel. The whole scene is bathed in the colours of the brilliant sunset reflected in the water, so that the stately warship and the tug seem to be part of the river and the sky.

Shining translucent colours were Turner's hallmark; he created extraordinarily beautiful effects with colour and light so that his subjects seem to melt almost magically into the atmosphere.

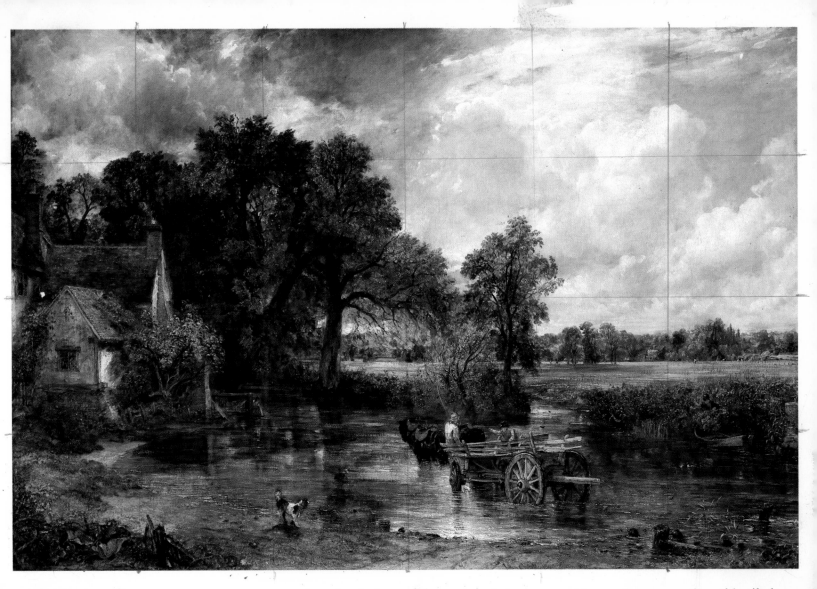

John Constable (1776–1837)

The Hay-Wain (1821)

The National Gallery, London

John Constable was born in Suffolk, the son of a mill-owner, farmer and merchant; and the scenes that surrounded him in his childhood are the ones he later made famous through his beautiful landscapes. He went to the Royal Academy Schools in his early twenties, but not until his forties did he achieve a measure of success. *The Hay-Wain* was shown at the Royal Academy in 1821, and in 1824 it was exhibited with two other Constable landscapes at the Paris Salon, where it was awarded a gold medal. The best-known paintings of the English landscape are those by John Constable, and of them all *The Hay-Wain* is the most famous.

Constable's life was divided between London and Suffolk, but it is East Anglia, and Suffolk in particular, which to him was the heart of England. He has caught its character so superbly that his paintings of winding streams and rivers, flat water-meadows, brick farm buildings, and fast-moving clouds in a vast expanse of sky seem to sum up the spirit of the English landscape. He wrote of his love for 'the sound of water escaping from mill dams ... willows, old rotten banks, slimy posts & brickwork ...', and he said he would always 'paint his own places best ... Painting is but another word for feeling.'

The Hay-Wain is one of a series of six large paintings (each about six feet across) in which he expresses his feelings for landscape superbly. He completed it in about five months, and would have made sketches of the subject on the spot before starting work in oils in his London studio.

The paint is applied in short and long, rough and smooth strokes, making a rich variety of texture. Constable has picked out the characteristic elements of the landscape: light glitters off moist leaves in shadowy places; water reflects the plants along its banks and the light in the sky; and it is the sort of cloudy day, with intermittent sunshine, which is typical of English weather.

It is rich farming country, and there are signs everywhere of activity: in the distance are cattle and farm-workers, in the foreground a low fence borders a vegetable garden near the old tiled cottage, and the centre of it all is the wide shallow river. A man can be seen in the bushes on its far bank, with a rowing boat moored close by, and a group of ducks in mid-stream. By the watergate outside the cottage a woman appears to be washing clothes or maybe collecting water in the large jug beside her. A farm dog trots along the near bank watching the two men as their horse-drawn wagon makes its way through the river. Little touches of red, often to be found in Constable landscapes, provide a focal point.

It is a very peaceful scene, but Constable's eye for detail has noted all the small features which might otherwise be overlooked. He draws attention to them with little pinpoints of light against the shadows, filling the composition with interest, and building up a picture which typifies nineteenth-century English rural life.

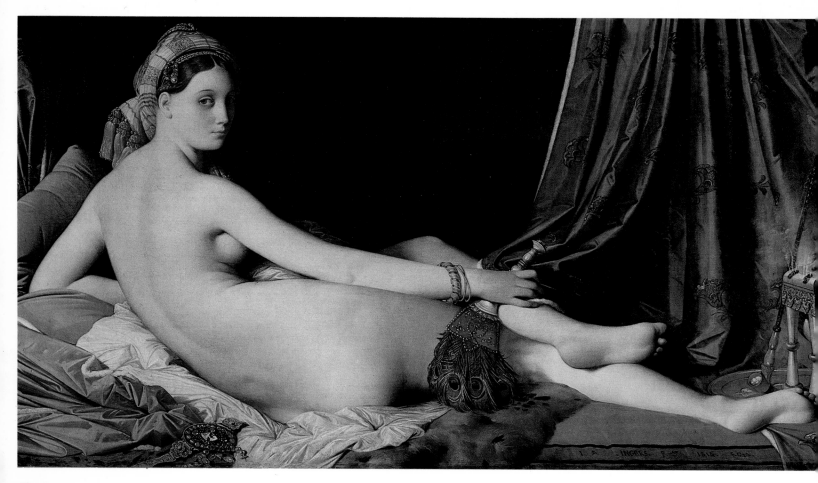

Jean-Auguste-Dominique Ingres (1780–1867)

La Grande Odalisque (1814)

The Louvre, Paris

Suffering only occasional setbacks, Ingres had a glittering career. He was born at Montauban in France. His father, a mediocre artist, first taught him to paint, but, recognizing his son's talent, sent him to the studio of David in Paris, and then to the School of Fine Arts. Ingres was passionate in his love of drawing, and the importance of line is paramount in his work.

Nearly twenty-five years of his life were spent in Italy, mostly in Rome, where for a period he was Director of the French Academy. He received many official honours in France, and no matter who ruled the country, Ingres remained in favour.

His most ambitious paintings, with classical or historical themes, are admired less today than his vivid and compelling portraits and nudes. He intensely admired the smooth perfectionism of Raphael, and this had an influence on him which can be seen in the immaculate finish of the *Grande Odalisque*.

An odalisque, a female slave or concubine of a Turkish harem, was a popular theme in the early nineteenth century. The lure of the Orient and an excuse to paint the female nude proved an appealing combination to many artists, especially in France, and the subject occurs often in the work of Ingres. Here the beautiful provocative woman wears only a headdress, similar to those worn by some of Raphael's Madonnas (see p. 37), and her pose recalls reclining nudes by Titian and Giorgione. Yet her exceedingly long back came in for a great deal of criticism when the painting was first displayed in Paris in 1819. The critics complained that she is anatomically inaccurate: she has three vertebrae too many and lacks muscles, life and substance. This may be partially true, but it gives her a wonderful smoothness and elegance of line, and a sensuality that is highly erotic.

The richness of the materials and textures – the soft fur beneath her legs, the shining satin curtain, and the peacock feather fan against her smooth skin – all enhance the feeling of sensuous luxury and seduction. The odalisque turns her head to the spectator with a confidently provocative gaze, subtly combining the head of a Madonna with the body and languid nakedness of a traditional Venus in a way that is tantalizing and somewhat shocking. At her feet is her hookah pipe, steam escaping from its ornate stand; it adds another element of the exotic East and heightens the atmosphere of sensual indulgence which Ingres has portrayed with such coolness and style.

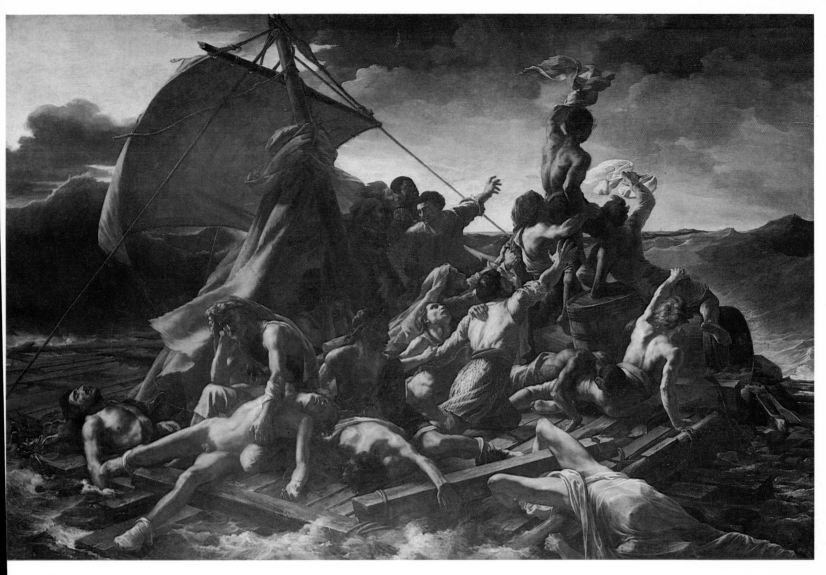

Théodore Géricault (1791–1824)

The Raft of the Medusa (1819)

The Louvre, Paris

Géricault was born in Rouen, the son of wealthy parents, and unlike the majority of artists he had a measure of financial independence all his life. He was fanatically interested in horses, both as a painter and as a reckless rider, and his tragic death at the age of thirty-two was hastened by the after-effects of riding accidents. But in about twelve years he produced enough work to leave a substantial legacy of paintings when he died.

He trained in the studios of two French painters, Carle Vernet and Guérin, but Rubens, Michelangelo, Caravaggio and the Venetian painters were perhaps the strongest influences on his work. He developed a superb flair for composition and a dramatic style that are clearly displayed in *The Raft of the Medusa*.

In 1816 a French military transport frigate, the *Medusa*, laden with settlers and soldiers for Senegal, had been wreck-

ed off the coast of West Africa. The incident caused a scandal at the time because of the captain's ineptitude, the lack of lifeboats, and the number of people drowned as a result. A hundred and fifty passengers and crew were crammed on to a makeshift raft, but two weeks later only fifteen of them were alive to tell the tale.

Géricault worked for over a year on the huge painting, some sixteen feet high and over eighteen feet wide, in a special studio hired for the purpose. He launched a raft into the sea to see how it would work; he interviewed survivors; and he visited hospitals and morgues to make studies of the ill, the dying and the dead.

He chose to illustrate the moment when some of the survivors first glimpsed their rescue ship, the *Argos*, on the horizon, but it vanished from sight, although later returned to pick them up. Some of the raft's passengers were seized with excitement and tried desperately to attract the ship's attention, but others, if they were not already dead, were sunk in desolation and too weak to move. The subdued colours are sombre and expressive of the horror of the whole event. The sharply contrasting light and shade on the figures is a clear

indication of the influence of Caravaggio, and their bodies are wonderfully taut and muscular, like those of Michelangelo.

The composition is based on the tension between two diagonals: the raft itself and the movement of the figures take the eye inwards from the left, while the ropes and the mast, with its billowing sail, strain back to hold the structural balance.

Géricault's ambition was 'to shine, to illuminate, to astonish the world', but *The Raft of the Medusa* was considered by some as an attack on a government which had allowed inefficiency to lead to tragedy, and it was given a lukewarm reception when it was first shown in Paris in 1819. Now, however, it is appreciated as an outstanding work of the French Romantic movement, brilliantly constructed and intensely powerful.

Ferdinand-Victor-Eugène Delacroix (1798–1863)

Liberty Leading the People (1830)

The Louvre, Paris

Delacroix's mother came of a family of noted designer-craftsmen, and his legal father, who died when Delacroix was a little boy, was an active revolutionary and Foreign Minister under the Directoire. Unprovable but tenacious rumour suggested that Talleyrand, the great politician and statesman, was Delacroix's real father. In any event a network of connections, allied with his talent, helped to secure official patronage for him throughout his life.

By 1816 he was studying painting under Guérin – the teacher of Géricault, whom he ardently admired. Delacroix visited London and became deeply interested in English landscape painting, especially the work of Constable, and in the epic poets of England and Germany. He copied the masters in the Louvre, notably Rubens and Veronese, and although a superb draughtsman, colour was his passion. He declared that 'when the tones are right, the lines draw themselves'.

He had an enormous range of subject matter, much of which was based on literary or historical incidents of the past, but although he lived through a time of political upheaval, *Liberty Leading the People* is his only major work which appears to comment directly on a topical event in France. He witnessed the fighting in the streets in the Revolution of 1830, which brought Louis-Philippe to the throne, and he wrote to his brother, 'I have undertaken a modern subject, a barricade, and if I have not conquered for my country, at least I will paint for her.'

The painting is grand, stirring and highly political; and when it was exhibited in 1831 the coarseness of the characters depicted aroused controversy and criticism. Bare-breasted Liberty, beautiful and resolute, is waving the people forward to the barricades. She carries a bayonet and the tricolour banner of France, and on her head is the Phrygian cap of Liberty. She is striding barefoot through a field littered with corpses, and behind her is an armed band of men and boys, determined and ruthless in their fight for freedom from oppression. They are armed with swords, muskets, pistols and even rocks as they march through the streets of Paris. In the distance are the towers of Notre Dame amid a low-lying haze of gunsmoke.

In Delacroix's crowded composition

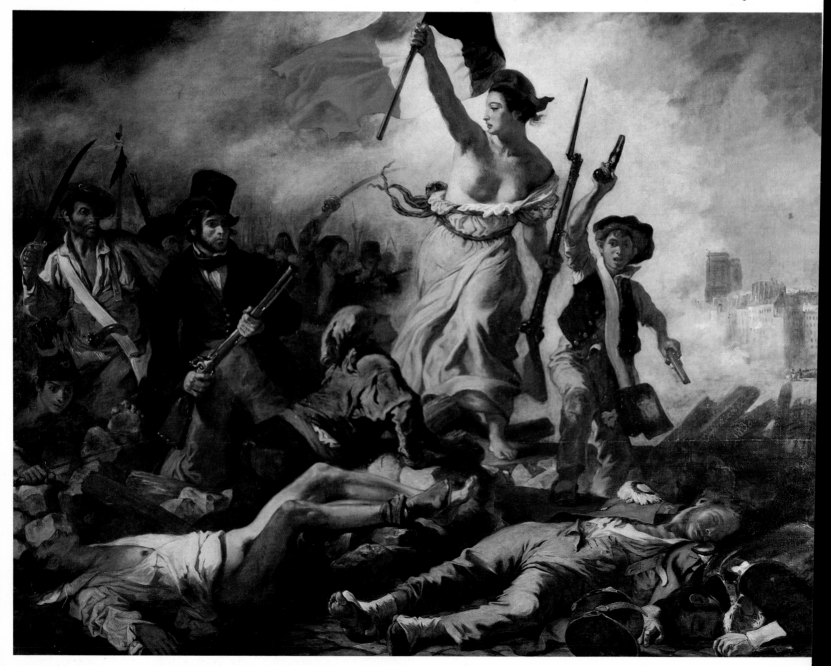

there is an underlying order; the figure of Liberty and the two bodies in front of her form a triangle, and the use of red in the sash and scarf of the figure looking upwards create a powerful vertical link with the red in the banner above, an example of his highly imaginative use of colour. He has been labelled a Romantic, and although the harsh realities of death and destruction are exposed in all their horror, the painting has a glory and patriotism that is highly romantic and inspirational.

BELOW

Gustave Courbet (1819–77)

The Studio of the Painter (1854–5)

The Louvre, Paris

Gustave Courbet was the son of a substantial country farmer at Ornans, near the Swiss border of France. By 1839 he had moved to Paris, and taught himself to paint largely by copying the pictures in the Louvre.

He took his role as an artist very seriously, and felt it his duty to depict the world around him as it was, without idealizing it in the way that many artists had done in the past. He painted portraits, nudes, landscapes, and scenes from everyday life which sometimes reflected abject poverty in a way that caused discomfort and brought him harsh criticism. He was intensely vain, and quite often painted himself, romantically handsome, pipe-smoking, greeting a patron with supreme self-confidence, or waving at the sea from the shore, as though he, rather than nature, were the master of the waves.

The Studio of the Painter has all the elements which typify Courbet's work. It is theatrical and flamboyant, and the life-size figures are painted with tremendous vigour and energy. The artist himself dominates the composition. He is seated at his easel in front of a huge landscape, in which the naked model presumably will be included, and a small boy gazes up at him with rapt attention.

Courbet has filled the room with people who had some personal significance in his life. He has said that amongst the crowd are 'A Jew I saw in England as he was making his way through the swarming traffic of the London streets ... behind him is a self-satisfied curé with a red face ... a huntsman, a reaper, a professional strong man, a clown, an Irish-woman suckling a child.' There is a motley collection of people on the left, but most of them are probably Courbet's models, and recently it has been shown that his words were partly a smoke-screen concealing friends from his childhood and people he admired. On the right is the philosopher Proudhon, the poet Baudelaire, his patron Alfred Bruyas, an art collector and his wife, and a fellow painter Champfleury.

The painting is highly personal and revolves around the painter's work and the Bohemian world in which he lived. It was, in his own words, 'a real allegory summing up seven years of my artistic and moral life', and it is a work which people have been discussing ever since. It combines Courbet's flair for unusual composition, rich colour and dramatic lights and darks, and reveals a great deal about himself and the world he inhabited.

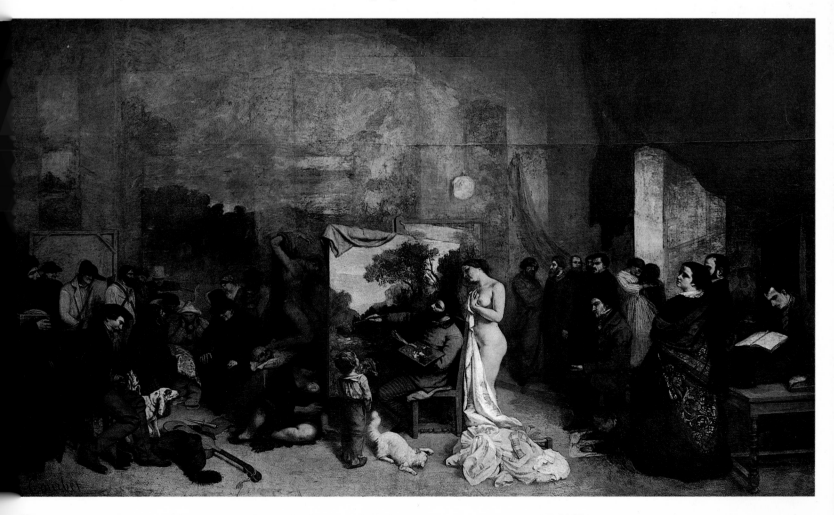

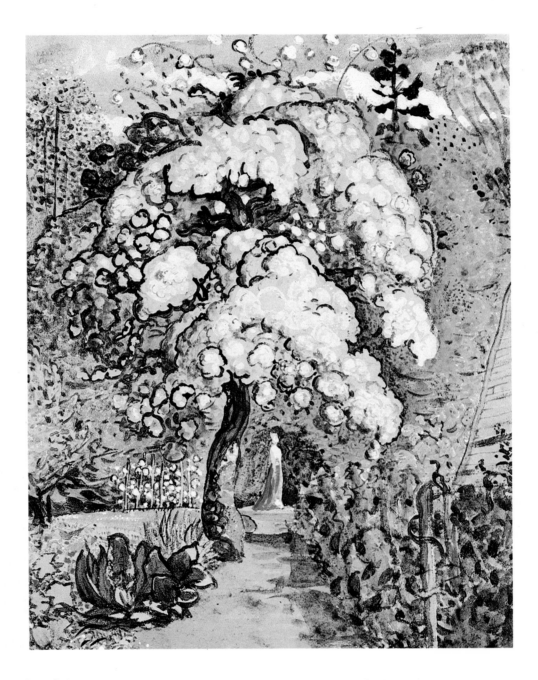

Samuel Palmer (1803–81)

In a Shoreham Garden (1830–5)

The Victoria and Albert Museum,
London

Samuel Palmer was born in London, the son of a bookseller. He was frail and highly-strung as a boy, and after only a few years of conventional schooling he was educated privately. His artistic talent was evident very early in his life, and by the age of fourteen he had exhibited at the Royal Academy. In 1824 he met the artist William Blake, whose visionary work made a strong impression on him.

Ill health, probably caused by asthma and bronchitis, counselled a move from London, and with his father Palmer went to live in Shoreham, a village in the Darent valley in Kent. For nearly a decade he produced small landscapes, charged with intense religious feeling and celebrating the beauty of the world around him. The fertility of the earth; a tree laden with fruit; people returning in procession in the twilight from a service at the village church: these were his subjects. The Darent valley was for Palmer a re-discovered Eden.

In a Shoreham Garden centres on an old apple tree laden with blossom. The tree itself had a special and almost mystical significance for Palmer – for him it was the Tree of Paradise. A path leads into the painting, bordered by a variety of garden plants, and a mysterious female figure stands at the end beyond the apple tree. Behind her a tree-covered hillside rises into the windy grey sky. In a delicate variety of texture and by the most subtle exaggeration of reality Palmer expresses here his wonder at the miracle of spring.

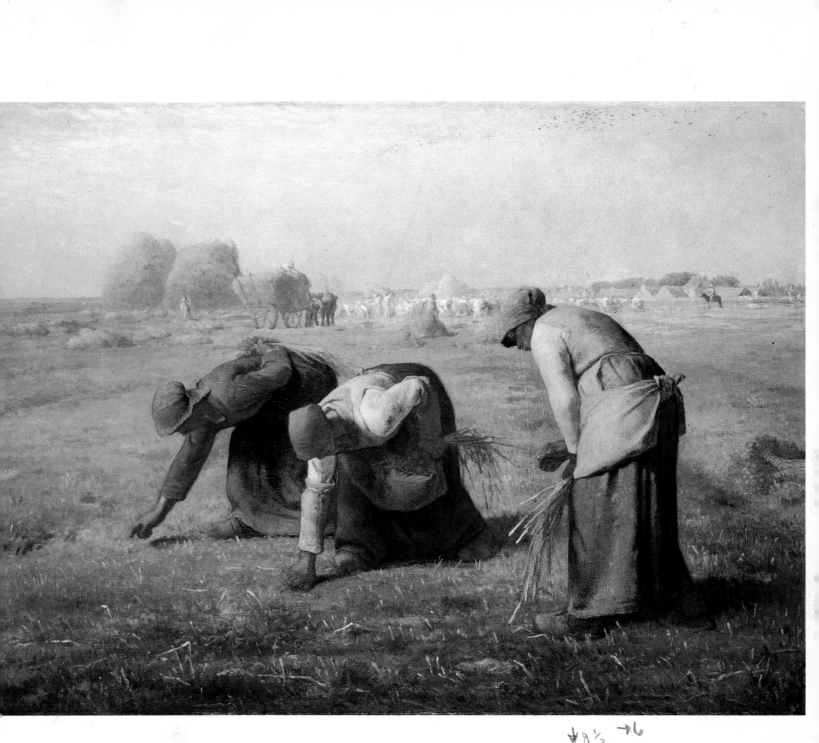

Jean François Millet (1814–75)

The Gleaners (1857)

The Louvre, Paris

For almost half his life Millet lived in Barbizon, a village near Paris that became a centre renowned throughout Europe and America for painters of landscape and country life. His parents were peasant-farmers near Cherbourg, but they encouraged his talent and sent him to have professional training locally; and by his early twenties Millet was studying in Paris. He made a deliberate choice to concentrate on scenes from rural life, often based on memories of his childhood.

The Gleaners was a highly controversial painting in its time because people saw it as criticizing a society which allowed extreme poverty. But the artist was in fact celebrating a simple hard-working and even religious life, rather than making critical social comment. Millet, in his youth a gifted portrait painter, declared that it was 'the human side' of life that he most wanted to portray in his art, and *The Gleaners* is an unsentimental statement about the back-breaking effort as well as the dignity of work in the fields.

In the pale clear distance a crowd of workers are cutting and binding corn into sheaves, and loading them on to horse-drawn wagons from a farm on the horizon. And in the foreground three peasant women are scouring the newly-harvested field and filling their aprons with any left-over grain they can find. Their bent figures have a rounded and superbly sculptural quality in the calm beauty of the countryside, reflecting Millet's interest in form and outline. The rich browns, ochres and greys of the field merge with the natural colours of their simple peasant costumes, as if the figures are an integral part of the landscape. The peaceful harmony of Millet's painting evokes the unchanging epic simplicity of a rural existence. It is not a fleeting moment that he has depicted, but a continuing way of life.

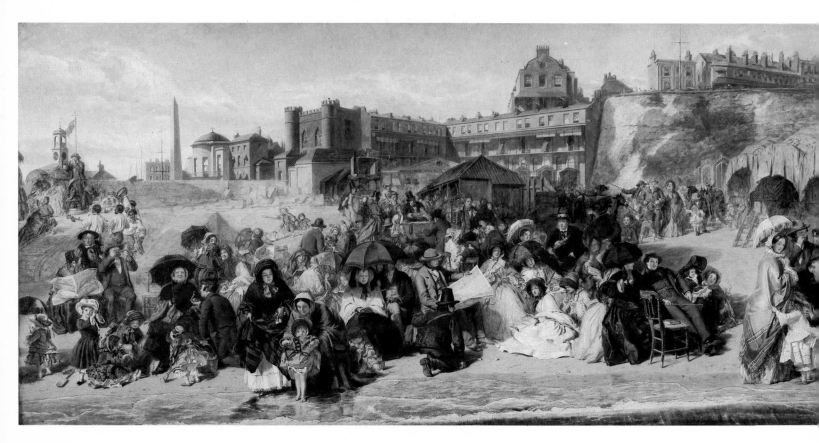

ABOVE

William Powell Frith (1819–1909)

Ramsgate Sands (1852–4)

Royal Collection

Queen Victoria and her consort Prince Albert exercized a powerful influence on the artistic taste and inclinations of England during her reign, and Frith was one of Victoria's favourite artists. He began as a rebel who did not even want to be an artist and finished as one of the most successful painters of his day.

He was born and brought up in Yorkshire, and his father was unusually determined the boy should make a career as a painter. He went first to train at Sass's Academy in Bloomsbury, London, and then to the Royal Academy. By 1853 he was a full Academician. Mostly he painted historical scenes, episodes from Shakespeare and from popular novels and plays; only occasionally did he turn to con-

temporary life. He was one of the first artists in the world to use photography to record a scene he wished to paint.

It was with three great paintings of nineteenth-century English life that he made his name: *Life at the Seaside* was the first, followed by *Derby Day* and *The Railway Station*. Crowds had to be kept back with protective ropes when these pictures were shown at the Royal Academy's annual exhibitions, and *Life at the Seaside* was bought for a thousand guineas by Queen Victoria at the Private View.

It was painted in 1851 after a holiday at Ramsgate, which was then a fashionable Kent seaside town. The painting is like a novel by Dickens in that a multitude of characters and incidents have been brought together to create a picture that teems with life and atmosphere. The gay society throng, the children dressed in replicas of adult clothing, the entertainers, the buskers and the stall-holders who amused the visitors to the beach, and the

new Victorian terraces which catered for the holiday population – everything that typified an English seaside resort at the time – is concentrated in a delightfully animated and bustling composition, which evokes the times and the people with unusually acute penetration.

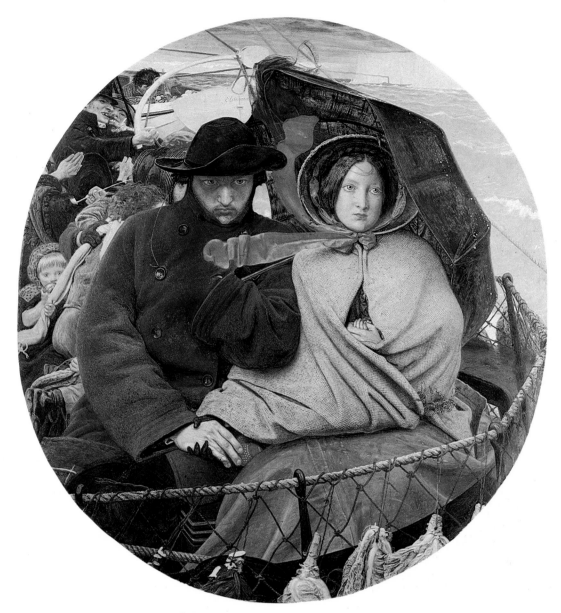

Ford Madox Brown (1821–93)

The Last of England (1855)

Birmingham City Art Gallery

Ford Madox Brown was born in Calais of English parents, and brought up and educated in Europe. He studied art in Belgium, France and Italy, and had settled in England by 1845. He had a varied career, was always highly esteemed by his colleagues, but never achieved popular success. Although older than they, he associated with the Pre-Raphaelite Brotherhood, that intense band of artists which included Holman Hunt, John Everett Millais and Dante Gabriel Rossetti. Brown painted a good many historical pictures, and for most of the 1880s he worked on subjects of local social history for Manchester Town Hall.

His serious, determined career is crowned by one work above all, *The Last*

of England. The subject was inspired by the fact that a young sculptor associated with the Brotherhood, Thomas Woolner, had set out to seek his fortune in the goldfields of Australia three years before. The circumstances were common enough at the time: in 1852 there were 65,000 emigrants from Britain to Australia, few of whom ever returned.

Brown used himself and his second wife Emma as models for the painting; and, to give an example of his dedication, to make sure he captured the authentic look of things 'on a dull day at sea', he did most of the painting outside, his hands blue with the cold.

The couple are huddled together, sheltering from the sea-spray under a huge umbrella, as the curve of the white cliffs of Dover recedes in the background. Their silhouettes are sharply defined, and the shape of the painting unites the composition and focuses our attention on their figures. The ribbon of the woman's bonnet streams out to the side in the wind,

and her gloved hand grasps her husband's for comfort as they leave their homeland behind. The tiny plump hands of their small child can just be seen emerging from the folds of the woman's cloak, and she holds them tightly in her lap. Cabbages strung through the netting in the foreground indicate the provisions needed for the long sea journey.

Brown wrote that 'absolutely without regard to the art of any period or country, I have tried to render this scene as it would appear', and the combination of determined purpose for a better future and deep regret at leaving home are summed up vividly in the expressions of the young married couple. The artist has reproduced all the sensations and emotions of the experience, so that we feel we know exactly what it was like, not only for this couple but for all the others who embarked on such a momentous journey.

Sir John Everett Millais (1829–96)

Autumn Leaves (1855–6)

Manchester City Art Galleries

The English painter Sir John Everett Millais was one of the most prosperous artists in history. He entered the Royal Academy Schools when he was only eleven, the youngest pupil ever accepted. He was elected a Member of the Royal Academy in 1863, knighted in 1885, and became President of the Royal Academy in 1896, the year of his death.

As a young man he was a founder member of the Pre-Raphaelite Brotherhood, a band of painters who wanted to revive the sincerity and deep significance which they believed had existed in art before the time of Raphael. Their work was serious in subject matter, usually with a detailed natural setting, and it conveyed a spiritual message through a variety of symbols.

Four years before beginning this painting Millais had remarked to a fellow Pre-Raphaelite, 'Is there any sensation more delicious than that awakened by the odour of burning leaves? To me nothing brings back sweeter memories of the days that are gone; it is the incense offered by departing summer to the sky; and it brings one a happy conviction that Time puts a peaceful seal on all that is gone.'

John Ruskin, the great nineteenth-century critic, considered *Autumn Leaves* to be 'the first instance of a perfectly painted twilight'; Millais had captured 'the glow within the darkness'. And the artist's wife Effie wrote that he wished 'to paint a picture full of beauty and without subject'. Yet Millais himself has recorded that *Autumn Leaves* was not just a charming, wistful scene, but was intended to arouse the deepest religious reflections.

The two girls at the centre, one with a basket, one holding leaves, are Effie's younger sisters, Alice and Sophie; the others are local youngsters, Matilda Proudfoot and Isabella Nicol, whom Effie had found to model. The setting is the garden of Annat Lodge in Perthshire, its distant hills shading into purple at the far horizon. The dresses of the two older girls act as dark foils for the heap of papery fallen leaves – bronzes, reds and pale yellowish-greens – and the younger girls are in russet and deep purple, blending with the colours around them.

They have a mystical look, as if they are taking part in an ancient ritual charged with intense emotional feeling. Pictured at twilight, near the end of the year, they are just beginning their lives, suggesting an eternal cyclic renewal. Millais has used colour and the elements of nature to convey his own understanding of the deep spiritual beauty of life in this sensitive and evocative painting.

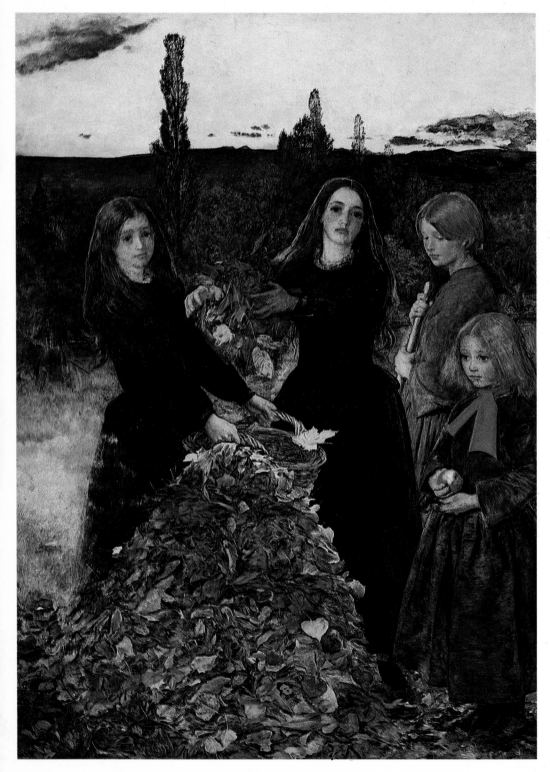

Camille Pissarro (1830–1903)

Garden with Trees in Blossom, Spring, Pontoise (1877)

Jeu de Paume, The Louvre, Paris

Camille Pissarro was born and brought up in Charlotte-Amalie, in the Danish West Indies, where his father had a general store. He was sent to school in France, encouraged to paint by a sympathetic art teacher, and found, on his return to the West Indies, that clerical work in the family business was more than he could stand. He left for Venezuela with an artist friend, and in 1855 he settled in Paris, to a life of painting and poverty.

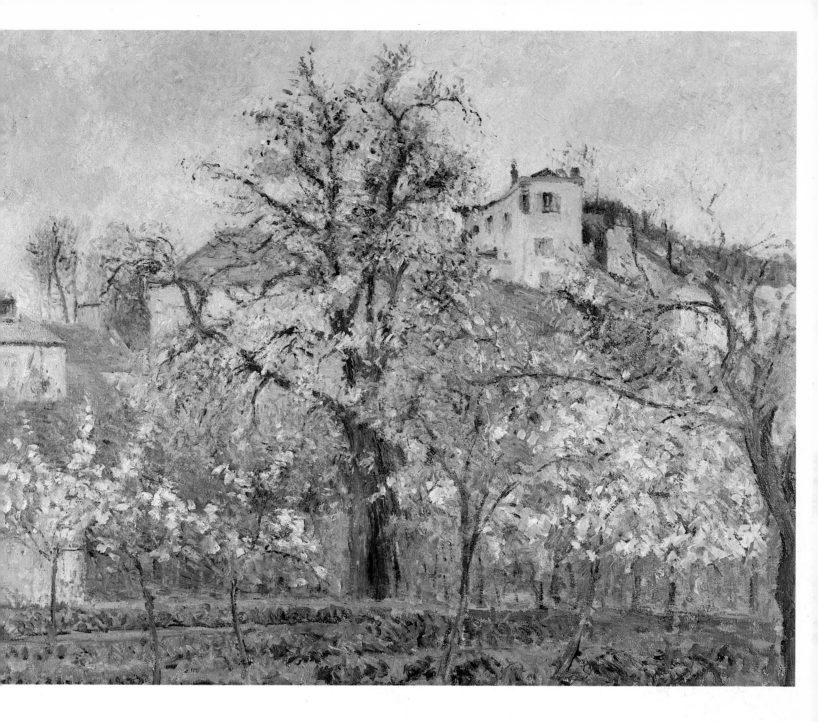

A number of young Parisian painters, who came to be known as the Impressionists, formed a group in the 1870s. Their principal aim was to capture the fleeting effects of colour and atmosphere caused by the play of light and shade in the open air. The official Salons consistently scorned and rejected their work because it was unconventional and appeared unfinished by the accepted standards, and from 1874 the Impressionists held their own independent exhibitions. Pissarro was one of the founders of the movement. He was a little older than the others – Monet, Renoir, Degas and Cézanne among them – and was regarded almost as the honorary uncle of the group. He was a gentle man, full of warmth, enthusiasm and curiosity, and he believed in freedom and mild anarchy. He never compromised; nor did

he ever attach blame in the frequent quarrels that broke out around him. He remained friends with everybody and was respected for his principles as much as for his art.

Pissarro was enormously prolific, and painted farming scenes, streets in Paris or country villages, all with a spontaneity and life that captured his first vivid impression of his subject. *Garden with Trees in Blossom* was painted in the orchard behind Pissarro's house, in the small village of Pontoise, near Paris. The freshness of spring and new growth is perfectly conveyed by the flurry of falling petals and the young green shoots under the apple trees. Blue and red roofs of the village merge with feathery trees in the distance in the small brush strokes that cover the canvas. The Impressionists' interest in light meant that sharp outlines

disappeared as objects fused under the effects of light and shade. Pissarro believed that every element in a picture should be completely understood, and should work together so that the eye takes in the whole scene at once, as it does in life. He declared that nature was 'always to be consulted'.

Cézanne worked with Pissarro at Pontoise, and sketched him, with his flowing beard, big hat and boots, a stick in his hand and his materials strapped to his back as he set off for a day's painting in the country; and Cézanne said of him, 'He of all painters most closely approached nature'. He painted the French countryside at every season of the year, from spring orchards to snow-bound winter landscapes, and demonstrates in all his work the intense joy he derived from it.

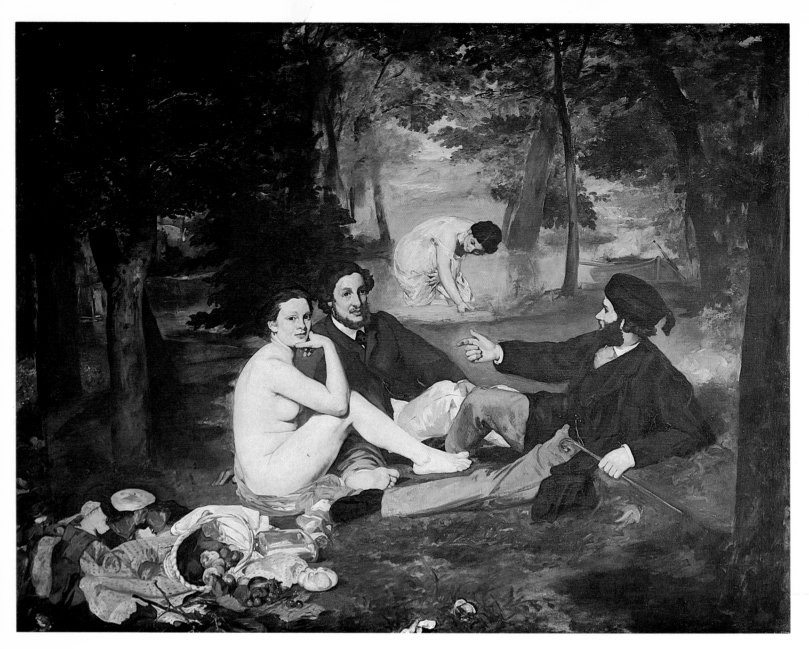

Edouard Manet (1832–83)

Le Déjeuner sur l'Herbe (1863)

Jeu de Paume, The Louvre, Paris

Manet came from a comfortable middle-class Parisian background – his father was an official in the Ministry of Justice – and his decision to be a painter met with strenuous family opposition. He studied under Couture, a much admired artist of the day, who gave him a thorough grounding in technique; but his travels studying European art, and the experience he gained from copying Old Masters in the Louvre were equally valuable. He developed a brilliant technique, based on a limited palette and the use of contrasting light and shade, and he painted directly on to the canvas, which gives his work great zest and vitality.

He longed for public recognition, but his unconventional ideas led to him being labelled a rebel, and his paintings were frequently refused by the official Salons. He joined the Impressionist group soon after it was formed, and became one of its key figures, although, fearing more disparagement from the critics, he refused to take part in its exhibitions.

The painting that caused one of the greatest upheavals of the time was an early work – *Le Déjeuner sur l'Herbe* – which preceded the Impressionists by nearly a decade. When it was first exhibited it caused a scandal, and the Emperor himself called it 'an affront to modesty'. It was revolutionary not because the woman is naked, but because she is shown with two men who are fully clothed in contemporary dress, and they are engaged in an ordinary conversation at an ordinary picnic. The nude was no longer protected in the traditional way by the scene being set in some mythical place, and illus-

trating an ancient legend. Even the picnic itself consists of ordinary everyday food – not exotic sweetmeats, but the bread rolls that were part of the staple diet of every Parisian. Manet wanted to be free to paint any subject that appealed to him, without preserving conventions, and this attitude was hard for his contemporaries to accept.

The people represented in *Le Déjeuner sur L'Herbe* were well known to him: the woman in the foreground is Victorine Meurand, one of his favourite models, and the men are his brother Eugène (who later married one of the Impressionist group, Berthe Morisot) and a young Dutch sculptor Léon Koella-Leenhoff. He has shown them in a wooded country setting, with a woman bathing in a pool in the background, and a soft light filtering through the trees, highlighting the pale flesh against the rich deep greens of the grass. The flesh tones are contrasted so dramatically with their dark background as to seem almost luminous.

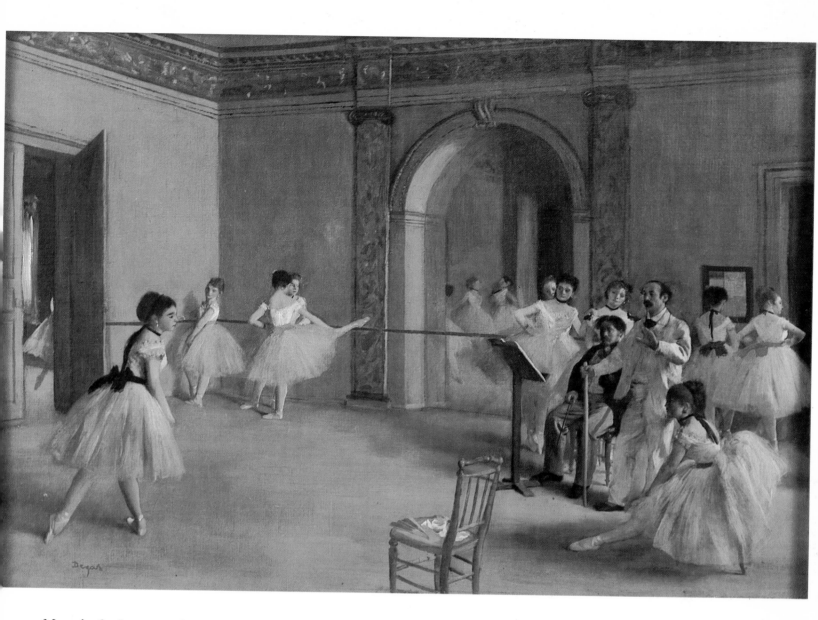

Manet's fresh approach, turning his back on restricting conventions in order to achieve his aims, was a startling revelation at the time, and it marked an important change in nineteenth-century art.

ABOVE

Hilaire Gérmain Edgar Degas (1834–1917)

Le Foyer de la Danse à l'Opéra (1872)

Jeu de Paume, The Louvre, Paris

Degas, born in Paris, was the son of a wealthy banker, and for most of his life he was free to paint without depending on his art for a livelihood. He was something of a recluse, troubled from his early forties with failing eyesight, a witty, formidable and forbidding character. He was a member of the Impressionist group for a time, but his work was more academic than theirs, and although he made intense studies of light and colour, he was fascinated principally by movement.

Many of his pictures are of women – laundresses, hat-makers and, above all, dancers – depicted in a deeply perceptive and sympathetic manner in paintings, drawings and sculptures. His interest in movement can also be seen in his pictures of horses in training, scenes at the race-track and people at work.

The French poet Baudelaire remarked that artists 'must draw out of daily life its epic aspect', and this is precisely Degas' achievement as he shows us an everyday rehearsal at the ballet.

The painting has an air of uninter-rupted activity. The dancers seem to be unaware of an observer and nothing is posed: some exercising at the barre, some listening and watching as the teacher instructs a soloist, and a violinist waits to begin; one resting; one reading notices on a board at the back.

The horizontal red line of the barre forms a link between the groups of dancers, and the red is picked up in the girls' sashes and the fan on the foreground chair, making a perfect rectangle.

The open space in the centre, and the apparently random arrangement of people and chairs, accentuate the life and im-mediacy of the painting. A mirror reflects a group outside the composition and a girl whisks past a half-open door, perhaps on her way to another studio; everything suggests that movement is continuing beyond the scene portrayed.

Degas observed, analyzed and recorded with great care, by means of numerous sketches from life, before beginning work on a canvas in the studio. As a result he caught revealingly, and with extra-ordinary realism, the movement and atmosphere of his subject.

James Abbott McNeill Whistler (1834–1903)

Arrangement in Grey and Black No 1 : Portrait of the Artist's Mother (1871)

The Louvre, Paris

Whistler was born in America and spent much of his life in England, and both countries claim him as their own; yet he belongs as much to France, where he studied art and became friends with most of the great painters of his day. He was always a controversial figure, the centre of public quarrels and a libel case; and he was also a dandy with a biting wit, who could outdo even his friend Oscar Wilde in verbal repartee.

Whistler was a master etcher, and was more interested in the formation of shapes and colours on a canvas than in subject matter. Art for art's sake was his motto, and his portraits of women, domestic interiors and views of water are vehicles for the creation of perfect compositions, each one made up of delicate gradations of tone.

This portrait of his mother, to whom he was deeply attached, is intensely personal and full of character and atmosphere. She is seen in profile, her grey hair rather severely dressed and her hands folded in her lap. The effect is dignified and a little austere, but alleviated by the delicate lace at her neck and trimming her sleeves and cap.

As its title states, the painting is primarily 'an arrangement' of colours, and its most arresting feature is the way in which areas of subtle colour have been weighed against each other. The woman's dress is a bold expanse of black, balanced by the dark vertical mass of the curtain

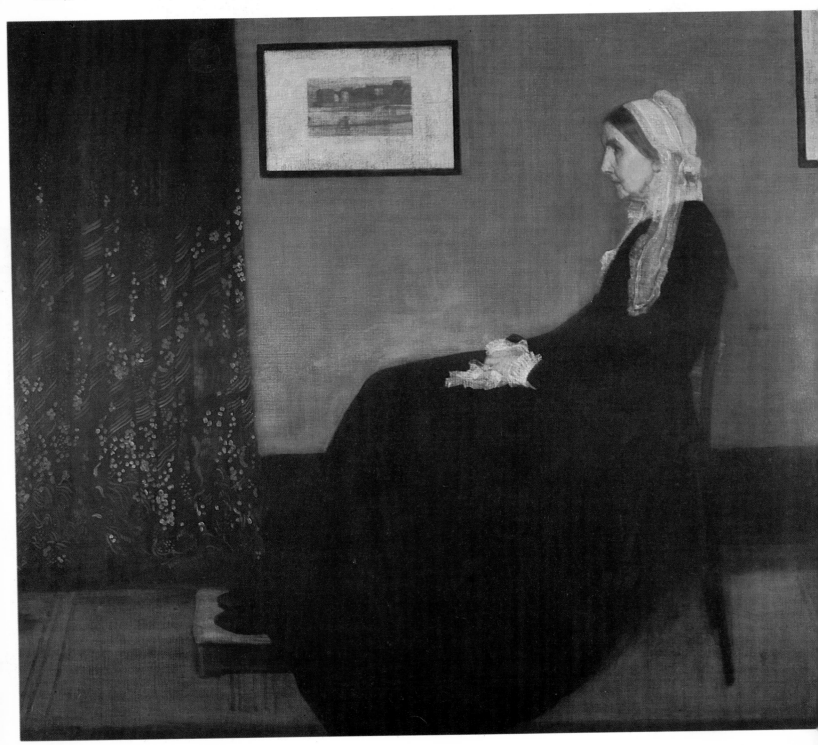

and the frame of another Whistler painting on the wall; and these dark shapes are offset by precisely calculated areas of grey and white. It is a sensitive and beautifully constructed composition of blocks of muted colour, in which any change in emphasis would upset the delicate balance.

Winslow Homer (1836–1910)

Breezing Up (1876)

National Gallery of Art, Washington DC

The American artist Winslow Homer – the greatest painter of New England country life – was a leading figure in nineteenth-century American art. His aim was accurately to portray nature and the times in which he lived. He spent long periods in country districts of France and England, and for the last third of his life lived in some isolation in Maine, painting the sea and the lives of the people who lived by it. He had little conventional art education, but learned lithography in Boston, and then worked as a free-lance illustrator; a series of his black-and-white pictures, published in New York's *Harper's Weekly*, provide a powerful record of the horrors of the American Civil War.

A mood of sombre acceptance of the overwhelming power of nature characterizes much of his later work; but *Breezing Up* is a marvellously exhilarating painting in which the force of the sea seems to be more a challenge than a threat. The brushwork is vigorous and energetic. It is a windy day, probably summertime, off the coast of the eastern seaboard, and three boys are out fishing under the guidance of an older man. Their boat, the *Gloucester*, is heeling into the wind; and the boys are helping to balance it, one of them controlling the rudder. In the distance are the sails of a schooner and the faint outline of another small fishing boat.

The *Gloucester* seems to be sailing right out of the picture, and the spume and spray fore and aft heighten the feeling of speed. The horizon line is sharply dissected by the steep angle of the boat, with the heads of the crew clearly silhouetted against the sky. Floating clouds reinforce the white crests of the sea, and glistening fish in the bottom of the boat echo the sparkling surface of the water.

The painting conveys a sense of physical enjoyment and energy; we can practically feel the spray and the freshness of the air. The boys and the fisherman are wrapped up in the intensity of the moment as they manoeuvre their boat against the wind. Homer's feeling for man in relation to nature is magnificently displayed in this spirited and evocative picture.

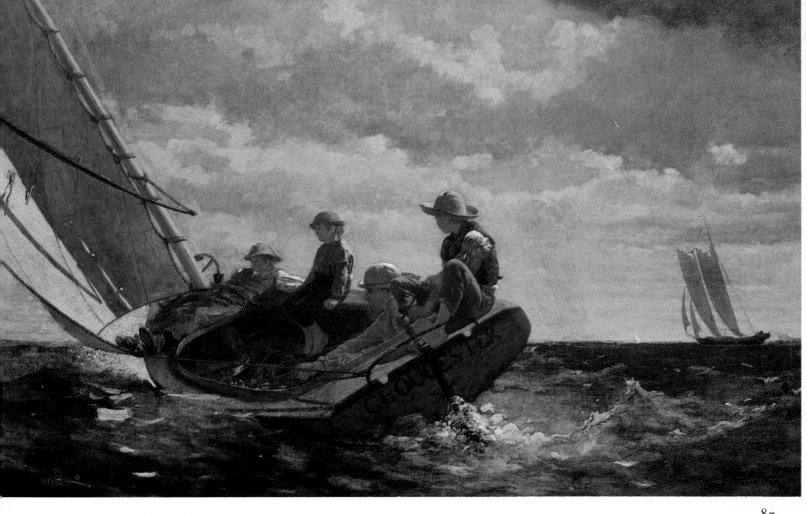

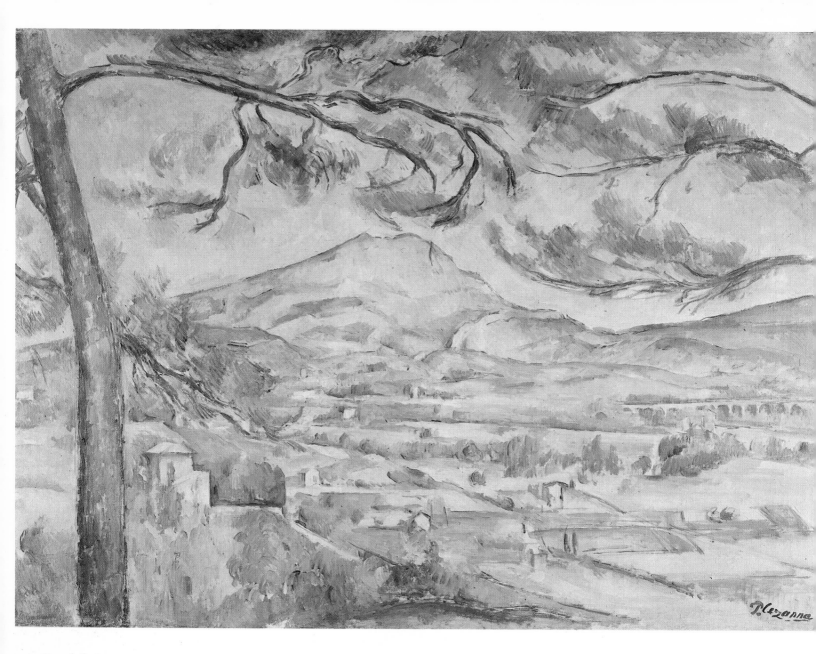

Paul Cézanne (1839–1906)

La Montagne Sainte-Victoire (*1886–8*)

The Courtauld Institute Galleries, University of London

The work of Paul Cézanne has had such a far-reaching influence that he has been called the father of modern painting. It was not until the end of his life, however, that his genius was widely recognized. In the year after his death a major exhibition of his work was held, which startled the world.

He was born in Southern France, the son of a wealthy banker, but much of his working life was spent in Paris, where he mixed with all the Impressionist painters of his day. Whereas other artists in the group sought to capture rapidly changing light and colour, Cézanne's greatest achievement lay in exposing in planes of colour the underlying shapes in nature,

which he believed to be the sphere, the cylinder and the cone.

He applied this analysis of structure to *La Montagne Sainte-Victoire*, a scene in his native Provence. The greens and terracottas in the foreground fade almost imperceptibly into the pale blues and pinks of the distant rocky mountains, yet each individual area is made up of separate geometric slabs of colour carefully worked together to form the shapes in the landscape.

The sharply defined outline of the mountain is framed by the branches of two Mediterranean pine trees, the fields and houses set out in such a way that the eye is guided through the painting to the Roman aqueduct in the middle distance, and on to the peak of the mountain itself. The horizontal planes are perfectly balanced by the vertical tree trunk on the left and the tower of the building beyond it. The effect of distance is emphasized by the scale of the foreground trees, but somehow the mountain's bare surface

seems to loom towards us and dominate the peaceful cultivated scene.

Cézanne painted this landscape many times, and this calculated, finely balanced picture reveals his intimate familiarity with his subject.

He became the most important of the Post-Impressionists, who concentrated in a rigorously disciplined way on form and outline. In his technique of exposing the structural shapes in nature he was also the forerunner of Cubism, which was fully developed by Picasso and Braque (see pp. 104, 105). He was greatly respected and admired by his fellow artists, and is generally considered now to be one of the most brilliant painters of the last hundred years.

Claude Monet (1840–1926)

Women in the Garden (*1866–7*)

Jeu de Paume, The Louvre, Paris

It was from one of Claude Monet's paintings – *Impression, Sunrise* – that the Impressionist group, of which he was the leader, acquired its name.

He was born in Paris, but spent most of his working life on the Normandy coast or in the French countryside, and he passionately loved the sea and the open air. Poverty dogged him for many years, and the dreary problems of how to live exasperated and depressed him. He was reduced to scrounging from his friends and patrons just to survive, and frequently had to sacrifice finished work by scraping off the paint in order to use the canvas again.

He spent the summer of 1866 at Ville d'Avray, near Paris, and it was there that he painted *Women in the Garden*. He worked, as usual, out of doors, and had a trench dug in the garden into which his huge canvas – about eight-and-a-half feet by six-and-a-half feet – was lowered, and a pulley arrangement was rigged up so that he could reach the top. Light interested him more than anything, and he was concerned to reveal the fact that colour only exists in terms of light, and that it changes in all the normal variations of daylight and shadow.

The scene in the garden is a study of the effects of sunlight filtering through leaves, casting dark shadows and dappling the figures of the four women (who were all modelled by Monet's mistress Camille). Roses are in bloom, the trees are dense with the dark green leaves of midsummer, and the women wear pale delicate dresses of embroidered cotton and fine muslin. The seated woman shields her face from the sun with a parasol; and Monet has caught precisely the effect of shade on the colour of her skin and the top of her dress, contrasting it with the bright undeflected light on her skirt and the flowers in her lap. The two women standing together are in the shade of a tree, with the sun flickering through and forming patches of light on their dresses. The fourth is in the full sun, its strong rays shining directly on to the back of her dress and her gleaming red hair. The long dark shadow in the foreground accentuates the brilliance of the light, especially where it edges the white skirts

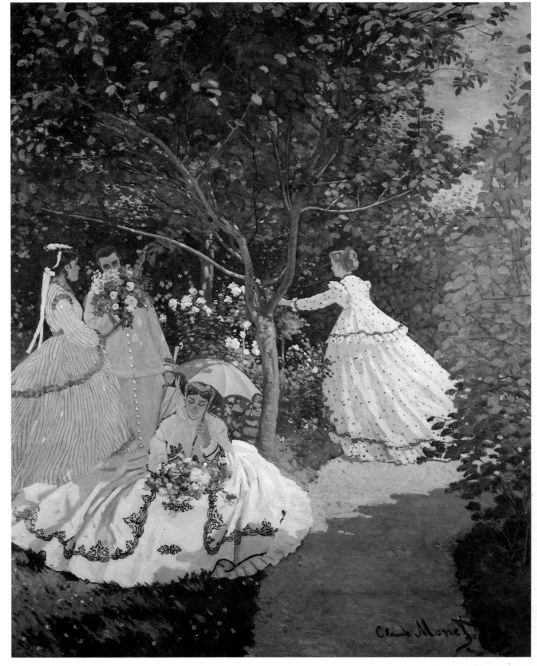

spread in a circle over the grass. The swirling movement of light summer dresses makes an extremely romantic composition, and Monet's understanding of the effects of light bring out all its subtle variations of colour and atmosphere.

He is generally considered to be the greatest of all the Impressionist painters. He had an astonishing ability to observe and record a scene with a fresh eye, as free as possible from influences and conventions, and to paint exactly what lay before him as if he were seeing for the first time.

In spite of his destitute state, he more than anyone stuck to the ideals of Impressionism throughout his long life without deviating, and he was a great source of stimulation to others in the group in the face of poverty and endless

criticism. Renoir said of him, 'Without Monet, without my dear Monet who gave us all courage, we would have given up.' After about thirty years of struggle, their work began to be understood and appreciated; and finally it has come to be valued as one of the most important movements, and certainly the most popular, of the nineteenth century.

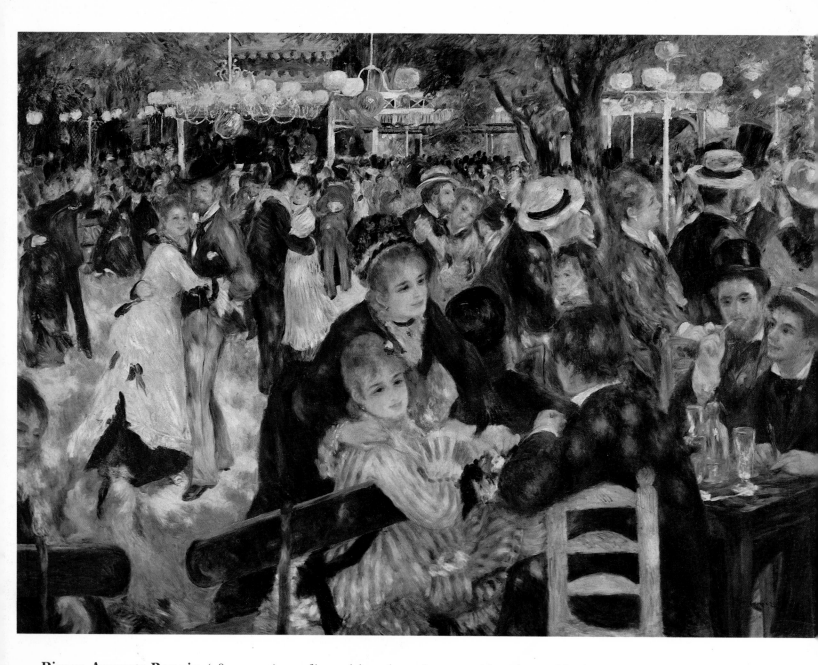

Pierre-Auguste Renoir (1841–1919)

Le Moulin de la Galette (1876)

Jeu de Paume, The Louvre, Paris

Renoir came from a poor Parisian family – his father was a tailor, his mother a seamstress – and by the age of thirteen he was at work in a factory, painting decorations on to china and porcelain. Undoubtedly the use of clear, light colours in this work was a permanent influence on him.

The encouragement of Monet, and the resilience of his own cheerful nature, sustained Renoir through periods of appalling poverty. He seems to have endured all his hardships with optimism, and his paintings reveal none of the problems of his life. Groups of people in riverside landscapes, dance-halls and cafés, and latterly nudes, were his principal subjects, and their warmth and charm have made him one of the best-loved of all the Impressionists.

The attraction of *Le Moulin de la Galette* is largely the result of Renoir's preoccupation with a technical problem: the portrayal of dappled sunlight filtering through trees and illuminating the dancing, chattering figures underneath, and he has mastered it with a wonderful delicacy.

He was fascinated by the pearly tints of female flesh, and frequently used this colour scheme of pinks and blues to accentuate the softness and clarity of skin tones. The play of light and shade on the girls' dresses and hair, and on the men's straw hats and dark jackets, softens the outlines of the figures and blends them with their surroundings and the shadows on the ground, so that a haze of diffused colour fills the entire canvas.

This café in Montmartre, housed in an old windmill, was a favourite gathering place for flirting, drinking grenadine, eating the *galettes* or pancakes from which it took its name, and waltzing on Sunday afternoons. Renoir took his canvas there every week, and painted the picture on the spot. His friends and regular models posed for most of the figures. He has captured delightfully the atmosphere of gentle gaiety and the soft shimmering effects of summer afternoon light.

RIGHT Detail from *Le Moulin de la Galette*

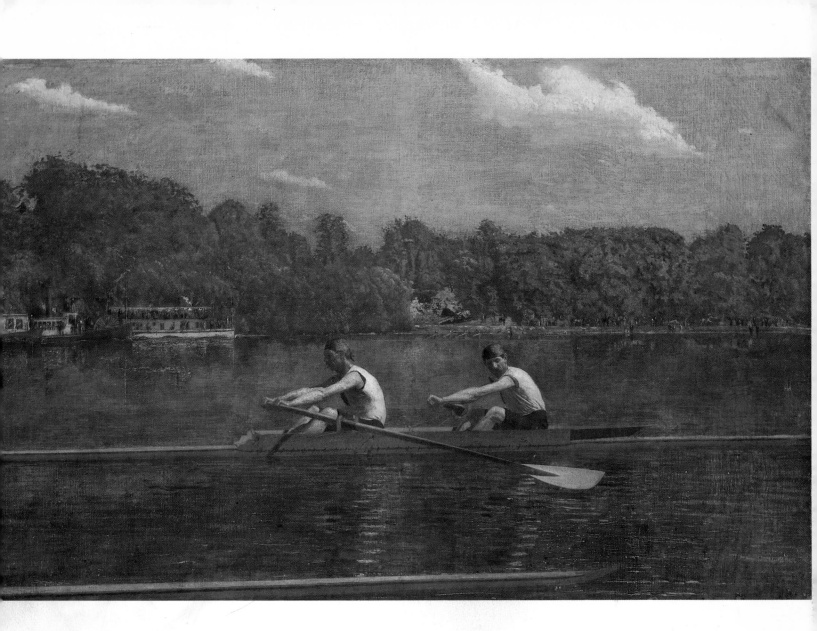

Thomas Eakins (1844–1916)

The Biglin Brothers Racing (c. 1873)

National Gallery of Art, Washington DC

Thomas Eakins is one of the best-known painters of American life. He travelled to Europe as a young man and studied art in Spain, Italy, Germany and France. In 1870 he returned to his native Philadelphia and was never to leave America again.

The goal of his art was realism, and among the painters he most admired were the Spaniards Ribera and Velázquez, both supreme realists. As Eakins expressed it, he wanted to show 'what o'clock it is, afternoon or morning, winter or summer, and what kind of people are there, what they are doing, and why they are doing it.' He believed that the artist must be faithful to nature, but not simply copy life; he must attempt to re-create nature and life through his own understanding of what he saw.

On his return from Europe Eakins produced a number of paintings on the theme of outdoor life: hunting, swimming, sailing and rowing. Rowing was a popular sport on the Schuykill River in Philadelphia, the scene of the Biglin brothers' race. John and Barney Biglin were professional oarsmen, and Eakins painted them several times.

He generally worked in oils in his studio from notes and sketches made on the spot. He was interested in photography, then in its early stages of development, and used it as a reference for paintings such as this, where quick movement is arrested. Eakins was also fascinated by mathematics, and would have employed it here to work out problems of perspective, and the most convincing way of indicating the ripples on the water's surface. He made little models of the figures and the boat, and put them out in the daylight to catch the exact variations of colour and lighting.

The fast-running river with its sparkling reflections, the sharp horizontal slice of the boat skimming the surface, the zigzags formed by the two men leaning forward while their oars touch the water, all imply a rapid gliding movement. The composition itself, with both ends of the long, sleek boat dissected by the sides of the painting, adds to the feeling of speed.

The two brothers, in their bright white shirts and racy blue bandannas, are a superbly co-ordinated team. Eakins has captured a moment of control and physical effort, in which the spectator can actually see the perfect rhythm achieved by the skill of the two oarsmen. It is an example of harmony and collaboration between two professionals, depicted with such freshness and vigour that we feel as if the scene is taking place before our eyes.

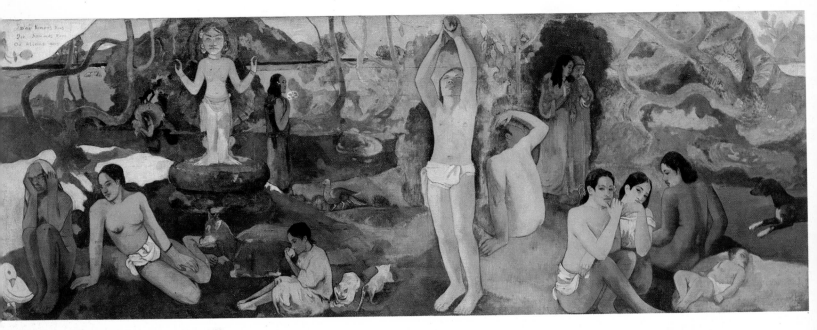

Paul Gauguin (1848–1903)

Where do we come from? What are we? Where are we going? *(1897)*

Museum of Fine Arts, Boston

The French painter Paul Gauguin led an unsettled and stormy life, and his dramatic story has been as much the subject of novels and films as his work has been analyzed by art historians. He was descended on his mother's side from a Spanish-Peruvian family, from whom he inherited his independent spirit, fierce pride and restless fiery temperament.

He did not begin to paint until his twenties, but in 1873 Gauguin gave up his business career and stable, bourgeois existence, abandoned his wife and five children, and devoted all his energies to art.

His restlessness and need for an escape from conventions took him to Martinique and, in 1891, to Tahiti, where his work began to develop the features for which he is best known: simplified figures, clear outlines, rich colour patterns and exotic tropical settings. His new life brought him no real happiness, however, and he was tortured by anxieties and self-doubts. This troubled, searching picture reflects his state of mind and sums up his thoughts about life before his attempted suicide. It is the largest painting Gauguin ever produced (over twelve feet wide and some four-and-a-half feet high), and he finished it in a month, working day and night at high pitch. It was not meant to depict a real scene, but to reveal the world of the mind.

The painting shows a mysterious region filled with intense, thoughtful, monumental figures. In the centre a young man plucks a ripe fruit from the tree above his head; on the right are young people with a baby; and on the left an old woman crouches waiting for death. The painting moves from infancy to old age, and from birth to death; and at the back a stone idol, its expression enigmatic, raises its hands in benediction.

Gauguin believed that the universal force of nature could be expressed through the vibrations of colour. The landscape elements are shown in the vivid dark purples, blues and greens of the painting's tropical background, and they seem to throb with the energy of life. The plants are like airborne snakes, curved, sinuous, binding the various features of the composition together. The artist himself considered this painting to be his masterpiece. It combines his brilliant, heightened colours and dramatic imagery with a passionate expression of his inner thoughts and feelings about the meaning of life.

RIGHT Detail from *Where do we come from? What are we? Where are we going?*

94

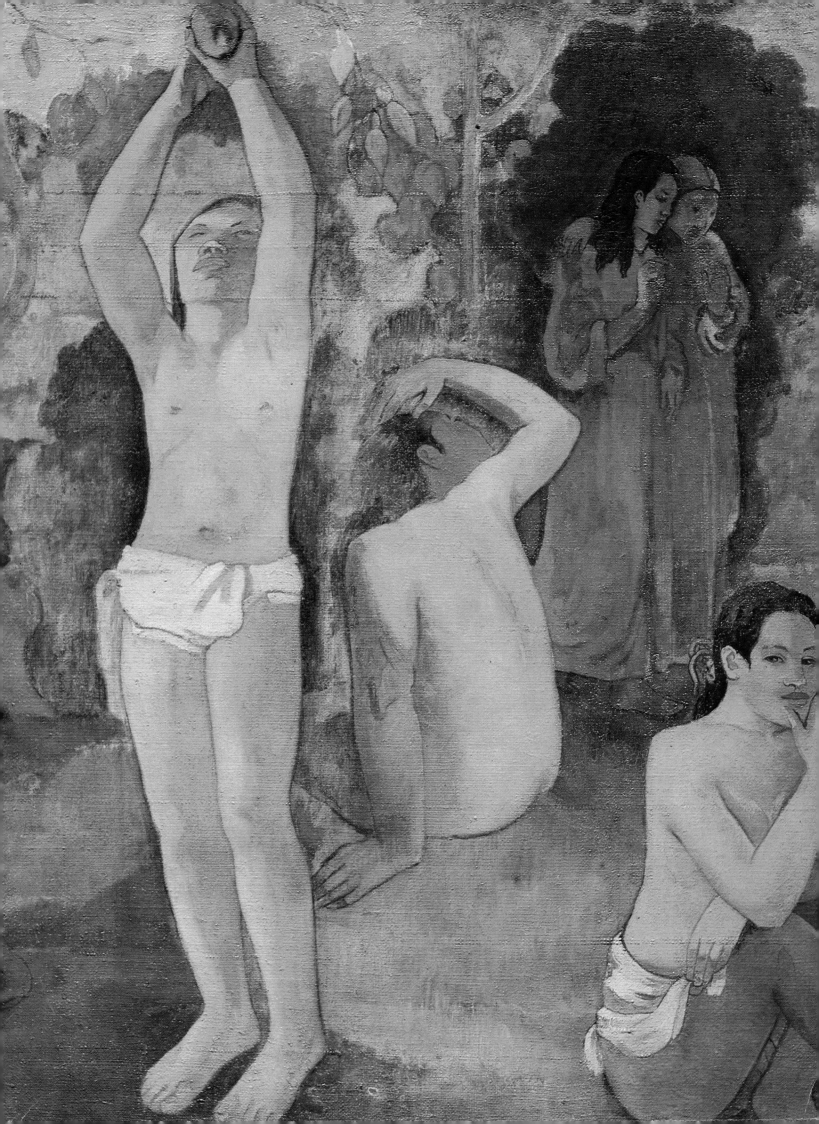

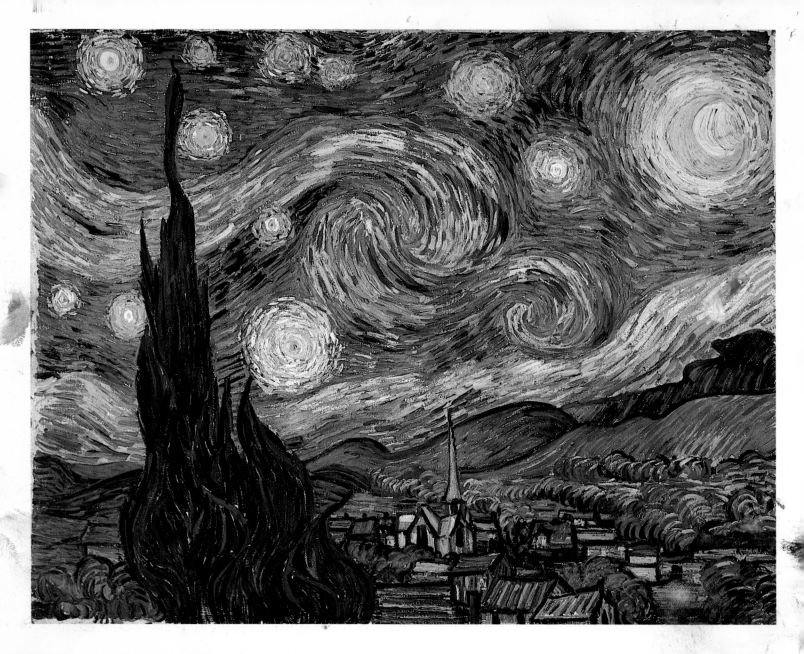

Vincent van Gogh (1853–90)

Starry Night, Saint-Rémy (June 1889)

The Museum of Modern Art, New York

Van Gogh was probably the greatest Dutch artist after Rembrandt. He was a bitterly unhappy and lonely man, and we know a good deal about his inner life as a result of a massive, stirring and deeply moving autobiography in the form of hundreds of letters written to his brother Theo. These described how his paintings and drawings attempted to give shape to his feelings; they were cries of anguish in his passionate and ultimately destructive search for self-knowledge.

He was a man of deep religious belief, the son of a minister, and he was both lay preacher and missionary in a coal-mining district of Belgium before he took up painting. His character is full of contradictions: his dedication has resulted in a large number of magnificent and important paintings and drawings; yet he also abandoned himself to drink, despair, and the violent expression of his personal feelings. He mutilated himself by cutting off his ear, and finally committed suicide.

Most of his short life was spent in Holland, and his paintings of Dutch peasants are characterized by heavy dark colour; but in 1886 he joined his brother Theo in Paris, where he was influenced by the Impressionists and his entire colour range broadened and lightened. In 1888 he moved to Arles in the South of France, and his work became increasingly vivid and passionate as his mental state deteriorated. He suffered from fits, and was eventually admitted to an asylum at Saint-Rémy. He was allowed freedom to paint, however, and in his clear periods was still productive, but it was there in 1890 that he eventually shot himself.

In *Starry Night* it is easy to see the turbulence of his unbalanced and tormented personality behind the vibrant colour and fast and furious brushwork, with its characteristic short strokes and swirls of paint. But the painting has too the energy and vigour which were an essential part of van Gogh's temperament and art.

It is full of a sense of joy and understanding of the relationship between the world we know on earth and the vast expanses of the universe. The cypresses, familiar features in his landscapes, tower against the deep blue of the night sky, with its sun and crescent moon and eleven stars whirling in space. There are lights in all the village houses, and a church at the centre whose central spire reaches up to the sky above the distant hills. The eleven stars are other worlds continuing into infinity and dwarfing our own planet, yet the village lights and the church link the earth with them, emphasizing that it is part of the same immense creation. It is an intensely religious picture, painted with an almost fanatical fervour, and its strength and energy are electrifying.

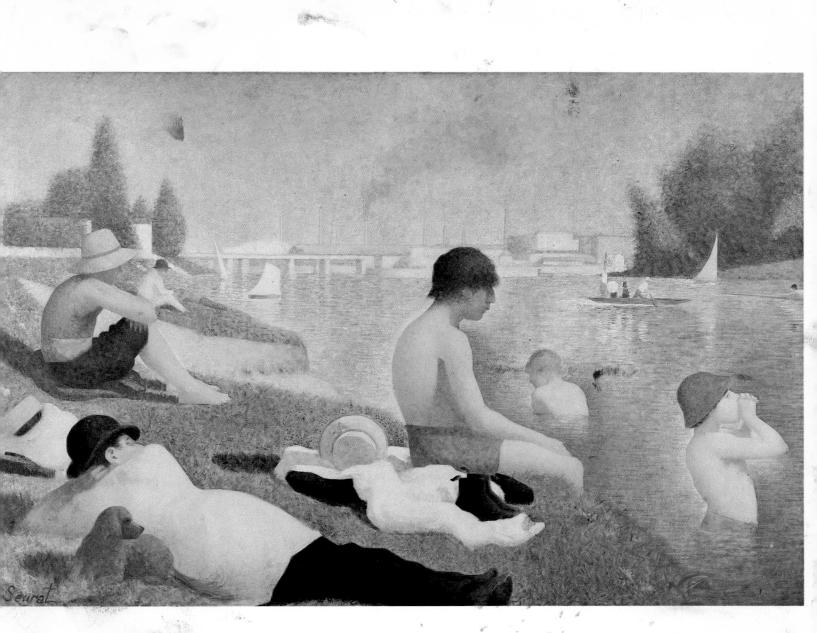

Georges Seurat (1859–91)

The Bathers, Asnières (1883–4)

The National Gallery, London

Georges Seurat's brief life included a short academic art training in Paris, a year of military service, and a decade of intense work and artistic investigation. He died when he was thirty-two, but by then he had produced a handful of masterpieces which reveal his intelligent and rational approach to the problems of colour and light. He wanted to be able to apply a scientific system to the methods of the Impressionists, and he evolved a new technique which came to be known as Pointillism, in which he applied the paint in small dots of different colours which blend in the eye of the spectator rather than on the canvas.

Seurat combined several techniques in *The Bathers* as well as the features he was fully to develop in his later work. His pointillist theory was not entirely formed when he painted it, and he later added dots of colour in certain areas to heighten their intensity, but the principles behind his colour analysis are already evident. His aim was to achieve the exact interplay of colour and light in the open air, and, to this end, each area of shadow was broken down into the complementary colours of the surrounding areas of light, and every element in the painting – the grass, the water, the flesh tones – was made up of colour reflected from the objects next to it. There is something of the Impressionist style in the brushwork and the effects of light; but Seurat conveys not so much the light-heartedness to be found in their work but more the dignity and solemnity of everyday life.

He was equally absorbed in the study of composition, and his major paintings and small landscapes are the results of extremely careful preparation. For *The Bathers* he made no less than fourteen small paintings and ten drawings before putting together this formal and precise composition. It now seems as if the arrangement was inevitable: the placing of the figures, the spaces between them, and even the points of colour on each fine blade of grass are essential parts of the carefully calculated scheme.

Seurat's early work was received with consternation and criticism, but for the last five years of his life he found himself the centre of a cult, and his effect on modern art has been considerable.

Edvard Munch (1863–1944)

The Scream (1893)

The National Gallery, Oslo

The Scream is one of the most disturbing and famous paintings of modern times. Munch's mother died when he was only five, and his beloved sister eleven years later, and these two tragic events in his early life affected his psychological health. Ill as a child, he had several nervous collapses as an adult, and in 1908–9 was one of the first people to be treated with electric shock therapy. He was outstandingly good-looking, drank far too much, never married, and seems at times to have regarded women as devouring, destructive creatures, in spite of or perhaps because of his extended love affairs.

Munch was an Expressionist painter: one who deliberately rejects fidelity to nature, which the Impressionists had striven for, in favour of a simplified and emphatic use of line and colour which carries great emotional impact. It was a movement which took strongest hold in Germany and Northern Europe at the start of this century, and Munch was one of its founders. The darkest recesses of his emotional life were his subject. He said, 'Art is the opposite of Nature. A work of art can only come from inside a person. Art is the shape of the picture fashioned through the nerves, heart, brain and eye of a man.'

Munch has left us an exact description of how he came to invent the image of *The Scream*. He was taking a walk one evening, feeling tired and ill, and in this mood observed the sun setting over the sea and the clouds burning fiery-red. He was possessed by a consuming fear, and felt in the fibres of his being a loud, unending scream piercing nature. The painting that resulted is one of a cycle of pictures Munch called *The Frieze of Life* in which he revealed his deepest feelings about life, love and death. Through them all runs the undulating line of the shore and the waves of the sea.

The face is transfixed and frozen, contorted in a dreadful, anguished scream of fear and pain, and the sunset a fiery blood-red, like the sunset that inspired it. The swirls of rough paint flow across the painting as though they are about to engulf the foreground figure. Behind are two mysterious people: perhaps they stand for approaching death. Man at the mercy of terrible forces beyond his control, forces within himself maybe, is exposed in this strange, powerful and unnerving painting.

Henri de Toulouse-Lautrec (1864–1901)

At the Moulin Rouge (1892)

The Art Institute of Chicago

Henri de Toulouse-Lautrec was the son of a French aristocrat. As the result of two accidents as a boy, in which he broke first one leg and then the other, he was crippled for life: his legs never grew normally, and he became a grotesque figure with the body of an adult and the legs of a child. He began to paint during the periods of convalescence from his accidents, and went on to study art in Paris. His physical disability had had a psychological effect on him too, and he led a decadent life, seeking the company of people who would accept him without discomfort. He mixed with singers, dancers and prostitutes, entertainers of the music hall, the circus and the cabaret with

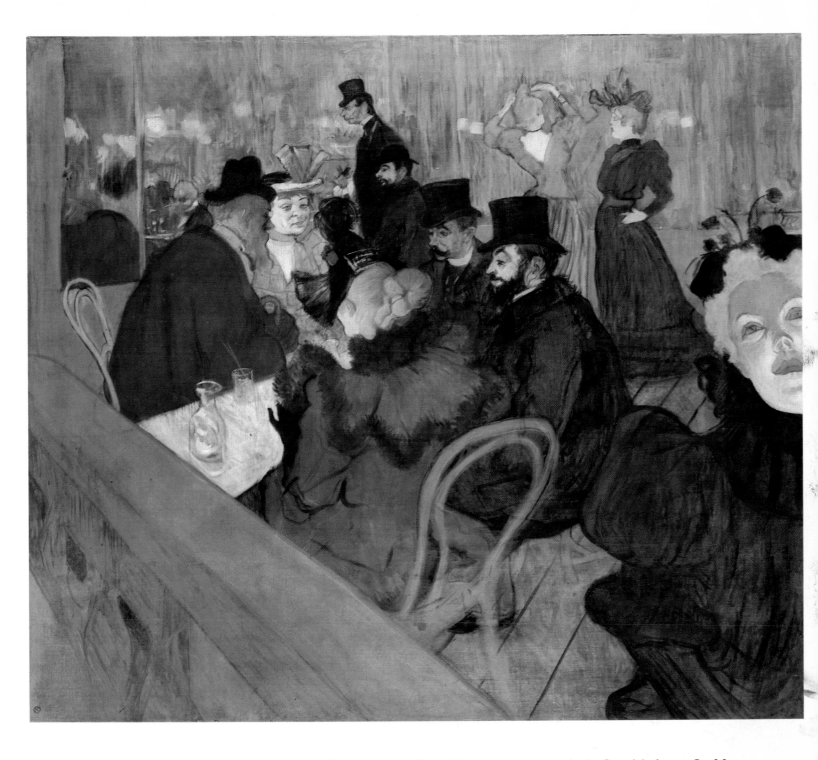

whom he felt at ease. These people and other artists formed the subject matter of his art.

He had an infallible eye for design, a gift for conveying movement and atmosphere in a few rapid strokes, and he recorded what he saw without implication of any kind.

At the Moulin Rouge shows his world, unique and full of gossip. The Moulin Rouge (where the can-can was made famous) was a music hall at the centre of Bohemian life in Montmartre, and Toulouse-Lautrec, initially through the medium of posters, made many of its stars immortal, and made his name as a painter.

The inhabitants of the room are arranged in an apparently accidental way, but the painting is in fact made up of precise diagonals formed by the table, the balustrade on the left and the planks on the floor. The brilliant hennaed hair of the woman with her back to us is echoed throughout the composition, so that colour as well as line unifies the picture; she also provides a striking focal point.

In the foreground a woman stares out at us, her face mask-like under heavy makeup. She is only partially visible, as if her movement has been caught as it would be in a photograph. Lautrec's friends sit drinking absinthe (a powerful liqueur which was popular in their circle) and talking at the table in the centre. Amongst

them is the Spanish dancer La Macarona, her bright red lips in a rather jaded smile. The artist himself can be seen at the back, his top hat barely reaching the shoulder of his cousin next to him; to the right a famous dancer at the Moulin Rouge known as La Goulue (The Glutton) arranges her hair.

There is a feeling of continuous activity, as if the artist actually is part of the scene he has painted, and the movement in the picture is going on all around him. Mirrors reflect the crowded, smoky, slightly out-of-focus haze of the room, accentuating the life and the atmosphere of the place which Lautrec has caught vividly.

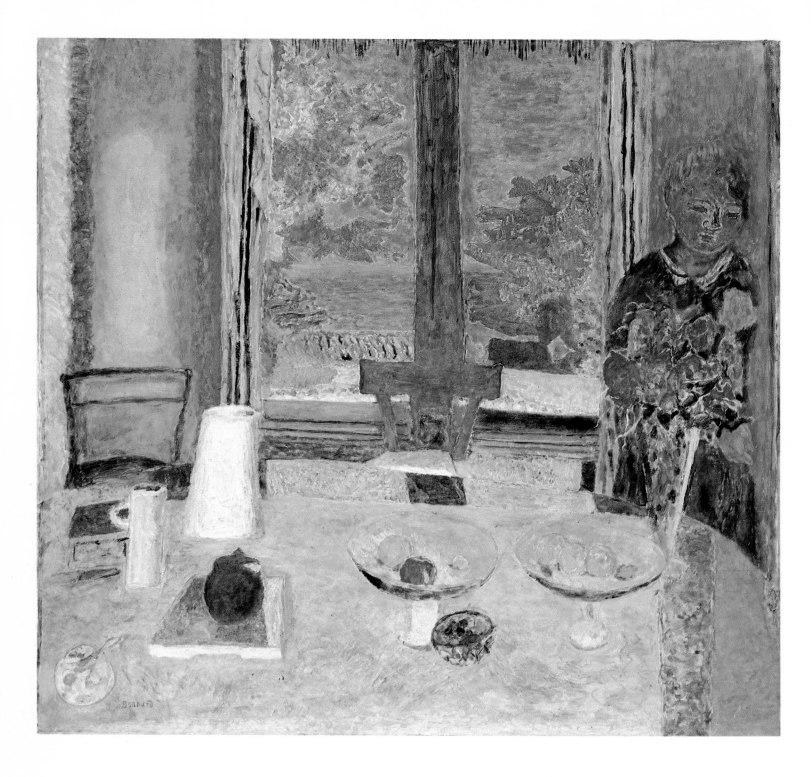

Pierre Bonnard (1867–1947)

Dining Room on the Garden (*1934–5*)

The Guggenheim Museum, New York

After three years of studying law, Pierre Bonnard entered the Ecole des Beaux Arts in Paris. He designed for the theatre, and was a superb graphic illustrator and printmaker, but it is above all the subject matter he chooses for his paintings – quiet interiors and intimate family life – and his dazzling patterns of colour that are the most outstanding characteristics of his

work. In some of his interiors there are no people; he concentrates simply on the objects of domestic life. In others a woman is sleeping, dressing or bathing, or a family is gathered round a table in a peaceful room.

Dining Room on the Garden is a scene from a seaside villa where Bonnard and his family spent the summer of 1934. The woman, painted three-quarter length in elegant dark clothes, her figure anchoring the composition, is his beloved wife Marthe.

The painting glows with clear bright colours both in the room and in the view of the garden, the sea and the sky through

the window, and they are remarkable for the way they intensify each other as blue turns to green, violet to blue, orange to yellow, scarlet to turquoise.

The vertical lines of the walls and window and the horizontals of the table and sky-line accentuate the feeling of order and stability. On the table's tip-tilted surface are plates of fruit, jugs, boxes, a jam-pot, everyday items that imply an ordinary life, but one full of deep contentment and joy.

Edouard Vuillard (1868–1940)

Mother and Child (c. 1899)

The Glasgow Museum and Art Gallery

Edouard Vuillard spent practically all his life in Paris. He was the son of an army officer and expected to become a soldier too, but he developed an interest in painting when he was at school and went on to study at the Académie Julien.

When his father died, his mother, whose own family were in the textile business, turned to dressmaking to support her children, and this domestic feminine atmosphere no doubt influenced Vuillard's lifelong choice of subject matter. His work is closely linked with that of his friend Bonnard, and like Bonnard he was a painter of family scenes and intimate domestic life. He painted people in drawing-rooms and bedrooms, at dinner parties, in private gardens and public parks. Moments of affection, conversation and rest are depicted in flat patterns of brilliant colour, worked together so that the whole composition is united like a mosaic. Vuillard sketched constantly, and continually photographed his friends; these visual diaries provided him with relaxed, informal references for many of his paintings.

In *Mother and Child* the two figures – a woman in a blue robe with her young child in her arms – emerge from a kaleidoscope of brilliant, glowing colour that fills the room. The furniture, the bedspread and the picture on the wall reflect the light and heighten the dazzling effects of the colours around them.

The woman's face is turned towards her wide-eyed rosy-cheeked baby. The warmth of the colours and the close-knit patterning of the entire composition reveal the love as well as the physical bond between them.

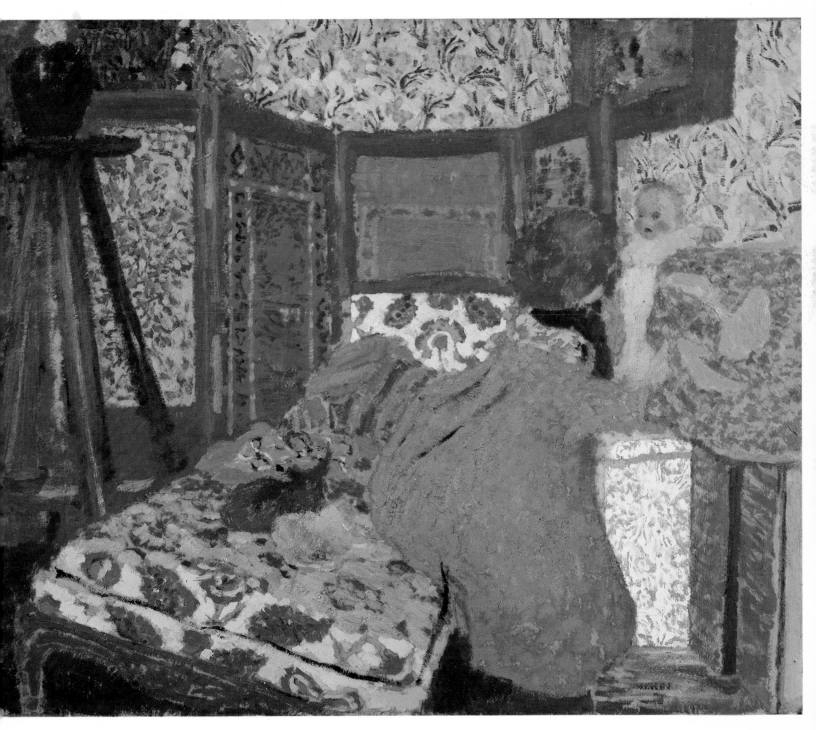

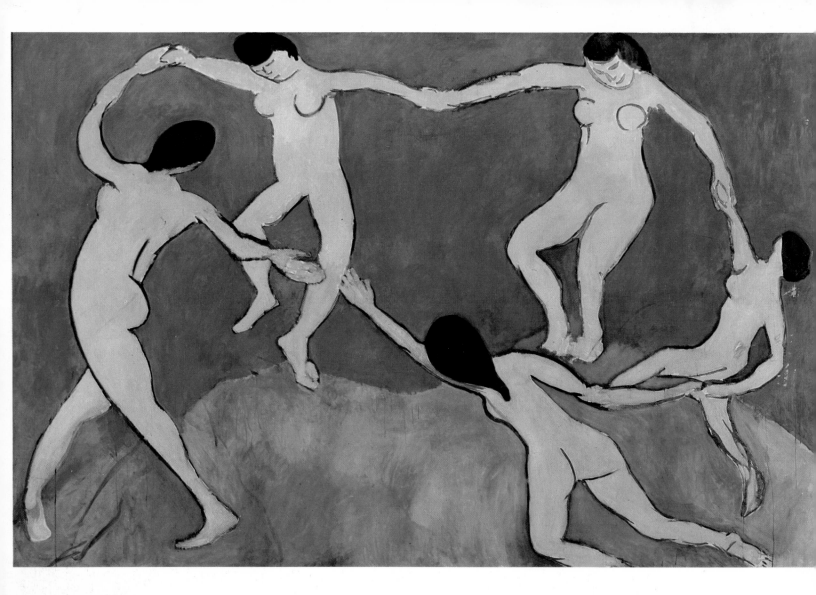

Henri Matisse (1869–1954)

Dance (1) *(1909)*

The Museum of Modern Art, New York

Matisse had an orderly and brilliant academic mind; he would probably have been a lawyer if he had not turned to painting to amuse himself during a period of convalescence from appendicitis. As a result, the world of art gained one of its most outstanding and admired figures of the twentieth century.

What began as a diversion for Matisse became an obsession, and he gave up his legal training and joined the studio of Gustave Moreau in Paris. He was influenced by the Impressionists, and particularly by the work of Cézanne. But he broke away from their gentle studies in light, and by 1905 had become the leader of a group of artists known as Les Fauves, the wild beasts, because of their use of violent explosive colour and aggressively rough paint textures. He was also much drawn to the formality, the inventive patterns and the colours of Islamic art,

particularly after a visit to the great Islamic exposition in Munich in 1910. This influence can be seen in the pure, contrasting colours and shapes of most of his work. He turned his talent to sculpture and printmaking, books, murals and designs for the theatre as well as painting.

His subjects were mainly domestic interiors, scenes framed by windows, and – above all – the female form. He said, 'What interests me most is neither still life nor landscape, but the human figure. It is through it that I best succeed in expressing the almost religious feeling I have towards life.'

Dance and *Music* were two decorative panels produced for the Russian collector Sergei Shchukin, which explains why they are now, after confiscation from private ownership, in the Russian state collections. But Matisse had initially produced for Shchukin's inspection another full-scale version of *Dance* – over eight-and-a-half feet high and nearly thirteen feet wide – and this is the one that is now in the Museum of Modern Art in New York. In it Matisse probably used as his starting point a ring of dancers from

the background of his own painting *Bonheur de vivre*. 1909 was the year Diaghilev and the Russian ballet arrived in Paris, and dance was a topical subject. The figures are dancing on a hill (a traditional site for ancient mystic rites and ceremonies), but it is as if they are afloat in the blazing blue sky, their feet barely touching the ground.

Their five naked bodies, linked in a circle, are painted in clear flat colour without shadows, and the simplified outlines of the figures stand out very strongly against the background. They are drawn without detail, but the movement of their limbs and twisting bodies is realistic and full of life. The vibrant blue and green of the sky and the grass are perfectly balanced and extraordinarily intense. The total effect of this striking painting is one of primitive joy and exhilaration, communicating the joy Matisse derived from brilliant colour and dramatic forms.

Gustav Klimt (1862–1918)

The Kiss (1907–8)

Osterreichische Galerie, Vienna

Klimt lived and worked in a scandalous city at a scandalous time: Vienna in the late nineteenth century. It was a hothouse of creative activity, producing the deliciously amorous operas of Richard Strauss, the salacious witty plays of Arthur Schnitzler, and a new wave in art and architecture called 'Jugendstil' (Young Style) a variant of Art Nouveau. All this came together with a new sexual freedom and an emphasis on the female form to produce the highly erotic work of Gustav Klimt.

He was the son of a gold and silver engraver, and this influence can be seen in his craftsmanship, and in his extensive use of gold. He set up a highly successful artists' workshop which provided mural decorations for public buildings and private houses. By 1898 he was both founder member and president of a newly formed artists' society, the Vienna Secession, and had embarked on an intellectually fashionable career. His later style was much influenced by a visit he paid in 1903 to Ravenna, where he was dazzled by the ancient mosaics which decorate the churches. This is evident in the rich ornament and intricately worked small areas in his pictures which are linked to form complex, tightly-knit patterns.

Klimt was naturally a silent man, but he expressed himself eloquently through his art. He never married, but he adored women and often painted them. *The Kiss*, his most famous painting, was shown in 1908 at a major exhibition in Vienna, and, in spite of its suggestiveness, it was bought by the Austrian government.

Against an enormous golden sky a man and a woman are embracing, naked under their richly patterned cloaks. The man's head is garlanded and the woman's red hair adorned with star-like flowers; his cloak is decorated with strong vertical rectangles, and hers with circular flower forms, to accentuate their sexuality. They are sinking together on to a carpet of flowers, and the woman's eyes are closed in ecstasy as he kisses her. She is supported by his arms, her hand resting lightly on his neck, only her toes stretched to balance her, and to increase the erotic tension of the painting.

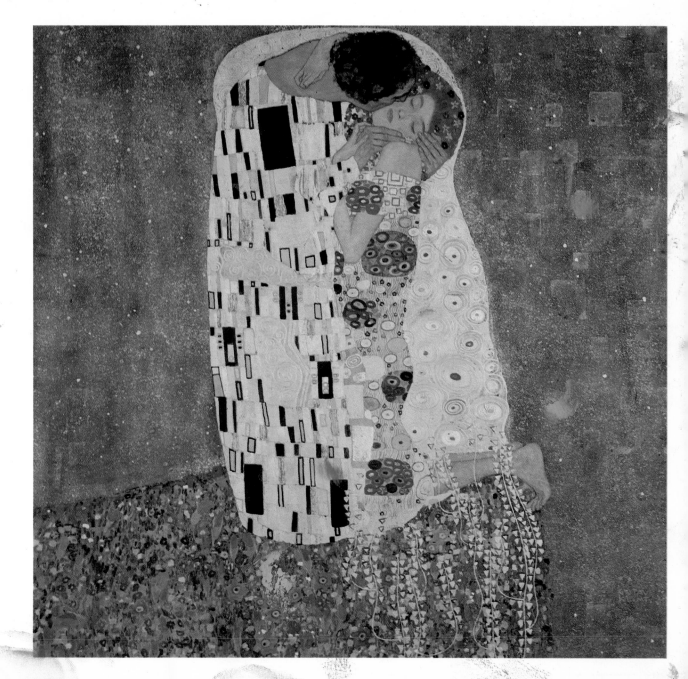

Pablo Picasso (1881–1973)

Les Demoiselles d'Avignon (1906–7)

The Museum of Modern Art,
New York

The Spanish artist Pablo Picasso was probably the greatest artistic genius of the twentieth century. He was first taught by his father, and showed exceptional talent at an early age. He exhibited and won awards when still a boy, and went on to study at the academies of Barcelona and Madrid. In 1900 he visited Paris, and by 1904 had settled in France, where he spent the rest of his life.

His early work is much concerned with poverty. His 'Blue Period' – showing the squalor of the Paris streets – produced some of his most famous pictures, and began his immense, lifelong success. His personal life was complicated by a series of mistresses, wives and children whom he used as subjects many times.

All Picasso's work in any style – and there are many – is concerned with his love of life, expressed through the eternal themes of birth, love, death and war.

He was astoundingly productive in a variety of media and techniques: drawing, sculpture, painting, print-making and ceramics. Over a score of volumes have already been published simply cataloguing his work. He had two great strengths beyond his remarkable technical expertise and outstanding energy: he could assimilate with almost alarming ease the art of many other cultures and other European artists, and combined this ability with his own imagination, verve and wit to extend the scope of art. He participated in all the movements of his own time, while remaining individual and becoming permanently identified with none.

Les Demoiselles d'Avignon, started when Picasso was only twenty-five, began a

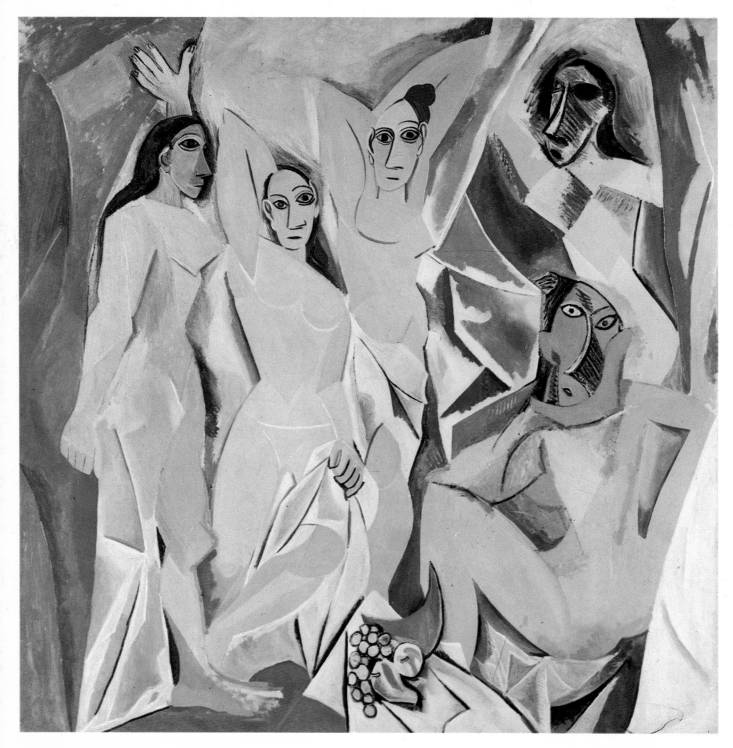

remarkable phase in his work. Artistic innovations do not come about in a vacuum: Picasso drew on the influence of African sculpture and the work of Cézanne and Matisse in this painting, and it is therefore a meeting place for the traditions of primitive and contemporary art, disrupting both to create something new and disturbing. The harsh angularity and distortion of the almost naked figures, heralding the movement known as Cubism, are as disconcerting and alarming now as they were for Picasso's astonished fellow artists.

The title of the painting comes from a street in the red-light district of Barcelona, and the five statuesque females are presumably prostitutes, their gestures aping those of sexual invitation. Two women in the centre face towards us but their noses are painted in profile; two others wear frightening masks, one of them shown both full face and in profile although the woman has her back to us. As became typical of Cubist paintings, the colours are flat and unemphatic, limited to flesh tones and a muted background, with the result that the firm, deliberate outlines dominate the painting. The five women are simultaneously passive objects and aggressive predators, and the painting has a mood of restlessness and violence, and a strange primitive energy. Its influence has been vast, and it has become one of the most famous works of art of this century.

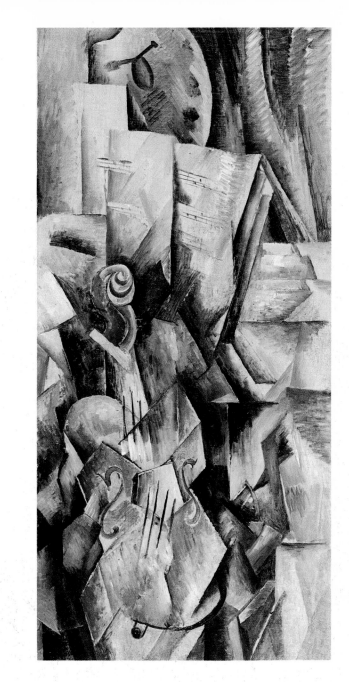

RIGHT

Georges Braque (1882–1963)

Violin and Palette (1909–10)

The Guggenheim Museum, New York

Georges Braque was the son of a house-painter and amateur artist. He was first apprenticed to a decorator at Le Havre, but soon went to Paris, where he fell under the spell of Cézanne and Picasso. It was a period of intense activity and inventiveness in Paris, and Braque became one of the leaders of a new group with new ideas and new ways of expressing them. He was one of the innovators of collage; and he turned with Picasso to the depiction of still life, landscape and portraits in the manner which came to be known as Cubism. Many people believe it to have been the most influential movement in modern art.

After the First World War Braque's style developed in the direction he was to follow for the rest of his life. He produced large still-life and figure compositions with perfect harmony of colour and design, incorporating many of the aims of Cubism. He was the first artist to have his work exhibited at the Louvre in his own lifetime.

Violin and Palette reveals that the depiction of an object can be highly complicated. The Cubists combined several different aspects of an article in one painting, in order to give as full a description of it as possible. Whereas a painting is static and hangs in one place, in life we move about and have different vantage points, and Braque wanted to show not only three-dimensionality on his flat painted surface, but also the feeling of movement which exists in life. Painting facets and fragments of objects was, in his own words, 'a means of getting as close to

the objects as painting allowed.' He was especially drawn to musical instruments, which involve the use of other senses to bring them to life.

Here almost everything is distorted, except the nail on which the palette hangs in the top left corner, and the fact that the nail and its shadow are painted with conventional realism emphasizes the distortion of the other objects. Yet this strange technique does bring us into closer contact with them by drawing our attention to every angle and facet. We understand more about them as a result of their fragmentation, and begin to see them with greater insight.

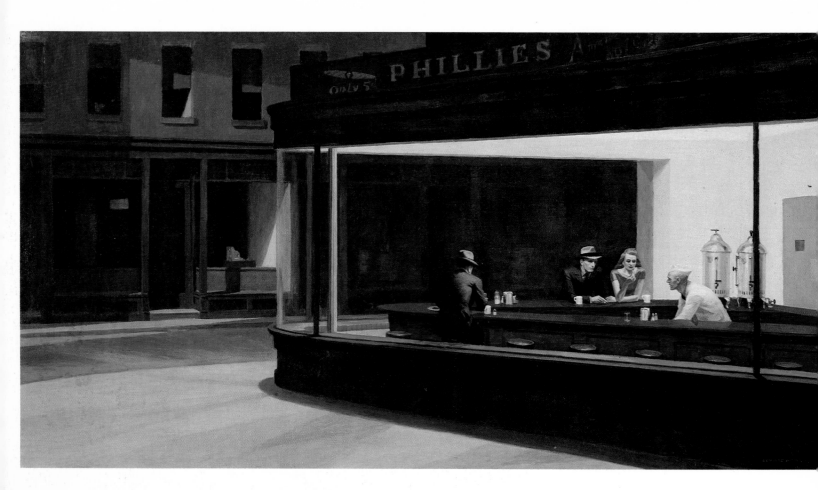

Edward Hopper (1882–1967)

Nighthawks (1942)

The Art Institute of Chicago

Edward Hopper was one of the pioneers of twentieth-century American realism. He painted scenes from the country of New England and the city of New York: backwater scenes – old shabby houses, a few people waiting at a cinema, a street early on a Sunday morning or a lonely garage at dusk on a country road. He painted an America of loneliness and isolation, whose citizens lead lives of spiritual poverty, and he found a sad, touching beauty in their desperation.

The city scene *Nighthawks* is filled with the atmosphere of depression and anxiety at the start of the Second World War. The clothes of the people at the all-night 'lunch counter' and the lettering outside, as well as the mood of the painting, are strongly evocative of the 1930s and early 40s. The upper windows have their blinds halfway down, the windows of the shops are bare, and the city is silent. A harsh fluorescent light ruthlessly exposes the small group of people as though they are on a stage, and floods through the glass walls on to an empty street, its effect heightened by the surrounding darkness.

A man is seated with his back towards us, a little hunched up, as though he is drawing comfort from a drink in front of him. A couple wait to be served; they are together, but they appear to have little to say to one another. Hopper's people are passive; they seem resigned and desolate, unable or unwilling to communicate. The hard light gleams on two large metal coffee urns, making them look strangely dramatic and menacing.

The paint is applied quite thickly, and the intense, bitter colours reflect the glare. The composition is made up of simple, stark horizontal and vertical shapes, which emphasize the bleakness of the environment, and make the people seem more vulnerable.

Hopper thought of his art as 'intimate transcriptions from nature', and he denied any social message or purpose, but he conveys through his paintings such a deep understanding of human isolation that we can identify with this silent group.

Amedeo Modigliani (1884–1920)

Woman with a Fan (*1919*)

Le Musée d'Art Moderne
de la Ville de Paris

Amedeo Modigliani's short and tragic life contributed his own particular vision of women to the world's art.

A member of an Italian-Jewish banking family, he was born in Leghorn, and studied art in Italy before going to Paris in 1906. He was good-looking, fond of women, and addicted to drugs and alcohol. He said, 'I am going to drink myself dead', and it was drink and drugs, combined with tuberculosis, which killed him at the age of thirty-six.

He spent his adult life in Paris, then the art capital of the world, and lived a poverty-stricken existence with his artist friends, who were equally young and struggling. He carved in stone for several years as well as painting, and turned to painting exclusively in about 1915; neither his health nor his finances permitted further sculpture. His work consists almost exclusively of portraits, and they are so skilled that although the exaggerations of his style are always recognizable, so is the individuality of each sitter.

The face of a Modigliani woman is a pronounced oval, set aslant on a long neck which emerges from sloping shoulders. The almond-shaped eyes are often all pupil, the nose long and splayed out at the end, reminiscent of noses in African art. The mouth is small and pinched. Yet the results, in spite of these unpromising ingredients, are strong and sensual and often very graceful. His colour range was deliberately limited; he managed to extract extraordinary expressiveness from a range of reds, blacks and flesh tints.

In *Woman with a Fan*, thought to be a portrait of a Polish woman Lunia Czechowska, all these features are present. The body is elongated, and her curving shape is as formal and poised as a lily. Her fan is held correctly and elegantly, its angled markings echoing the sharp indentations in her flesh which indicate Modigliani's interest in the use of line. Her face is smoothly modelled, almost like a piece of china. The result is wistful, sad and beguiling, typical of this artist's unique and distinctive work.

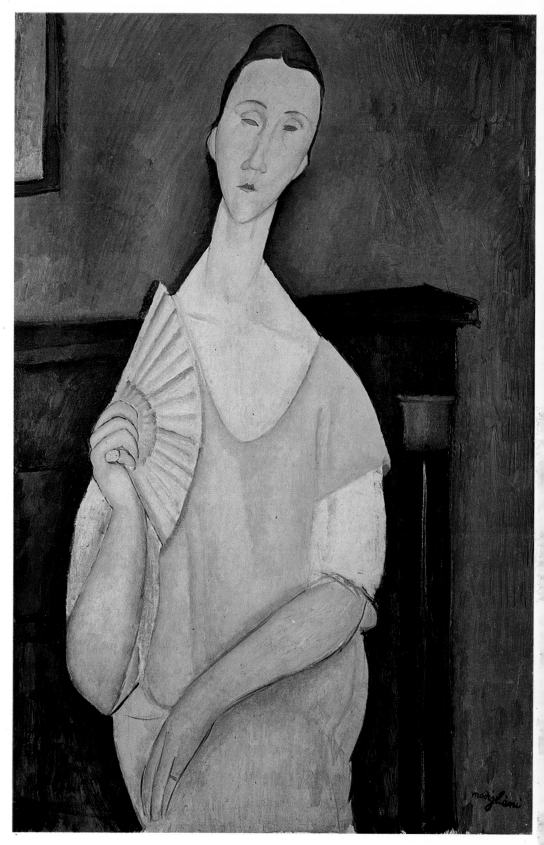

Marcel Duchamp (1887–1968)

Nude Descending a Staircase (2) *(1912)*

The Philadelphia Museum of Art

Duchamp was born in France, the son of a notary who disapproved of the artistic tendencies of his children: four of them became painters, and Marcel Duchamp developed into one of the most influential and puzzling figures of modern art.

He studied art in Paris, and supported himself in France and America by giving French lessons, illustrating, designing, and working as a librarian. His early paintings were fairly conventional and he experimented with all the styles which had recently preceded him: Impressionism, Post-Impressionism, Fauvism, and Cubism. Finally he branched out into entirely new regions, and became one of the leaders of the anti-art movement known as Dada, which was intended to outrage and scandalize the public and the critics, to promote anarchy, and to dispel some of the preciousness of the 'Fine Arts'. One example of this is Duchamp's copy of the Mona Lisa, adorned with a moustache.

His enquiries into the nature of art were serious and constructive. His revolutionary ideas, and his invention of the concept of the 'ready-made' – in which ordinary everyday objects already in existence (usually manufactured) are exhibited as art – have caused considerable controversy, but they have opened our eyes to new possibilities. Duchamp was highly provocative and contradictory in his ideas and attitudes, declaring 'What the artist chooses to be art *is* art'; 'I have forced myself to contradict myself in order to avoid conforming to my own taste'; 'It is the *spectators* who make the pictures'. Enigmatic, elegant, witty and brilliant as he was, Duchamp could never resist this kind of teasing, but it was partly intended as an encouragement to other artists to be open-minded and adventurous.

One of his last 'conventional' paintings, *Nude descending a Staircase*, caused a scandal at the great show of 'advanced' art at the Armoury in New York. The painting reveals Duchamp's interest in photography, in which the various stages of an action could be arrested in a series of still photographs. He transferred this technique to canvas by means of a succession of outlines of a figure, used to create an illusion of continuous movement. The dotted lines in the centre show the swinging movement of the pelvis. By examining a single figure from different angles, and simultaneously suggesting movement, Duchamp was adapting the principles of Cubism to suit his own individual ideas. He also used their restricted palette of greys and browns in order to concentrate the eye more closely on line and structure.

This impressive and elegant painting is typical of the spirit of intelligent investigation that characterized his work.

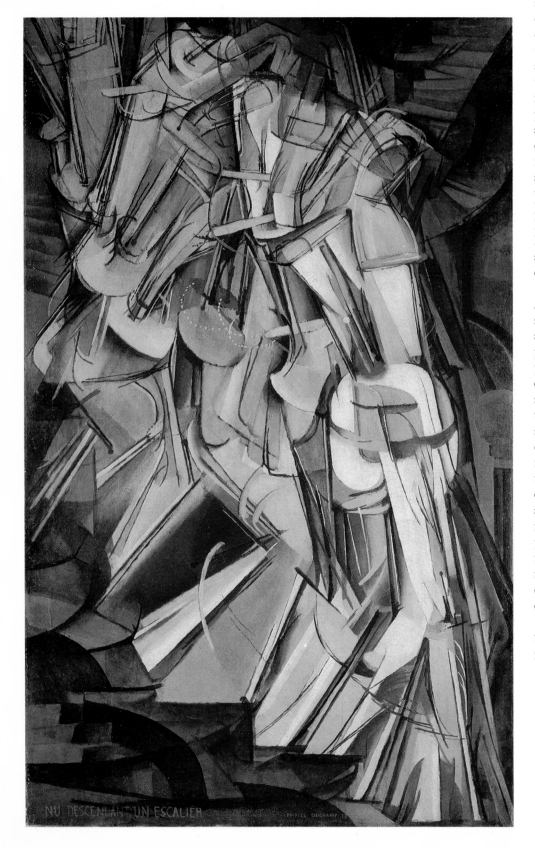

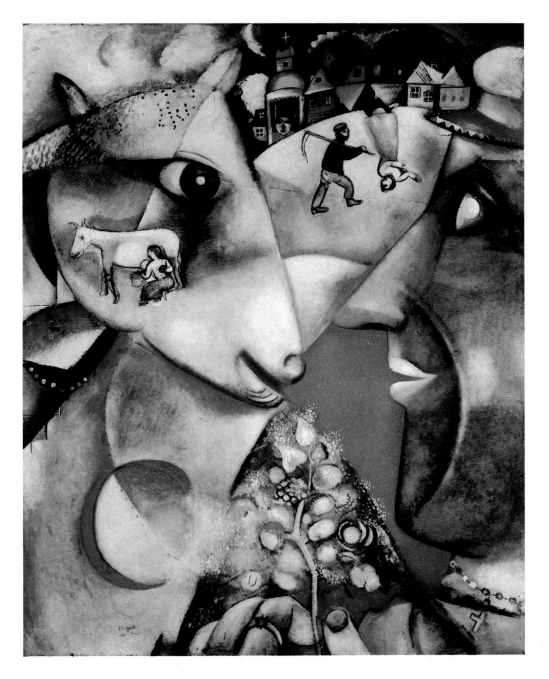

ABOVE

Marc Chagall (b. 1887)

I and the Village *(1911)*

The Museum of Modern Art, New York

Marc Chagall, artist, painter, print-maker, designer of sets for ballet, decorative work for public buildings and magnificent stained glass, has created a body of work which is among the best-loved of the twentieth century.

He trained in Russia, but in 1910 was sent by a benefactor to study in France, where he absorbed the richly creative atmosphere of Paris at the time. He returned to Russia, married his childhood sweetheart, and supervised an art institution until it became apparent that his art was unacceptable to the régime. He returned to France, and most of his life since has been spent there.

The majority of his paintings weave memories of his Russian up-bringing with fantasies, folk tales and fables; others have religious subjects, and show the importance he attaches to Jewish beliefs and traditions.

His figures are often adrift in space in a world that seems naive, but in fact it is carefully constructed to express his ideas about life and religion. His use of colour is brilliant and highly individual.

I and the Village was painted in Paris in the course of his first prolonged stay, but it is full of images from the Russian village in which he was brought up. It is a youthful painting, experimental and daring.

As if in a dream, a young man offers a bunch of flowers to a beautiful cow, while a milkmaid – his sweetheart perhaps – is milking another cow, superimposed in miniature. At the top of the painting are the houses of the village; and from one of

them a gigantic head is peeping out. A young man marches up a hill, his farm implement on his shoulder, and a village girl, upside down, beckons him on.

The elements of the painting are not clearly related, and this dream-like un-reality was to have a lasting influence on modern painting. The glowing colours, soft and transparent, fill the scene with a wistful charm, and the simple images are gay and witty. Chagall must have immersed himself in the past to produce this nostalgic vision of the village and the people who meant so much to him.

René Magritte (1898–1967)

Time Transfixed (*1939*)

The Art Institute of Chicago

René Magritte was the son of a Belgian businessman, and the eldest of three brothers. Most of his life was spent in Brussels, where he studied for several years at the Académie des Beaux-Arts, and for a while supported himself and his wife Georgette by designing wallpaper and commercial catalogues. In the 1920s he began to paint full time, and during a few tremendously productive periods he produced a painting a day.

He spent five years in Paris from 1927–32, and joined a group of painters who came to be known as the Surrealists. The movement developed from Dada, and its object was to explore the subconscious mind, and provoke an emotional and instinctive reaction to the world that was free from preconceptions.

With the dream-like clarity and enormous inventiveness typical of the movement, Magritte combines ordinary everyday objects in an incongruous and startling way that is often funny and always surprising. He worked in a bland, deadpan manner, the paint smooth and dry-looking, the colours usually dull browns, blues and greys, which makes the strange mixtures of unrelated objects seem normal and convincing, and the effect therefore even more disconcerting.

Most of Magritte's work was the result of a long period of reflection, but *Time Transfixed* appeared to him spontaneously, like a sudden vision. It shows a mantelpiece, as anonymous and simple as most of the elements in his paintings, with empty candlesticks and a clock reflected in a large mirror. From the empty fireplace a locomotive engine rushes into the room, smoke and steam pouring up the chimney from its funnel.

A train is associated in our minds with motion, and a clock is of course the emblem of time, but they are used here in a sort of double bluff: as a reminder of life rushing on and as an implication, because a painting can only capture a split second, of time and movement transfixed. The painting has a logic of its own, and a distorted connection with reality, which makes it seem as if the impossible could easily happen.

An unnerving tension is set up when one is faced with something unexpected, and Magritte, by creating an Alice in Wonderland world of his own inventing, full of illusions and surprises, jars us out of our preconceptions about the world we take for granted.

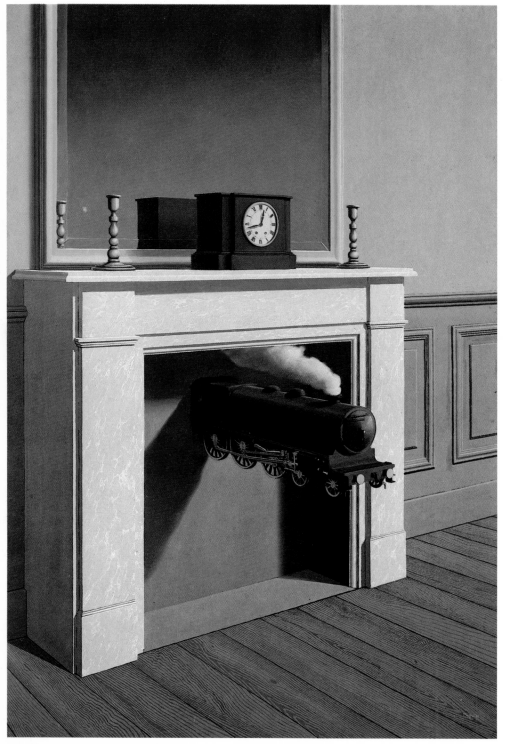

Salvador Dali (b. 1904)

The Persistence of Memory (*1931*)

The Museum of Modern Art, New York

Perhaps the most spectacular personality in twentieth-century painting is Salvador Dali. He was born in the Catalan region of Spain, and at seventeen went to Madrid to study at the School of Fine Arts. He

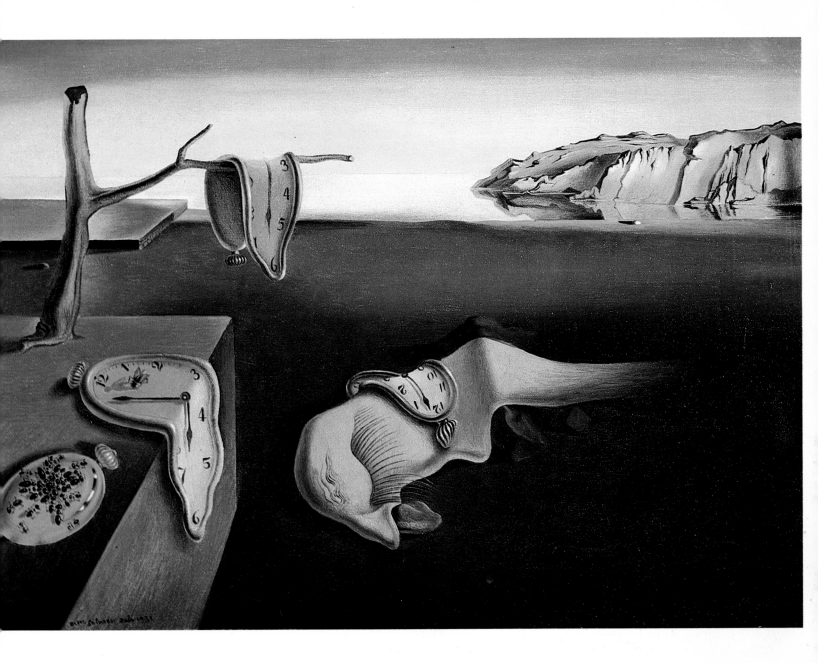

was suspended and finally expelled for his outrageous behaviour and refusal to conform. He moved to Paris, where he joined and became one of the leaders of the Surrealist Movement, and as a result of his inventive genius and his flair for personal publicity he has become its most famous representative.

His egotism, narcissism and showmanship have all contributed to the exotic legend which surrounds him. (On the occasion of the International Surrealist Exhibition in London in 1936, Dali lectured in a complete deep-sea diving-suit.) In 1937 he was expelled from the Surrealist Movement, and left for America. Since then he has moved from one extreme to another: from embracing revolutionary politics and producing highly provocative work, he has turned to religious pictures and right-wing orthodox views. His life and paintings have always caused violent reactions, but he

has defined the aims of Surrealism more precisely than any other artist. The work of Magritte is intellectual and turns physical laws upside down to express an idea; Dali appeals directly to the emotions for an instinctive spontaneous reaction, and he does it with enormous technical skill and originality.

The Persistence of Memory is an early work, and one of his most fascinating. In a flat deserted landscape, probably based on the coast of Catalonia, Dali has created the weird images of three limp watches. They are draped like rubber or plasticine: one from a branch of a dead tree growing out of a wooden platform; another, with a fly on the glass, over the edge of the platform itself; and a third folded over what might be a distorted head on the ground. Glistening ants have gathered on the metal back of an apparently normal watch turned face downwards. The limp watches have been compared to the human

tongue, and they may have some erotic symbolism. Dali himself has characteristically said that the idea came to him when he was eating a ripe Camembert cheese. His autobiography *Diary of a Genius* tells us that he experienced hallucinations in his childhood; as the title of the painting suggests, perhaps the subject was inspired by persistent visions and memories from the past.

Like a dream, the picture is probably impossible fully to explain. Although harmless, its images are threatening and disturbing, both because they are unexpected and because they are so convincingly real. Dali's exaggeratedly precise drawing and brushwork and transparently clear colours in the brilliant Mediterranean light create a clinically accurate illusion of reality, which is alarming, amusing and brilliantly inventive.

Francis Bacon (b. 1909)

Figure in a Landscape (1945)

The Tate Gallery, London

Francis Bacon is one of the few internationally significant English painters of this century. His parents were English, but his father was a horse-trainer in Dublin, and Bacon was born and brought up there. In the 1920s and 30s he designed furniture, rugs and interiors, and he also began to paint. He spent considerable periods in Berlin and Paris, the two major centres of artistic activity at the time, but is entirely self-taught.

Two principal strands run through his work: the disturbing unexpectedness of Surrealism and the fervent, sometimes destructive, emotions explored in Expressionism (see p. 98). The majority of his paintings are concerned with isolated human figures. Most are portraits, authentic if physically distorted, of people known to Bacon, and almost all of them are represented as caged in some way. Behind many of his disquieting images is the distress, physical and psychological, of Europe during the Second World War.

Figure in a Landscape is a picture of Bacon's early maturity, based on a photograph taken of a friend dozing in a chair in a London park. It was painted in the last year of the war: the park railings and chair have been turned into weapons; the masculine figure is headless.

The terror Bacon portrays is heightened by his smoothly confident brushwork, sombre colours and exceptionally imaginative use of space: the central arch

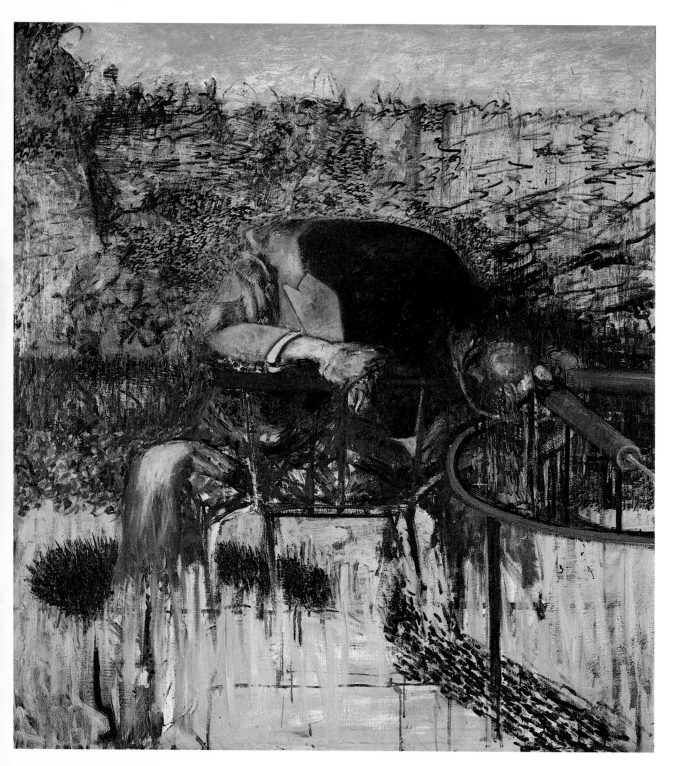

opens into a black tunnel, which both anchors the composition and suggests that a void is its focal point, underlining the mood of helplessness and anxiety.

Bacon's figures are palpitating, trembling beings, isolated and terrified in a hostile environment, and they convey all the frustration, loneliness, degradation and brutality that exists in the modern world. His work is immensely powerful and he is thought by most of his contemporaries to be the greatest living British painter.

Andrew Wyeth (b. 1917)

Christina's World (1948)

The Museum of Modern Art, New York

In his own country Andrew Wyeth is the best-known and most popular American artist of this century. He was the first artist to appear on the cover of *Time* magazine, his work commands high prices, and his exhibitions have record-breaking attendances.

He is the son of a popular illustrator N. C. Wyeth. As a result of ill health as a child he was educated at home at Chadds Ford, Pennsylvania, and taught to paint by his father. His own son James is also a painter, so three generations of one family have now lived and painted in 'Wyeth country'.

Andrew Wyeth has travelled very little, but he has explored in detail the farms, houses, land and people around two small areas of the east coast of America: Chadds Ford and Cushing, Maine. He has said that 'It is not the country but what he carries to it that makes an artist.' His meticulous technique, depicting everything with a heightened accuracy, has led to him being called a magic- or super-realist.

In *Christina's World* a young woman sits with her back towards us; she is wearing a brilliant pink dress, which stands out against the minutely variegated browns of the hayfield. Her arms and legs are emaciated as a result of polio, which in 1948 was still a terrifying and mysterious disease from which many people died. It is no longer the familiar scourge it was then, but the sympathy one feels for her pathetic figure is instinctive and unchanging.

There is a bleak beauty in the countryside. The simple stark farm buildings loom on the horizon beyond the enormous hilly field in which the girl sits, and the steeply sloping perspective of the painting gives us her particular viewpoint on life in an understanding and unusual way.

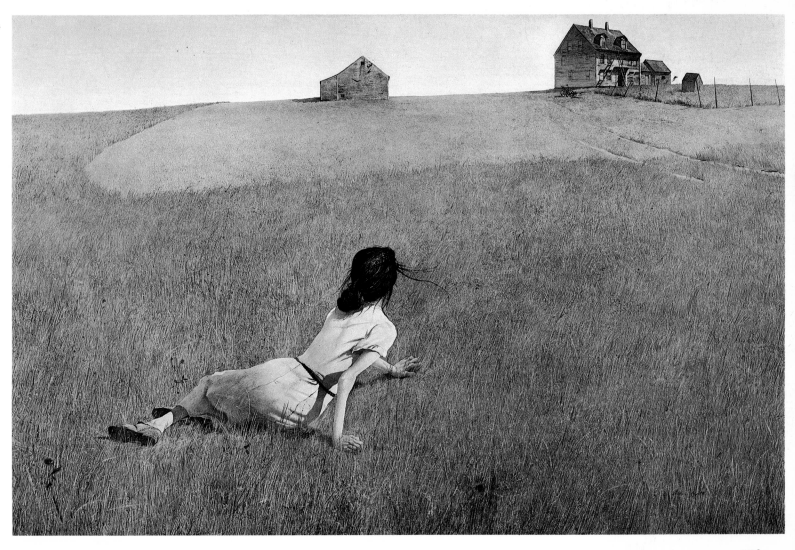

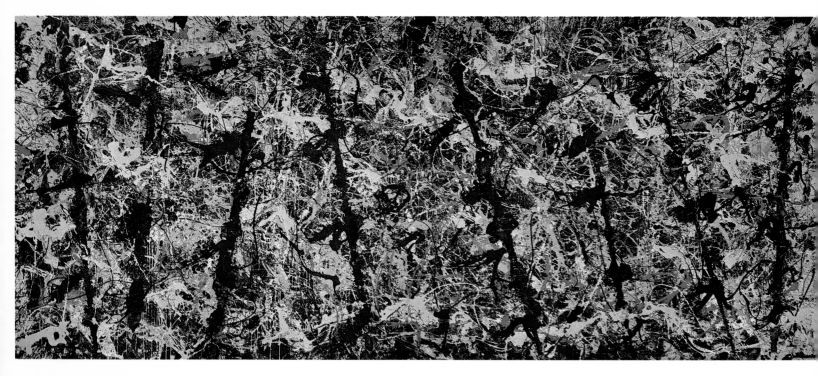

Jackson Pollock (1912–56)

Blue Poles (*1952*)

The National Gallery of Art, Canberra

Jackson Pollock was born on a farm in Wyoming, and his childhood was spent in Arizona and California. He studied art in Los Angeles and New York, and worked for the Federal Arts Project, a government-funded programme for artists which was part of President Roosevelt's New Deal to combat the Depression. He was killed in a car accident in his early forties, but he has left a legacy of over a thousand paintings. His subjects were abstract, and he was the greatest American exponent of Action Painting. Pollock underwent psycho-analysis, and his pictures seem to involve a release of tensions, as if he is allowing things to emerge from the depths of his subconscious.

His technique was unconventional: he spread a length of unprimed canvas on the floor, instead of stretching it in the usual way, and tacked it to the boards. He said, 'On the floor I am more at ease. I feel nearer, more a part of the painting, since this way I can walk round it, work from the four sides, and literally be *in* the painting.' He abandoned the use of brushes, and splashed or poured the paint straight on to the cloth. He wanted nothing to come between him and the colour itself. He felt that the painting had a life of its own, and if things went well it would come through. 'My painting is direct ... I want to express my feelings rather than illustrate them. . . . When I am painting I have a general notion as to what I am about. I *can* control the flow of paint: there is no accident. . . .'

The results are dramatic. *Blue Poles*, like many of his paintings, is very large. Skeins and streaks of brilliant colour weave a web in which one is almost engulfed. There are no recognizable forms depicted, and the spectator is free to interpret the result in whatever way he likes. It is different for each person each time he looks at it; and this changeable quality adds to its energy and vitality.

The purchase of *Blue Poles* by Australia's relatively new National Gallery was controversial: the price of two million dollars was thought to be high. Yet Pollock made a new and inventive contribution to modern art: he devised a method of painting in which old conventions are set aside and new disci-plines imposed, and the result is spon-taneous, stimulating and adventurous.

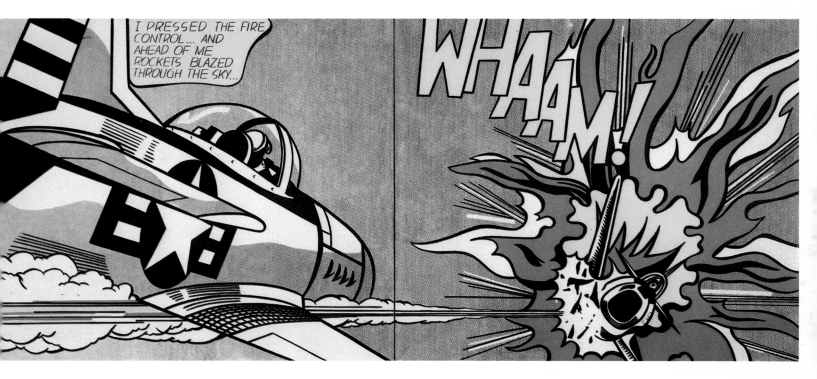

Roy Lichtenstein (b. 1923)

Whaam! *(1963)*

The Tate Gallery, London

Roy Lichtenstein is the best-known American Pop artist. Although he has worked with a variety of materials, including enamelled metal, brass and plastics, he is first and foremost a painter. His early career was spent as an engineering draughtsman and art teacher, but he made his name as an artist when he turned in 1961 to the development of his own highly individual style. It is based largely on the techniques and subject matter of commercial art: details taken from advertisements for everyday objects – a cooker with food in the oven, a foot on a pedal bin, golf balls and exercise books – all exaggerated and emphasized out of all proportion to the original subject.

In his most famous technique, derived from that popular and typically American medium – the strip cartoon – he magnifies the dots and imitates the primary colours used in cheap newspaper screen-printing. He simplifies and clarifies the sources of his ideas, paring them down to the bare essentials, and transforms them into stunningly powerful images.

The subject for *Whaam!* probably came from the comic *Armed Forces at War*. Lichtenstein was amused by the thought of repeating on such a vast scale its narrative theme – one aeroplane shooting down another – and using all the traditional clichés of strip cartoons: the speech bubbles, emphatic lettering with exclamation marks, spectacular stylized explosions and lurid colour.

Since it is in two separate sections, like part of a comic strip, the painting also harks back to medieval altarpieces, which often consisted of two or three panels, and the combination of these two incongruous traditions must have appealed to his sense of humour.

He has blown up the cartoon conventions to a massive size – the painting is over thirteen feet wide by five-and-a-half feet deep – and the effects created by this distortion are unusually powerful and exciting.

Lichtenstein's methods have not been imitated by any other major artist, but his subject matter has had a strong influence on modern art, and also on the commercial world which is his own starting-point. His work is typical of the energy and dynamism of post-war American art.

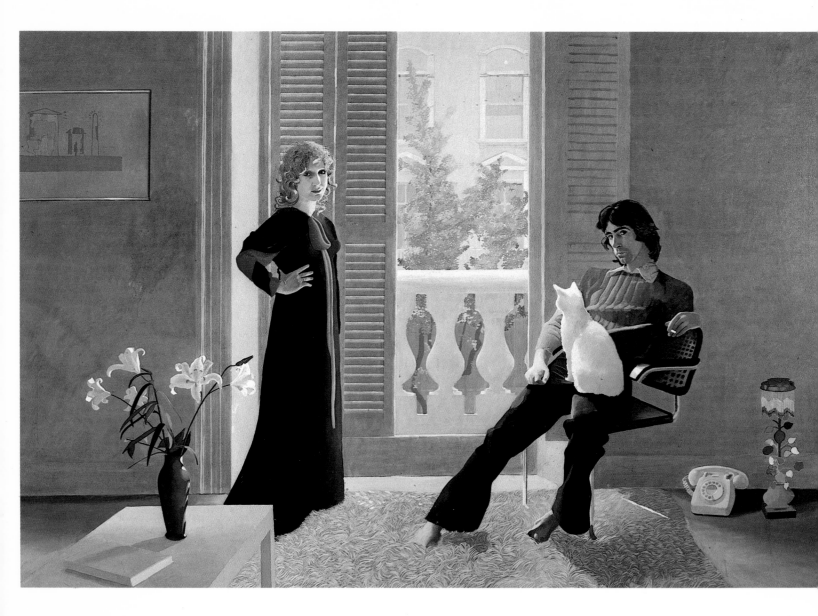

David Hockney (b. 1937)

Mr and Mrs Clark and Percy (1970–1)

The Tate Gallery, London

The British painter David Hockney was born in Bradford, Yorkshire, and studied there and at the Royal College of Art in London. His work is highly personal and not always very revealing or easy to grasp. It has a reticence and restraint, which makes it strangely elusive and intriguing. He is a gifted print-maker, and he has also designed sets for opera, including Mozart's *The Magic Flute*.

Mr and Mrs Clark and Percy is one of a series of portraits Hockney has painted of his friends in the last decade. The scene is a drawing-room on the first floor of a nineteenth-century London terraced house, a cool room with an uncluttered modern décor. The woman standing hand on hip by the shuttered window is Celia Birtwell, a fabric designer and the wife of the dress designer Ossie Clark, who is sitting with his bare feet buried in the deep pile rug on the floor. Percy, their large white cat, sits contentedly on his lap. A vase of lilies, a book, a white telephone, an art deco lamp, and a framed print by Hockney on the wall are all arranged with great precision. Their placing creates a perfect harmony and balance which gives the room its air of rather formal, calm stillness. Clear daylight falls across a white balcony; through the window, its shutters half open, we have a view of houses across a Bayswater street.

It is a controlled and cool study of two young and successful people from the world of fashion and art, the world Hockney himself inhabits. In its own way it forms a link with the group portraits which are so important a part of the British tradition of the eighteenth and nineteenth centuries.

Acknowledgments

The publishers are grateful to the following museums and art galleries for supplying transparencies for use in this volume:

ENDPAPER *L'Enseigne de Gersaint* Schloss Charlottenburg, Berlin–Dahlem
HALF-TITLE *Turner on Varnishing Day* The Guild of St George, Ruskin Collection, Department of Art History, University of Reading
The chart on pages 10–11 was drawn by Michael Fry.

12 *The Rucellai Madonna* Uffizi Gallery, Florence
13 *The Lamentation* Arena Chapel, Padua (Scala)
14 *The Annunciation* Uffizi Gallery, Florence
15 *The Arnolfini Marriage* National Gallery, London
16–7 *The Battle of San Romano* National Gallery, London
18 *The Deposition* Prado, Madrid (Weidenfeld and Nicolson Archives)
19 *The Annunciation* S. Marco, Florence (Scala)
20 *The Expulsion of Adam and Eve* S. Maria del Carmine, Florence (Alinari)
21 *The Baptism* National Gallery, London (John Gates)
22 *The Feast of the Gods* National Gallery, Washington DC (Widener Collection)
23 *The Martyrdom of St Sebastian* Louvre, Paris
24 *The Adoration of the Shepherds* Uffizi Gallery, Florence
25 *The Birth of Venus* Uffizi Gallery, Florence
26 *An Old Man & His Grandson* Louvre, Paris
27 *Mona Lisa* Louvre, Paris
28–9 *The Garden of Earthly Delights* Prado, Madrid
30 *The Forest Fire* Ashmolean Museum, Oxford
31 *Self-Portrait* Prado, Madrid
32 *The Crucifixion from the Isenheim Altarpiece* Colmar, France
33 *Cupid Complaining to Venus* National Gallery, London
34 *The Creation of Adam* Sistine Chapel, Vatican City (Scala)
35 *The Tempest* Accademia, Venice (Cooper-Bridgeman Library)
36 *St Augustine in his Study* S. Giovanni Augustine e Trifone, Venice (Scala)
37 *The Alba Madonna* National Gallery of Art, Washington DC (Andrew W. Mellon Collection)
38 *The Venus of Urbino* Uffizi Gallery, Florence (Scala)
39 *The Ambassadors* National Gallery, London
40 *An Allegory* National Gallery, London

41 *The Origin of the Milky Way* National Gallery, London
42 *Lady Bathing with Children and Attendants* National Gallery of Art, Washington DC (Samuel H. Kress Collection)
43 *The Return of the Hunters* Kunsthistorisches Museum, Vienna
44 *The Marriage Feast at Cana* Louvre, Paris
45 *Christ Driving the Traders from the Temple* National Gallery, London
46 *Portrait of An Unknown Man* Victoria & Albert Museum, London (Crown Copyright)
47 *Bacchus* Uffizi Gallery, Florence
48–9 *The Descent from the Cross* Cathédrale d'Anvers, Antwerp
50 *The Laughing Cavalier* Reproduced by Permission of the Trustees of the Wallace Collection, London
51 *A Dance to the Music of Time* Reproduced by Permission of the Trustees of the Wallace Collection, London
52 *Charles I with an Equerry and Page* Louvre, Paris
53 *Las Meninas* Prado, Madrid
54 *Portrait of the Artist* Iveagh Bequest, Kenwood House, London (Cooper-Bridgeman Library)
55 *Head of a Girl* Mauritshuis, The Hague
56 *The Courtyard of a House in Delft* National Gallery, London
57 *The Avenue, Middelharnis* National Gallery, London
58 *The Embarkation for Cythera* Louvre, Paris
59 *Kaisersaal, Episcopal Palace, Wurzburg* (A. F. Kersting)
60 *The Harbour of San Marco with the Customs House from La Giudecca* National Museum of Wales, Cardiff
61 *The Graham Children* The Tate Gallery, London (John Webb)
62 *The Kitchen Maid* National Gallery of Art, Washington DC (Samuel H. Kress Collection)
63 *Reclining Girl* Alte Pinakothek, Munich
64 *Miss Bowles and her Dog* Reproduced by Permission of the Trustees of the Wallace Collection, London
65 *The Melbourne and Milbanke Families* National Gallery, London
66 *Mr and Mrs Robert Andrews* National Gallery, London
67 *The Swing* Reproduced by Permission of the Trustees of the Wallace Collection, London
68 *The Third of May, 1808* Prado, Madrid
69 *The Death of Marat* Musées Royaux des Beaux-Arts, Brussels

70 *The Ancient of Days or God Creating the Universe* Reproduced by permission of the Syndics of the Fitzwilliam Museum, Cambridge
71 *The Stages of Life* Museum Bildenden Kunste, Leipzig
72 *The Fighting Temeraire* National Gallery, London
73 *The Hay-Wain* National Gallery, London
74 *La Grande Odalisque* Louvre, Paris
75 *The Raft of the Medusa* Louvre, Paris
76 *Liberty Leading the People* Louvre, Paris
77 *The Studio of the Painter* Louvre, Paris
78 *In a Shoreham Garden* Victoria & Albert Museum, Crown Copyright
79 *The Gleaners* Louvre, Paris
80 *Ramsgate Sands* Reproduced by Gracious Permission of Her Majesty the Queen
81 *The Last of England* Birmingham City Art Gallery (Weidenfeld and Nicolson Archives)
82 *Autumn Leaves* Manchester City Art Gallery (Weidenfeld and Nicolson Archives)
83 *Garden with Trees in Blossom, Spring, Pontoise* Jeu de Paume, Paris
84 *Le Déjeuner sur l'Herbe* Louvre, Paris
85 *Le Foyer de la Danse à l'Opéra* Jeu de Paume, Paris
86 *Portrait of the Artist's Mother* Louvre, Paris
87 *Breezing Up* National Gallery of Art Washington DC (Gift of W. L. and May T. Mellon Foundation)
88 *La Montagne Sainte-Victoire* Courtauld Institute Galleries, London
89 *Women in a Garden* Jeu de Paume, Paris
90–1 *Le Moulin de la Galette* Jeu de Paume, Paris
92 *The Sleeping Gipsy* Museum of Modern Art (Gift of Mrs Simon Guggenheim)
93 *The Biglin Brothers Racing* National Gallery of Art Washington DC (Gift of Mr and Mrs Cornelius Vanderbilt Whitney)
94–5 *Where do we come from? What are we? Where are we going?* Museum of Fine Arts, Boston
96 *Starry Night, Sainte-Rémy* Museum of Modern Art, New York (Acquired through the Lillie P. Bliss Bequest)
97 *The Bathers, Asnières* National Gallery, London (John Webb)
98 *The Scream* National Gallery of Art, Oslo
99 *At the Moulin Rouge* Collection of the Art Institute of Chicago
100 *Dining Room on the Garden* The Solomon R. Guggenheim Museum,

ACKNOWLEDGMENTS

New York (Robert E. Mates) © SPADEM Paris, 1979

101 *Mother and Child* Glasgow Art Gallery © SPADEM Paris, 1979

102 *Dance (1)* Museum of Modern Art, New York (Gift of Nelson A. Rockefeller in honour of Alfred H. Barr Jnr.) © SPADEM Paris, 1979

103 *The Kiss* Osterreichische Galerie, Vienna (Cooper–Bridgeman Library)

104 *Les Demoiselles d'Avignon* Museum of Modern Art, New York (Acquired through the Lillie P. Bliss Bequest) © SPADEM Paris, 1979

105 *Violin and Palette* The Solomon R.

Guggenheim Museum, New York (Robert E. Mates) © ADAGP Paris, 1979

106 *Nighthawks* Collection of the Art Institute of Chicago (Robert E. Mates)

107 *Woman with a Fan* Musée d'Art Moderne de la Ville de Paris (Bulloz) © ADAGP Paris, 1979

108 *Nude descending a Staircase (2)* Philadelphia Museum of Art (The Louise and Walter Arensberg Collection) © ADAGP Paris, 1979

109 *I and the Village* Museum of Modern Art, New York (Mrs S. Guggenheim Collection) © ADAGP Paris, 1979

110 *Time Transfixed* Collection of the Art

Institute of Chicago © ADAGP Paris, 1979

111 *The Persistence of Memory* Museum of Modern Art, New York (Given Anonymously)

112 *Figure in a Landscape* Tate Gallery, London (John Webb)

113 *Christina's World* Museum of Modern Art, New York (Purchase)

114 *Blue Poles* National Gallery of Art, Canberra, Australia

115 *Whaam!* Tate Gallery, London (John Webb)

116 *Mr and Mrs Clark and Percy* Tate Gallery, London (John Webb)

The author would like to thank Elizabeth Falconbridge for her research assistance and Wendy Dallas for her editing.

Index to Artists, Movements and Technical Terms

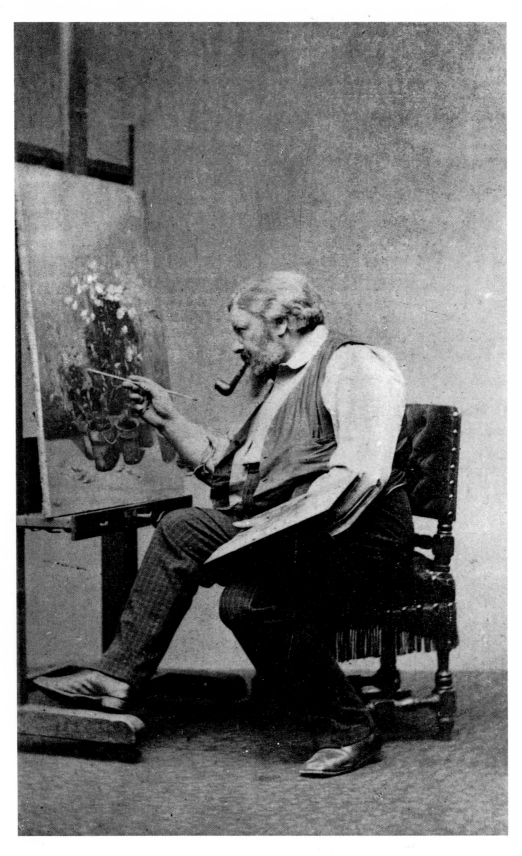

The artist at work. A rare photograph, taken in 1870, of the flamboyant Courbet, deeply involved with his subject and dedicated, as always, to representing reality.

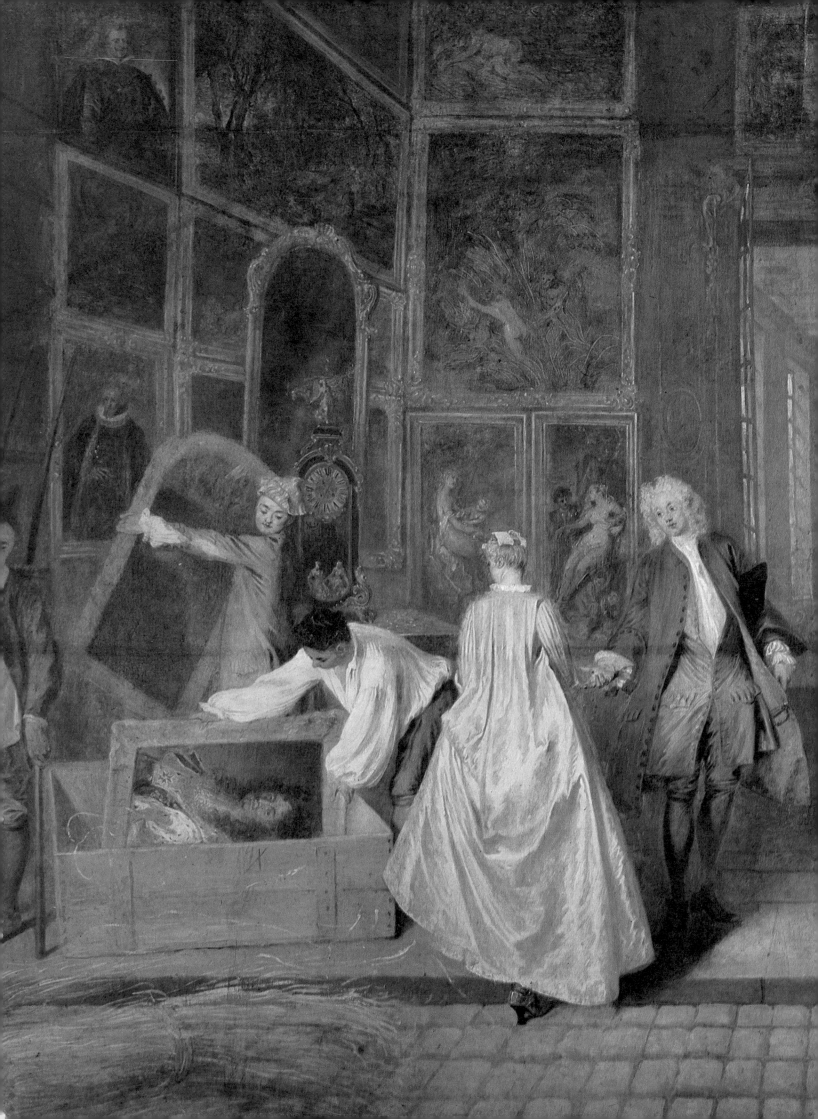